William Tillyer
The Loneliness of the Long Distance Runner
By Bernard Jacobson

Works © William Tillyer
Text © Bernard Jacobson
Portrait © York Tillyer
ISBN 978-1-901785-19-7

Published on the 25th September 2018
by 21 Publishing
28 Duke Street St James's
London
SW1Y 6AG
+ 44 (0)20 7734 3431
info@21publishing.co.uk
21publishing.co.uk

Designed and Printed by
Witherbys Limited

2|

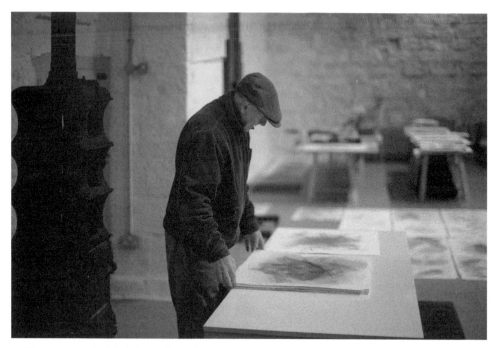

William Tillyer in his Stokesley studio

William Tillyer

The Loneliness of the Long Distance Runner

Bernard Jacobson

For William and Judith

The Road Taken

Every summer, all of July and all of August and well into September, I go to our mill house in Lacapelle-Livron in southern France.

Most days I will walk four kilometres to the village of Caylus, to buy early morning croissants or some bread for afternoon tea. Sometimes Karin will come with me, usually I make the journey alone. You will pass many cows, grazing in the silent and still air. Often, when it gets too hot, you will find them under a clump of trees on the hillside.

You pass by our neighbours at the next mill about a kilometre away, Etienne and Anita Wermester. We often eat together and Etienne, a retired cultural attaché from Paris, and I will talk into the night about culture, his experiences of a lifetime, my world of art, which he is always interested to hear about. Another kilometre along this tiny road of ours, which follows the river la Bonnette, you will come across an amazing sight, la cascade pétrifiante, the petrified cascade of Caylus, which in the high summer will allow a reasonably small flow of water from its tip into a gorgeous pool at the foot of it. Children will often be seen and heard there, enjoying the cool water. In the winter months the water can gush at a frightening and thrilling torrent.

Then I carry on, until I get to the main road and up the hill to the shops.

If I walk at a fast pace it is great exercise. If I dawdle, which I prefer, my mind drifts more freely and more creatively. The art world and the art market are so far away at this moment in time. And I enjoy other things, different sensations, a clearer head. These walks, over so many years and on so many occasions, have, quite inadvertently got me to become substantially less interested in much of the art of our time, the art of the marketplace. Even many of those very artists, who I held so dearly in the sixties and seventies and eighties, became of considerably less significance to me. Piero della Francesca would become of today, as would Poussin and Cézanne and Matisse. In fact each summer we will drive to Aix-en-Provence to visit Cézanne's house and studio and travel along the Côte d'Azur to Nice and visit Matisse's home and grave.

The only artist who has been allowed to visit our sanctuary, far away from the pretentiousness of the art world, is in fact Willi. He and Judith stayed here once.

I like to draw and paint. I'm not very good at it, although it relaxes me while not writing. Anyway, while that time he and Judith were our guests, I had a small dilemma and I asked Willi for help. He too was attempting to relax, and get away from his studio life for a few days. I felt a bit like a host asking his doctor friend staying at his holiday retreat that he has these pains in his stomach or dull pains in the lower part of his back. I just wanted to understand something quite basic and straightforward though. I had for days been drawing the space from the portal of our house, through the large walnut tree in front of it, across our mill pond, and over to the trees way in the distance. I didn't know how to depict it all in a simple and modern way. Without having to stick in loads of visual information, like a Constable or something. Then I just felt plain silly, as if asking a great concert pianist to teach me how to play my banjo I just got from Hamley's. He grabbed my drawing pad and, within seconds, and with a few simple lines, managed it to perfection. The result was so basic, uncomplicated and elegant – and correct! Terrific. Thank you, doctor, so sorry to have asked you this on your day off.

The only other artist who actually promised to come as his own choice, was Pierre Soulages, now aged ninety-nine. For all his rigorously black paintings made over his entire lifetime, he often can be quite a romantic. He and Colette would often say they would love to come and stay. He said he knew the region well and even, as a child would go fishing in la Bonnette. He was born and raised in Rodez, just one hour away from us. In fact that city has now given Pierre a magnificent museum, with his name, and filled with his art. We visit them fairly regularly in Paris and also in their superb house overlooking the Mediterranean in Sète. He still has not reciprocated!

After all these endless summers in this mill house deep into France's landscape, on that constantly bending road to the village of Caylus, I return from this idyll to London, none of my passion for William Tillyer diminished, but simply grown from my time away from it.

Caylus, September 2018

6

Foreword

William Tillyer was born in the late thirties and began to make significant art in the mid-fifties, a decade before I met him.

His ambitions have always remained solely within the confines of his studio, never in the market place.

It was not until the eighties that I began to see that this very private and quiet man might possibly be a great painter. A decade later I realised that he had indeed become one.

In the early years of the new century I began to consider writing a book on Tillyer, to explain my thoughts and feelings.

In my opinion he has, within the past few years, become a giant among his peers, and quite possibly this country's greatest painter since Constable and Turner.

I found it necessary to write this story down. Doing so has taught me a lot.

The Loneliness of the Long Distance Runner

It's a perfect summer's day in the fifties. William runs across the North York Moors and the heather, tough and hard but springy under his feet, is a mass of purple as far as the eye can see. Away in the distance there is a copse of ash trees and as he runs he notes a small group of cumulus clouds directly above them. A perfect day. He finds a small outcrop of sandstone and decides to rest for a short while. Now in his early teens, he contemplates his future. He has recently been grappling with the idea of becoming a farmer, a monk or an artist.

It is indeed a perfect Yorkshire day, as he runs back through the purple, home to nearby Glaisdale, where tea is ready. 'Mum, dad, I am going to be an artist!'

* * *

William Tillyer is now in his eighties. When I first came across him I was in my twenties and he was just thirty-one. In *Art International* he had read a feature describing me as the new voice of limited-edition prints, and the year was 1969. I was already involved with Warhol and Lichtenstein and Hockney and Oldenburg. I had already published prints by Malcolm Morley, Robyn Denny, Ivor Abrahams. I could have gone out for a stroll that afternoon, as I often did during those years. If I sold a Warhol print I would set out from my fourth floor walk-up in Mount Street and wander the tiny park behind the block, or sit at the Italian café on the corner. But I happened to be in my office when Tillyer appeared.

In walks a soft-spoken and slight young man, holding a small black faux-leather case, stuffed with etchings. He was quiet and unassuming, already somewhat defiant. This was Mount Street in Mayfair, opposite Scott's fish restaurant and above Doug Hayward, tailor to the stars, who included Terence Stamp, Frank Sinatra, Tony Bennett, Laurence Harvey, Terry Donovan the photographer, movie moguls and more. But I was high above all this, in an L-shaped cupboard for gallery and office at £10 a week, including the use of a secretary. If you wanted to get to my gallery you had to be determined, and Tillyer arrived out of breath, probably from anxiety as much as the climb. 'So, let's see your work. . .'

He unzipped his portfolio and there they were. Those etchings. It was love at first sight. 'They are terrific. If you can get a reputation for your paintings I'd be happy to publish your prints.' He shuffled a bit. 'But that's why I came to you,' he replied.

Innocent but with a touch of confidence. I was taken aback. 'Open that folder again,' I said, before he had time to vanish back into Mayfair. 'OK, I'll publish this one and that one,' and they were *Mrs Lumsden's* and *The Large Birdhouse*. His titles were already confident, the etchings done in a one-off cross-hatch technique I had never seen before, where the image appears through an interrupted or broken grid, whose openings or apertures he had created by biting those parts more deeply and which gave the image its reality, its substance and also its light step, its topicality. I instantly realized that I was looking at a new language, one which I did not truly comprehend, although in time I thought I would. We made twenty-five copies of each. I got to work in earnest, and within a very short time had sold them all.

To put things in a perspective of sorts, if Cézanne had nowhere to go but Vollard, and if Manet, Monet and Pissarro had nowhere to go but Durand-Ruel, William Tillyer had nowhere to go but Bernard Jacobson. At the time he came into my life I was unaware of how his sixties had differed from mine. For him it was a decade of struggle and slow self-making, while his contemporaries like David Hockney, Peter Blake, Allen Jones, Richard Smith and Robyn Denny had constant exhibitions and instant exposure, at home and abroad. With my low overheads, when I sold a Warhol or a Lichtenstein or a Hockney or a Blake I could afford to take a walk. But these were early days for me too as an art dealer, and for Tillyer as a professional artist, each of us making a small income from the etchings we printed.

An artist needs a dealer, a dealer needs an artist. I believed I had found my home grown moment in William Tillyer. But greatness does not come from timing alone. It comes from the artist having a sustained vision and the strength of character to see the job through.

William Tillyer did two things in the mid-fifties to suggest these qualities. The first was a painting of a deserted beach in North Yorkshire, entitled *Beach and Sea Seaton Carew*, dated 1956, the year of Jackson Pollock's death – dates are always significant – where he was born and grew up and remained until he left for London to go to the Slade school of art. A small canvas, it is a Romantic vision of sea and land, as desolate as Caspar David Friedrich's *Monk by the Sea*. Heinrich von Kleist said that the experience of seeing it 'was as if one's eyelids had been cut away,' a place unpeopled for the rest of human time. It is the landscape of an only child. But the sea shore is there. What has disappeared is the monk.

The second hint he gave was more strident and assertive. A new William Tillyer was born with his first ever catalogue note, written for the final year exhibition at his local art school, Middlesbrough, in 1958, before he left for London. It is a brief text, which spells out, quietly but defiantly, what would obsess him for the rest of his career, an adolescent insight into what he would do with his life:

> In this exhibition I have tried to put down my feelings about such elements as sea, sky, beach, moor; and relating objects, including man, to them.
>
> Such areas have appealed to me because one is always aware of one's size and of surrounding objects. Objects become more important – points of excitement, such as a single figure on an open beach; giving size – scale.
>
> Standing on a beach I find my eye travelling down the beach by progression – pebble to man or a boat, to the horizon, up to a cloud, and back to the pebble.
>
> Thus a volume is created, a volume in which we live. These objects which are cornerstones of a space are given a scale by that space. Isolated from its surroundings, a pebble could appear to be of immense size. But seen against the vastness of the beach or covered by the water which stretches away to become the ocean, the pebble slips into its correct scale.
>
> In this way my interests have centred around scale from a space and scale out of natural order or progression.
>
> I feel that these thoughts are equally valid when applied to the earth in relation to the universe, this universe with other possible universes.

The programme it announces is both hugely ambitious and systematic, even pedantic: 'up to a cloud, and back to the pebble'.

My Courtauld

Since discovering the Courtauld Gallery in the mid-fifties – Gauguin, Cézanne, Van Gogh, Renoir, Pissarro, Monet, Seurat – the Impressionists and Post-Impressionists have held a very important place in my life. Visually, everything I saw after would be judged by this yardstick. All art, back to the Renaissance and earlier, or forwards to today, would need to sit comfortably with that first experience. It was never an art education, just an adventure. Moving forwards but also stepping back, the learning process was shorthand for those paintings and sculptures which had entered my soul.

The Courtauld's rooms are fixed in my mind. I can see myself standing there, and today I could go back and stare at the *Bar at the Folies-Bergère* as if for the first time. The Rubens sketches, the mysterious Bellini of the martyrs so cruelly slaughtered in that wood, Daumier's stick-thin Don Quixote with his round and faithful sidekick Sancho Panza. And – first and last – Paul Gauguin's *Nevermore*.

My eyesight was better back then. I could see colours and composition without spectacles, and feel the emotional pull of a picture, just my teenage retina confronting the paint, no complications of allegiance or knowledge, no sense of history, no perspective on life. Just me and Van Gogh, me and Gauguin, me and Cézanne. No preconceptions. No art appreciation. Just the magic, each and every time I visited. The Tate and the National Gallery may have had more pictures, and in many cases, better pictures. But those huge buildings could not, even then, create this resonance and allow a picture to be my picture. There is a lot to be said for small museums. My Courtauld – not my Tate.

* * *

It is difficult to say when Willi took his first steps to becoming an artist. Long before I knew of his existence.

He was born in Middlesbrough on 25 September 1938. It was a middle-class upbringing in the North East of England, an hour's drive from the Scottish borders. He was an only child. His father went off to war soon after he was born and did not return until it ended, five years later. So he was brought up amongst women, by his mother and grandmother and great grandmother, in leafy suburbia, even if the air was far from pure, thanks to the local ICI chemical factory. He would remember skies of yellow in this corner of Yorkshire.

When the war ended Willi had his father back, which meant having a father for the first time, and building warm memories of going fishing on the River Esk and home life above the family business, a hardware shop in Middlesbrough. Without knowing it he was already storing the raw materials of his future. On the one side there was the look and feel of objects in his father's store, just as Turner's late paintings remember the things he saw as a small boy in his father's barber shop: 'water, froth, steam, gleaming metal, clouded mirrors, white bowls or basins in which soapy liquid is agitated by the barber's brush', in John Berger's words. And on the other side the moving waters of the River Esk, an emblem of memory and

desire, and the unending expanse of moors and dales. And behind all of these things the watchfulness of a wartime child.

As is so rarely the case with creative children, his parents approved and encouraged his artistic learnings. In those years he would draw incessantly, and was singled out as the kid who could draw, who was asked to make a frieze of *The Wind in the Willows* for his classroom walls. Or perhaps the die was cast in 1955, when the Luxol enamel paint company ran a window-dressing competition which his father allowed or perhaps urged his teenage son to enter. A scruffy photograph survives to show his efforts, a sort of *arte povera* production before the movement got going, a collaged sculpture. At this time Robert Rauschenberg was experimenting with similar resources for rather more sophisticated and American purposes. Such are the workings of the zeitgeist.

A year later Willi produced *Beach and Sea Seaton Carew* and it was clear that the eighteen year old was going to be a painter. So he enrolled at Middlesbrough College Of Art.

He still cycled over the Cleveland Hills, picnicked on the moors, wandered across the dales, stared out to sea at Whitby. And now, as an art student, he would make occasional trips down to London, discovering the works of Ben Nicholson at the Tate Gallery. There was even a trip to Paris, where he saw the sculptures of Picasso and Miró and of fellow Yorkshireman Henry Moore at the UNESCO building. He was finding his way, pondering the revelation that at some point nature meets the city, and what this might mean.

He was now making his first independent forays into etching, at the kitchen sink at home. The copper plate is prepared with an acid resistant ground. You draw a line in the ground exposing the metal. The plate is then immersed in acid and the exposed metal is 'bitten', producing incised lines. Stronger acid and longer exposure produce more deeply bitten lines. Ink is applied to the sunken lines, but wiped from the surface. The plate is placed against paper and passed through a printing press with maximum pressure, so as to transfer the ink from the incised lines. Sometimes ink may be left on the plate surface to provide a background tone. The line has a sensitive, seductive furry quality, fantastic things happen in the space of a few inches, and the plate stores many kinds of visual information. Etching and its metamorphoses fascinated the youngster, and would continue to do so for the rest of his life.

The following year, 1958, he was twenty, and the family moved from the town to the small village of Glaisdale. His new work must now connect city to land and local scenery. More ambitious paintings followed, to which he gave the overall title of 'Vortex Works'. He has never been shy of giving titles, and as his master Marcel Duchamp remarked, a title is an extra colour.

In those last few years of the fifties, when the post-war pace was still slow, and acrylic had yet to be invented, William made some wonderful paintings, the last he would produce until well into the seventies. These were the fruits of his years at Middlesbrough College of Art. The oil paintings that followed from 1957 until 1960, *Fields, Moon Sea and Sky* or *Beach and Sky with House Boat*, both from 1957, owed a lot to his new passion, Paul Klee, who taught and practised the idea of art as a language which joins visual attention to a philosophical cast of mind. Tillyer's apprentice works from the following year displayed a steadily enlarging ambition and originality, like *Sea Clouds and Beach*, inspired by one of Britain's greatest post-war painters, Peter Lanyon, who rendered the landscape from above, looking down, so that the scene became progressively more abstracted while retaining an urgent sense of the specific. This place and not that.

And then there is the quirky *Pear and Cloud*, from 1958, his still life of an immense pear, alone on a table which looks more like a purple-grey landscape, with a tiny cloud hovering quizzically overhead. It might be an irreverent allusion to Piero della Francesca's *Baptism of Christ* at the National Gallery. The paint is rapid and carelessly confident, yet the work is coolly ambiguous. So is it a nod to Cézanne – replacing the signature apple with a Tillyer pear – or perhaps a friendly jab at him? Or it could be a Dadaist gesture, mocking the world of appearances, and mocking art for its attempt to render them. Or perhaps, as the artist himself once intimated, a vision of Heaven and Hell, with a heaving underworld below a sky of idealised blue.

In the following months, during his final days at art school, in works such as *Sky and Moor (The Vortex)* and *Brown Land*, he began to reflect upon another British painter, Victor Pasmore, an artist whose radically shifting styles – from his 1930s paintings of interiors to his constructivist sculptures in Perspex and wood, or his airy abstract canvases – gave new and vertiginous meaning to the word 'career'. Some of these Pasmore works were included in the 1959 Young Contemporaries exhibition in London.

Even as a schoolboy in the fifties Willi had a fully-formed sense of what art should and should not be, at least for him. He was not overly concerned by what others were thinking. If Duchamp was part of his self-making, so too was the wonderful landscape painter Ivon Hitchens, a delightful individual, born just six years after Duchamp. Neither of these two elder statesmen would have too much to say to each other about art, but both said a lot to the young William Tillyer.

From the great Frenchman he would learn a wry wit, and from the Englishman how to suggest a tree with one sweep of a brush on canvas. But these were only a few of the ingredients that would eventually make a mature Tillyer painting. As Adrian Heath – a friend of Hitchens and ally of many of Willi's heroes of that time, Ben Nicholson, Victor Pasmore, William Scott – put it to me, quietly but with his force and authority, 'Tillyer went where Hitchens should have gone.' Adrian's own paintings were certainly good, though I prefer what he said to what he painted, and especially his understatement that 'there seems to be little grasp of the values of abstract painting and consequently no general appreciation of its qualities.' He wrote this in 1953, when Willi was fifteen years old, but it still holds today. If Hitchens and his colleagues were necessary for Tillyer, so too was the Frenchman, with his bone dryness and a kind of pragmatic realism which can get you through life. And yet it was Duchamp the loner who, of all people, quoted Lord Byron, 'There is society where none intrudes.'

However eclectic, Tillyer had no need to thrash around to discover what kind of art he would make. His direction was clear, from the brief manifesto he wrote at art school. Had he left it there, and contented himself with painting those very pictures he described in words, what would he have become? An extremely good artist, no doubt. But they were not a destiny, merely the clues he had so far picked up, living in the North East of England during wartime, in an industrial town where for several months of the year the air clouded your view, cycling out to moors and dales where the sky was cleaner and sweeter.

The Yorkshire altar boy would roam the hills, leaving a family home run by three generations of women, during the years his father was away, whistling as he peddled. Or he would get taken on long walks with a group of regulars known as 'ramblers', close friends staying in the same hotels, sometimes as far as forty miles away from the smoke and smog. The lovely and beckoning river Esk was to the south. The Tees, the industrial river which virtually created the town of Middlesbrough, lay to the north.

On the north shore of the River Tees he would endlessly sketch and paint. The child in time, in his element, running and walking and cycling across the North York Moors, carrying the recently acquired tools of his craft, pencils and drawing paper, paint and brushes and canvas. The world was opening up for him, laying itself at his feet!

As childhood gave way to youth, the Yorkshire skies stayed large and spacious but he became more analytical-minded, and drew on sources other than the visible. A new order was beginning to reveal itself, both far and near at hand. News from the metropolis. Richard Hamilton, the painter and printmaker and a loyal disciple of Marcel Duchamp, was teaching at Newcastle and starting to become extremely influential in that city, as well as exerting a significant influence at the Institute of Contemporary Art in London. In his openness to whatever swam into his view, it was obvious that young Tillyer was a contemporary artist in the making.

Within the space of three short years he was almost entirely concerned with the conceptual, and within less than ten years he had returned to painting. His conceptual moment was not a mistaken direction or a diversion, rather it was an essential rite of passage. It revealed to him the grid, which became the syntax of his visual world and conditioned his sense of the physical universe. The conceptual sharpened his appetite for the real.

Holding all these elements together, each informing the other, made unusual demands on a young artist. Had he settled into the centres of networking and socializing in London or Paris or New York, his own fragile centre might have fallen apart.

As the slow decade of austerity ended, Willi applied to the Slade School of Fine Art and his tutors in painting were William Coldstream who also taught Howard Hodgkin, and Claude Rodgers who also taught Euan Uglow, as well as the legendary and charming Anthony Gross for printmaking. He moved into a flat in Notting Hill, sharing it with two fellow students from Middlesbrough. One of his flatmates played double bass. They would all hang out in the city's bars and jazz clubs, and Willi made a bit of extra money as part-time cleaner and barman in West End bars.

Meanwhile Willi was finishing a National Diploma in Design, a four year course, tough and rigorous, and producing etchings in his mother's kitchen. In 1960 he won his scholarship to the Slade art school in Bloomsbury. This too was a sober and scholarly education, rather less glamorous than its rival, the more hip Royal College of Art in Kensington, where David Hockney, Peter Blake, Allen Jones, Joe Tilson, Malcolm Morley, Richard Smith and many others went. The Slade was analytical, followed the grand tradition of Art, and looked to Europe. The Royal College was sensational, taught the makings of a career, and looked to America.

Appropriately, in his second year Tillyer applied for a French government grant to go to Paris and become a student of the legendary print maker Stanley William Hayter, an Englishman who had worked with Picasso in Paris and with Jackson Pollock in New York. The young aspiring artist was given his own studio and now lived in the city of light, the shrine of Modern Art. But it was an old-fashioned trajectory. While Willi was living in Paris, Royal College students were looking to New York, at a moment when the pendulum seemed to be swinging to the other side of the Atlantic. But Tillyer was finding the quiet and privacy he needed, concentrating on woodcuts. Hayter's workshop, Atelier 17, was full of American girls 'doing Europe', and attractive as they were, Willi was there to learn. Anyway, by this time he was in love with Judith, and she was in Scotland, working in a hotel in Edinburgh. They had already lived together for half a year in Scotland, and in 1963 they would both move to London and marry, living above a ballet school in Warwick Avenue in Maida Vale.

At this time a friend introduced him to *À Rebours*, a strange and infamous little novel by a Dutch civil servant and fin-de-siècle aesthete who had lived in Paris, the mysterious Joris-Karl Huysmans. A critic and friend of artists of the day, and also of poets like Mallarmé and Paul Valéry, he invented the most mysterious of heroes, possibly the original anti-hero, Duc Jean Floressas des Esseintes, the central and solitary character in a book that would rock the Paris literary scene on its publication in 1884, and become a bible for Oscar Wilde's Dorian Gray, who would keep it by his bedside. This richly perfumed and blasphemous fantasy, usually translated as *Against Nature*, is a standard work for art students to this day, and would become an essential part of the life of the artist William Tillyer. *À Rebours* is translated as 'Against the Grain' in America, and this spoke to Tillyer in more ways than one.

The decade was ending in which Willi had looked and learned, moved from the north to the south, and was now on the verge of getting his diploma, ready to begin searching in earnest. As well as European artists he had studied local heroes, Nicholson and Pasmore, Lanyon and Moore and Hepworth. But one figure stood in his way. Before Tillyer could leave he needed that diploma, and another art world dignitary, fresh from a prestigious showing at the Venice Biennale, decided that Tillyer was not ready for the world. Most of the Tillyer student works that William Scott was asked to consider and judge were not in fact paintings but sculptures, which in effect disqualified themselves. So Willi was not recommended for the Slade diploma, and had to spend one more year at art school. He never held it against his external assessor, although it must have been painful for a young man eager to set out on his career.

Excellent painter that he was, William Scott would not have known what to make of *Falling Pinnacle*, a 1961 construction submitted for the diploma. The central panel of this compact triptych, which is painted all over in plain white gesso, shows a schematic drawing of a pollarded tree, above which floats an inverted triangle, all of it as plainly rendered as a signpost. Perhaps the artist was once again looking backwards to Piero della Francesca's *Nativity* in the National Gallery, and to the quattrocento religious triptychs which were folded for travelling purposes, or even further back to Byzantine notions of the icon as a repository of symbolic rather than pictorial meaning. At any rate Tillyer's triptych does not allow its viewer to enter the space, but holds us at a distance, as if forcing us to ponder this banal but mysteriously cosmic icon. It is a courageous and confidently laconic work, which equally alludes to the art of the present, to the work of Victor Pasmore and perhaps Ben Nicholson, and looks forward to a minimalism whose practitioners would surface in New York only later in the decade. If William Scott was thinking of the past or even the present in his responses to Tillyer, the young man was sniffing the future.

Difficult years lay ahead. He was certainly dedicated and skilled, and visually prepared enough to make his own art, but he was also flat broke. He returned to London and moved into Judith's flat in Notting Hill. After getting married they returned to Glaisdale, in Yorkshire, to his family home and he taught in art schools in Middlesbrough for a year. Later Willi found work in London teaching printmaking at Regent Street Polytechnic or at the Central School of Art, or at Chelsea, where he worked briefly as a technician in the printmaking department.

They managed to buy a small house in Wimbledon. Tillyer was thirty. It so happened that the print market was on the verge of a boom, the likes of which had not seen since the twenties, and for the first time in his life he was in the right place at the right time. He proofed many etchings at this time, but without sufficient funds to edition them. He would print the odd copy, selling it to a friend, or to the friend of a friend.

The following year he was offered a teaching position at the Bath Academy of Art in Corsham Court, a residential art school for education in and through the arts, with a distinguished tradition of teaching from practicing artists and designers, a native equivalent of Black Mountain College in North Carolina. Teachers and visitors included sculptors Kenneth Armitage and Bernard Meadows, painters William Scott, Terry Frost, Peter Lanyon, Adrian Heath, Robyn Denny, Howard Hodgkin, Gillian Ayres, Richard Hamilton, and even the Americans Jim Dine and Claes Oldenburg.

Life for Tillyer became a round of teaching. He worried that being a teacher would hamper or even compromise him as a practitioner, though he kept painting. Life in Parsons Green, where they now lived, was more tolerable but still precarious. The work he was producing was 'conceptual', although the term had yet to enter common currency. These were the early to mid-sixties and his subject was clouds, cut-out shapes neatly stacked in a plate rack he got from the hardware store. Or pebbles entitled *Clouds*, white and cloud-shaped and classified, each in its compartment, like an exhibit in the natural history museum. It was witty, it was smart, it was philosophically loaded and driven by a Dadaist humour of the wariest kind. And then there were the door handles, inspired by the same handles he had once seen in his father's hardware store in Middlesbrough, and which would become one of the props, painfully funny as it was, in a play by Timberlake Wertenbaker, *Three Birds Alighting on a Field* at the Royal Court Theatre in 1992. In which she brilliantly pointed out how successful her fictional artist might have been had he stuck to door handles and not regressed to painting landscapes – if only he did not have such high principles, or such protean means of expressing them. If only he would stop reinventing himself.

But it was not entirely a matter of 'principles'. Tillyer had little say in the matter. He was being led by a force or a daemon stronger than himself. While his peers and colleagues were casting around for their niche, their particular berth inside the

modern, Tillyer had his subject and he had his staying power. He just needed the time to produce his vision. And that is what he is doing to this day. The fact that he has been excluded from the metropolitan art party, the fact that he had to become an outsider, was the catalyst for his achievement. When other artists have been eaten alive by the demands of the art establishment, when a high price is paid for the high prices that are paid, even the great Francis Bacon was damaged by this, Tillyer has been free to make an art uncompromised by contract or commerce.

What he came to in his solitude was a pivotal moment, the discovery of how essential the grid would be to his work. The grid, which both creates and destroys the picture plane, was his way of getting as far away from figuration as possible, like climbing a hill to look back on the landscape spread out below. As he once said to me:

> In my teens I was inside the landscape, a Constable landscape of sorts, and said to myself, 'I want to be a painter – but what I make cannot look like Constable, so I have to re-invent what has been invented already.' This was around 1956. And it has taken me a long time, as it needed to. And I was well aware of artists like Henry Moore, Peter Lanyon and Ben Nicholson, all of whom were attempting to deal with this same problem.

Without the grid, like the scaffolding which cradles a house, the entire structure would fall apart. Tillyer built the scaffold and then dispensed with the house – along with all of its visual preconceptions, its designs on reality, its pretense of being a reality.

The mystery remains. How does William Tillyer make a painting? He always tells me that subject is unimportant, that process is everything. So when I suggest to him that the subject on the canvas, or should I say the grid, could be a tractor or an aeroplane, he makes no reply. And I like this. Because I know that subject matters a great deal, whether he is making a painting of his local river, the Esk, or a vase of flowers, which he says are the same thing. But he prefers not to continue this line of discussion.

No serious artist sets out to paint a beautiful picture. He or she paints a picture, then decides whether it has or does not have beauty. But this is of secondary interest, because it is feeling that matters. David Bomberg talked endlessly about 'The Spirit in the Mass', whatever that means. I always thought that what he

was getting at, and searching for, was Beauty, but as something occurring of its own accord, independently of him, as the paint worked its own logic across the canvas, in the writhing colours and compositional strength of his work from the thirties until his death in 1957. Tillyer has always been a deep admirer of David Bomberg.

After the Slade, in 1962 Willi went to Edinburgh. To make a bit of money he worked part time as a cocktail barman and made a series of woodcuts entitled *Heaven and Hell.* He was using found elements and objects, introducing collage into his work, putting out feelers.

In 1963 Willi returned to North Yorkshire. The married couple lived in a barn on his parents' land, in Glaisdale, beside the River Esk. There he built an etching press from an old mangle donated by a neighbour, and continued to paint and make prints while teaching at various schools in Middlesbrough. He even opened a small art gallery in Whitby, possibly inspired by Turner, who at one point had an art gallery in Soho.

Tillyer was not the only artist of his generation to move back north. So too would David Hockney return to his Yorkshire family house in Bridlington, several years later, after his decade in the Californian sunshine. But if Hockney was able to make the countryside around Bridlington seem familiar and therefore glamorous to the metropolitan art world, so Willi, perhaps with the help of Duchamp's stubborn stoicism, would make the leafy and verdant village of Glaisdale seem an unfamiliar elsewhere, unbeckoning, not asking to be explored.

By 1964 Willi was taking on any number of teaching posts, at the Regents Street Polytechnic, at Chelsea College of Art, at the Bath Academy of Art in Corsham, at the Central School of Art. He was pursuing his minimalist and conceptualist intuitions, and would shortly produce paintings using hardware, piano hinges, door handles. Once again, this work was not quite of its moment, which had yet to arrive. It was as if everything Tillyer made would have to wait its turn in being understood. It had no sell-by date stamped on its base. But certainly something was afoot, all around him, and it was taking a bewildering variety of graphic forms, some of them outlandish, and perhaps he needed to be part of this. Swinging London was in full swing, and it was a marketplace for imagery. With a wife and two small children, he must try to be a little more commercially minded. Perhaps what he needed was a dealer. All of which led to him turning up unannounced, one day in 1969, at my fourth floor walk-up in Mount Street.

'Only connect.' – E.M. Forster

Timing is everything. The hopeful lover may be too late, or too early. One day, over half a century ago, I was visiting the artist Bernard Kay in Holland Park, whose etchings I often bought with my pocket money. A door swung open in his elegant but ramshackle mansion and I saw a tall man in profile, contemplating a canvas, clearly grappling with a work in progress. It was an abstract painting, large and upright, a composition of hard-edged closely-related colours of a rich dark tonality. In that moment I fell in love – and the door closed. I asked Bernard who this was, and he quietly replied that it was someone to whom he rented a room. But the image I glimpsed was indelibly printed on my mind, and within a short time I worked out that this was none other than Robyn Denny. In time we became friends and when the moment was right, in the late sixties, I would become his print publisher and eventually his dealer. But the experience of the glimpse and the unfinished picture never left me. It was as meaningful as discovering Gauguin a few years earlier. The dusty mellow colours and the large canvas resonated with me as deeply as my beloved *Nevermore*, an image that would haunt my entire life and which, with perfect timing, I stumbled upon in a stall in a Covent Garden market, among the piles of used books and old postcards and vintage magazines. For a few shillings and the cost of the frame, I had my own *Nevermore*, in poster form.

The Gauguin connection does not end there. My favourite composer, Frederick Delius, whose lush soundscape revolved endlessly on my record player, was, I then discovered, the actual owner of *Nevermore*, which he bought from his friend Gauguin in 1898 and hung on the wall in his music room in Grez-sur-Loing, south of Paris, where he composed so many works. I soon discovered a photograph of the composer at his piano, with *Nevermore* on the wall behind him. Whether anyone else would see a meaning in such connections did not bother me. It was enough that I saw them. Ten years later, now in the business of buying and selling art, and already representing artists like Robyn Denny, I was visited in my fourth floor walk-up in Mount Street by William Tillyer. A new glimpse, a new link was forged, once again love at first sight. Not as yet the deep love for Gauguin or for Denny, more like a new friend, a new connection waiting to be explored.

More accurately, it was the work itself that I befriended, whether paintings or sculptures, watercolours or etchings, and the friendship as such must remain a rather guarded affair, a business. And if asked about the artist-dealer relationship,

what can I say? 'Not the painter but the picture.' Or 'I don't believe in him, I don't disbelieve in him. I believe in his work.' Or as D. H. Lawrence said, 'Not the teller but the tale.'

It is a reciprocal relationship, built on trust, the dealer believing that the artist will not cheat on himself, the artist hoping that the dealer will not cheat him in return. For me it is, at its rare best, a modern-day version of Ambroise Vollard in 1895, buying the entire studio output of Paul Cézanne because nobody else wanted it, and because he sensed a business opportunity. Vollard was rewarded for his astuteness by becoming the dealer of the greatest painter we have seen for several centuries. So great that both Picasso and Matisse, the masters of the following century, wanted to be exhibited alongside this genius, a figure as monumental as Mont St. Victoire itself, the mountain he would painstakingly describe and re-describe in paint, attempting to capture it more than forty times in his career. The established artists of the day, Pissarro or Monet or Renoir, had all been taken on by the bigger dealers such as Bernheim-Jeune and Durand Ruel. And so it was left to a mongrel art dealer, from Réunion, to be left alone with the outsider Paul Cézanne – who would, in time, become the master of the whole group. Vollard's timing was happy.

* * *

It was a modest and even inauspicious beginning, when I agreed to publish those two etchings using a technique nobody had quite seen before. I sold them to artists such as David Hockney and Ron Kitaj, to institutions like the V&A, the Tate Gallery, the Arts Council of Great Britain, the British Council, MoMA in New York, the Bibliothèque National in Paris, and to dealers across the United States of America on my twice-yearly trips there.

Weeks turned into months, the artist and his publisher bonding as we moved from one print project to the next. By the following year, 1970, he was producing watercolours, looser than the etchings and lithographs, but still using a cross-hatch technique as a window onto a late twentieth century world. As I grew he grew. As he grew I grew. There were so many other artists I was working with, Ivor Abrahams with his mysterious garden images, Peter Blake, David Hockney, obviously Robyn Denny, Andy Warhol, Richard Smith and Richard Hamilton, Frank Auerbach, Leon Kossoff, John Hoyland, Lucian Freud, Henry Moore, Ed Ruscha from California, Howard Hodgkin. But with hindsight, it was the reclusive, private and self-effacing William Tillyer who most captured my imagination.

The project in hand, in those first months, was to publish and distribute his prints across the world. By 1971 it was extended to represent in exclusivity the entire career of this artist. By now I had doubled the size of my space and now there were just two floors to walk up, although the rent had also doubled to £20 a week.

The early-seventies, coming after the reach-for-the-sky sixties, were an unexpectedly old-fashioned, handmade moment, when printmaking – etchings, lithographs, screenprints, woodcuts – was suddenly in vogue, thanks to practitioners such as Hockney and Richard Hamilton in Britain, Victor Vasarely in France, Warhol and Roy Lichtenstein in America. Prints had become glamorous. Tillyer did not have the cachet of those other names, and no reputation as an artist, internationally or even nationally. Secondly, he was a reticent figure in an indiscreet era. His fellow Yorkshireman Hockney had dyed his hair bleach-blond and wore a gold lamé jacket in his days at the Royal College of Art. Tillyer, who was the same age, wore green livery jackets, dark corduroy trousers and regular shirts. But he too was making a living. It was a different path, but a path nonetheless.

The pivotal year of 1973 was approaching, when several things happened. Firstly he took a humble studio in London Bridge. Then, with his wife Judith and two small children, York and Kim, he gave up his secure position as an art teacher at Corsham to be a full-time artist and embrace a precarious future. Thirdly, we embarked jointly on one of Tillyer's most ambitious print projects, *A Furnished Landscape*.

The formal backing of a gallery enabled him to work exclusively on what was a big adventure for both artist and publisher. While the prodigious and protean Hockney was busy etching his charming illustrations to Grimm's Fairy Tales, William Tillyer concentrated on a portfolio of twenty-five prints, producing a rich array of images which pushed the boundaries of printmaking. These images described the point of view of a solitary figure in the landscape, an unseen figure but present nonetheless, as what Andrew Marvell called 'a green thought in a green shade'. Tillyer had already spent most of the sixties making conceptual sculptures and images full of irony with a strange new idea of spatial meaning, and he was now putting all he had learned into this quietly sensational and integrated vision, melding topography and modernism in one portfolio, each print depicting a single object in a world of abstracted nature – a stile, a noticeboard in the woodland, a trough under rain, a cloche, a seat, a gate, a path, a woodland fire, a bridge, a

waterfall, a cloud, without distinction between man-made and natural 'furniture'. To the innocent eye they were attractive and graphically involved landscapes, but to the educated viewer they suggested a new philosophical vision of self and world, a unique and fresh visual language.

The *Furnished Landscape* portfolio was described by Pat Gilmour, the leading authority on printmaking during her tenure at *Arts Review*, as 'one of the most all-embracing graphic explorations on a theme of landscape ever made by a single artist.' She went on to become curator of prints at the Tate Gallery. In addition to etching and screen printing, Tillyer had added both lithography and woodcuts to his repertoire, and so his portfolio embraced the four graphic techniques, proceeding from a unique understanding of each medium and profiting from his teaching duties, which had covered all facets of printmaking.

In many quarters his reputation was now secure, as an original and ground-breaking printmaker with the beginnings of an international audience. Limited edition prints would remain a major part of Tillyer's output for many years. And like several major artists in their later careers, including Picasso and Motherwell, he is currently undergoing a return to printmaking.

The second major project, begun in 1974, was the more open-ended one of making a series of intaglio prints – using a variety of techniques – inspired by *À Rebours*, Huysmans' decadent masterpiece, which would span five decades of preoccupation and was only completed in 2018. The print medium, of which by now he was a true master, led Tillyer to print workshops all over the world, and to exhibitions in the United States, Europe, Australia, South America, Canada – and even England. But these were the years when printmaking in its myriad forms became central to the work of so many artists. Warhol and Lichtenstein and Jasper Johns in New York; Ed Ruscha in Los Angeles; and in England for Richard Hamilton, Eduardo Paolozzi, David Hockney, Patrick Caulfield — and Tillyer, whose prolific output was powered by an irresistible spirit of experiment, explored through woodcuts, lithographs, etchings and screenprints.

If the seventies were primarily a decade of printmaking, the eighties were a decade of paintings and watercolours. And if David Hockney was a keen rival in printmaking, there was to be no rival for Tillyer as a watercolourist.

Rather than the traditional associations between watercolour and the genius of place, as a form of fixity and rootedness, in Tillyer's case watercolour was a form of travel, of displacement. And where other artists, John Hoyland for example, lost their way in Australia and other exotic places, Tillyer found himself. He has never worked *en plein air*, but is a Modernist who soaks up the view or visual sensation and then goes to his hotel room or his studio to paint a series, to work through the problem of what he has seen, in days or weeks or sometimes months of intense activity and introspection. There are paradoxes here, as everywhere in Tillyer's work. Whereas Hockney modestly but famously submits to the rigours of *plein air*, the results often look studio-like. Tillyer only ever works in a studio and yet it looks *plein air*, so expressive and fluid and intuitive is his response to the outside world.

Although he has produced a mere three thousand works in this medium, as compared to his master in watercolour, Turner, who produced nineteen thousand, he probably stands as the most prolific watercolourist since Turner and most likely the greatest in modern times – and it is a body of work which is still very much in progress. In 2017 Tillyer made a series of watercolours in collaboration with the great British poet Alice Oswald. Oswald wrote a book length poem in response to his watercolours and he replied with a further group of watercolours, *Articulations for AO*, the title of the book is *Nobody* and its subject is the sea.

In this spirit of research, which he has never outgrown, he set out for Europe in 1983 on a modern version of the Grand Tour – by fast car rather than horse and carriage – which would yield two hundred works and confirm Tillyer as one of the most adventurous watercolourists alive. If the *Furnished Landscape* portfolio could reach a wide audience, so too might his modernist watercolours.

The production accelerated. Although he has always seen them as an adjunct to the main activity of painting itself, and intended them as 'drawings' which would produce ideas and feed into the imagery of his paintings, he has continued to make watercolour series as events in themselves. During some years they have been the main activity, for instance on his Grand Tour, when he travelled extensively in France, Italy and Switzerland. The early watercolours were more topographical than those to come, including depictions of actual views, or series of views. He would sketch a particular tree, a mountain, a house nestled in some wild and exotic foliage, a sunset, a Swiss lake, a tall French gorge. Like taking mental notes, which in turn led to the more exploratory sequences and their more formal ambitions.

Tillyer has always thought in series, and this is especially true of his watercolours. He would never think of producing a single watercolour, because he is a modernist for whom the world of appearances is a laboratory, subject to an idea of order and an ethos of experiment, where truth to nature and truth to materials are one and the same. Following on from the extensive series he produced in Europe, in 1984 he would turn his attention to America, which yielded a further two hundred watercolours. He got into a car once again and pointed it south-south-west, covered thousands of miles, mostly in Arizona and California.

Since the eighteenth century the Englishman has often dreamt of Europe, and the modern Englishman dreamt of America. But unlike so many of his British contemporaries, Tillyer did not go to America to find his influences, or to become American. Knowing exactly who he was, he went to America to become a stranger. He observed, made visual notes, and returned. It was a place among places, where he looked backwards as well as outwards. One earlier group of artists that influenced Tillyer considerably while in America were the Luminists, the group of late-nineteenth century painters who used vast perspectives and an unemphatic evenness of handling to depict light in all its abstract but entirely visible mystery.

Tillyer's wanderings confirmed his artistic destiny as a wanderer, at home inside homelessness. Not least in England, where he both does and does not belong. He had always produced intensely atmospheric watercolours of England, a lonely tree, situated halfway between home and studio, several miles away, or lost between his various homes in Yorkshire, a small woodland, idyllic in atmosphere but with a sly nod to Jackson Pollock. But now it was time actively to investigate his own island, and a further couple of hundred watercolours eventually found their way to my gallery.

Each series was a small revelation, and each time I would hate the thought of letting them go, even to art lovers. When my overheads were smaller, in earlier days, I had no great urge to sell the work. But as my gallery turned into galleries I sadly had to let far too many watercolours go, though this meant I could share my passion with like-minded souls. There was a sense of community around the works, even if the artist himself belonged to no easily described community or context. In the early days they were the price of a good dinner for four, with an excellent bottle of wine, but now they cost the price of a small car.

These extended series would arrive on my desk, signed, always wrapped in thick brown paper. Sometimes Willi and I would go through them together, sometimes I would savour the occasion, like a gourmet waiting for the arrival of the new season's truffles from Alba, or Vollard awaiting a new watercolour of Mont St. Victoire.

He returned again in 1993 to the United States, to produce a series devoted to Fallingwater, the extraordinary Frank Lloyd Wright house folded into the Pennsylvania landscape, whose vision matched perfectly Tillyer's sense of man meeting nature, 'controlling it and yet controlled by it'. This great modernist achievement came to mirror Tillyer's own ideal of synthesis, as both a machine for living and an authorless structure within the landscape. It also called out his wilder intuitions of man personified as a solitary building. Hilton Kramer, an admirer of Tillyer's and former art critic of the *New York Times*, once told me that with Fallingwater Frank Lloyd Wright had produced the largest sculpture ever made, with the suggestion that it didn't really work as a house. But this meeting of water and land and structure were a dream subject for Tillyer, an ultimate home, which fulfilled his own project of an analytical sensibility in dialogue with a romantic spirit of place.

It was around this time that the art critic Robert Hughes made one of his frequent visits to London, his former home, and was able to see a recent group of Tillyer watercolours. He insisted on meeting the artist, who reluctantly complied. Bob, being an ebullient and forceful personality, made Willi quieter than usual. But he loved the work, they discussed fly fishing and got along like old friends. Bob invited him out to Shelter Island, his home an hour away from New York, at the eastern end of Long Island, to fish. Willi never took up the offer. Any other artist would have been on the next plane, to sport and carouse with the great art critic of *Time Magazine*, but it would never occur to Willi that success might come in such a guise.

I became so frustrated with Willi that I phoned him one day to say he would be hugely famous and successful – after his death. He was appreciative and happy at the news, and I realized that he had missed my point. Or had he?

**'For last year's words belong to last year's language
And next year's words await another voice.' – T.S. Eliot**

The truth of the matter is that this artist lives in his own space, not displaced but indeed centred in the landscape. Very often he is working when he appears to be listening, while he is standing, glass of wine in hand, a couple of feet away. Like the novelist in Henry James's country house ghost story, *The Private Life*, who is really scribbling away in his room in the soft dusk while his mere apparition or double is downstairs in the gas-lit salon with the rest of the house guests.

So far we are only watching the artist in those modes which came easiest to him – the master of printmaking, the accomplished watercolourist. But these two activities were the means to a third, painting. And by the early-seventies he was a little rusty when it came to tubes of paint. It was at this delicate juncture that he returned to oil on canvas, and began by casting about, trying out different styles to see how they fitted.

From his printmaking and his conceptual sculptures he had already discovered that the lattice grid was of fundamental importance to his art. So he placed a piece of gridded metal over the canvas. This was already enough of a rogue statement for a hidebound and unsuspecting art world, insecure enough to need the constant reassurance of a signature style. But next he painted over the entire surface of the grid – portraits of heads and intricately decorative still lifes with a faint resemblance to Howard Hodgkin. Larger canvases soon followed, enigmatic and witty interiors influenced by Hockney.

I was already editioning prints by these three artists, along with many of the British sixties artists, such as Robyn Denny, Bernard Cohen, Patrick Caulfield, John Hoyland, Richard Smith. Tillyer would learn from all of them but they could not learn from him. His elders by a few years, they had captured the art market a decade earlier, and by now each had a clear and established signature tune. They had all seen exciting times, and this was now the seventies. Having made their mark they were beginning to sit on their well-earned laurels, especially since the times themselves were becoming more unsettled. William Tillyer was an interloper, an out-rider, still running, assimilating, digesting and discarding influences.

Through bloody-mindedness and a stubborn vision, he developed through the seventies by leaps and bounds. Although he was still in the shadow of these art

stars, he had been bringing into his pictures influences from earlier British artists whom the sixties had tried to forget – Ivon Hitchens, Ben Nicholson, William Scott, Peter Lanyon, Victor Pasmore. And he had never lost his allegiance to the masters of past time, whether the French seventeenth century genius Nicholas Poussin or the quattrocento genius Piero della Francesca. His deep love of the early British Romantics, such as Constable and Turner and Samuel Palmer – or of important minor figures such as Cotman, Crome, Bonnington, Cozens – now began to contribute to the essential Tillyer picture. As the seventies drew to a close and the eighties dawned, Tillyer's painting was increasingly enriched by his knowledge, as he mined the past and the more recent past, which included Marcel Duchamp and Piet Mondrian, towards both of whom he has enduring loyalties.

His return to painting on canvas was tentative and his learning curve protracted, especially as he had not painted since his student days. There was an interested audience, but the paintings would leave his studio at a slow and inconsistent rate. His contemporaries were of decreasing aesthetic interest to him, though there were hints of the mature Ivon Hitchens in his canvases, as well as allusions to Hockney and Hodgkin, to Richard Smith, John Walker and Stephen Buckley. He was casting about, trying his hand, but the distinctive Tillyer philosophy and language were not far away. The grid was stubbornly if discreetly present in all of these works.

Towards the end of the decade he would find his voice and his stride, suddenly turning up the volume in a series of wild and raunchy lattice works, whose metal mesh was overlaid with a bold collage of painted cardboard fragments. Later works such as the powerful and violent *Victorian Canvases*, the harvest of his years as artist in residence at the University of Melbourne in 1981, a visual explosion in the most English-looking city in the antipodes. Tillyer took as his motif the decorative and curlicued Victorian house fronts set amidst their luxuriant and burgeoning sub-tropical gardens, as sites of pictorial conflict, and of a conflict between history and nature. He cut into the canvases, then stitched them together with guy-ropes of string, showing the naked lattices and stretcher bars, creating an irregular collaged and 'repaired' surface on which he then worked with bold and textured brushstrokes, leaving empty spaces of wall visible behind these lurid and heady constructions. They are large, tough and uncomfortable works, to the point that viewers were baffled when they were first shown in Sydney, London and New York in 1982. Unlike the delicate and subtly delightful watercolours of the seventies — works that whispered 'you will like me' to the viewer — these

paintings virtually said 'go on, hate me'. They bordered on the erotic, with bruise marks and lush strokes of compulsive physical energy. Within a year Tillyer was back in his beloved Yorkshire, making yet another large series of serene prints, *Living by the Esk*, as if nothing had happened.

By the following year, 1983, he was painting again, and once more he was painting with a difference. Although he retained the structure of cut and torn painted canvas, the stretcher bar exposed to the viewer, the sewing together of ripped canvas was more forgiving and the pictures were calmer, more genial, his cherished motif of the Esk bridge hidden in the hinted-at foliage, like plover's eggs in a nest. This was followed by a smaller series, once again cut and sewn together, entitled *After Bruckner (The Romantic)*, and the decade would end on a note of exuberant confidence with the *Westwood* series, works large and small which are at once deeply expressive and contemplative, their surfaces unified rather than broken, and unapologetically beautiful.

The control and confidence of these massive floating shapes, created by single brushstrokes, suggestive of a Japanese master, looked forward to the nineties as the decade of fulfilment, when Tillyer surpassed each and every one of his peers, making images as unmistakably original as those of great international masters like Frank Stella in America or Gerhard Richter in Germany. In fact it was not long after this time that I became Frank's world dealer, so William was able to see at close quarters the workings of this American giant.

A country doctor

His response to neglect has been to avoid either paranoia or megalomania – those magnetic poles of anxious solitude – and to remain dry, sceptical, removed but watchful and engaged. By exploring rather than resenting his condition, he created new images of authority from a position of marginality. During the seventies until the end of the last century, while in his forties, fifties and sixties, Tillyer was earning approximately the same as a country doctor. Two professionals, contributing to society in their different ways, both men of science. And the provincial artist, like the doctor, could enjoy both cheaper overheads and better air. A figure reminiscent of Matisse, part of the occluded history of the bourgeois, Harrogate and its waters, discreet torpor, the secrecy of provincial life, a peaceful productivity.

By now he was experiencing more financial success than his tutors at the Slade had predicted that he or his contemporaries would ever receive. Tillyer came from a generation, a moment in time, when it was drilled into art students that they should not expect to make a living as artists, unless they supplemented it by teaching art. Tillyer foolishly and wisely gave up teaching in 1973, as soon as he had a steady flow of shillings at his disposal.

Meanwhile in the metropolis, art had turned a corner, and was beginning to become startlingly lucrative as a profession, for the lucky few. The London artists, his equals in artistic standing, but socializing in the higher circles of the metropolis, could now earn exponentially more than ever before from their paintings and sculptures. They were socially adroit, and in the newly fluid dispensation shaped by the sixties, the artist was on the same level as those above and beneath, like an escalator stopping at every floor, and could hobnob with the best of them – with heads of institutions like the Tate and the Arts Council, millionaires hungry for culture, visiting art dignitaries from America and Europe. Careers in art could now be constructed, step by step and brick by brick. The era of the artist as entrepreneur had begun.

Willi kept to Yorkshire where the atmosphere, in all senses of the word, was cleaner. The network was non-existent, the landscape unvisited except by the occasional farmer, and the possibility for concentration bore its own fruits. At no point did Tillyer say to himself 'I hate London'. In fact, he has always needed and has always loved London. He simply occupied a different 'place'.

As the last decades of the twentieth century and the first decades of the next millenium unfolded, his paintings became richer, more consolidated and more exploratory. Silence, solitude, slow time and secrecy all fed into the canvases, as he went wider and bit deeper into his art. The experimental ferment was extraordinarily intense, bringing the countryside literally into the studio – branches of trees from neighbouring woods relocated inside a modernist whiteness – or suddenly swooping upon his earlier work and its vocabulary of hardware, its door handles and the occasional piano hinge.

While his colleagues in the capital took larger and larger strides into the twin citadels of the museum and the marketplace, Tillyer took slow steps into a new and private wilderness.

There were pleasant diversions and digressions. He was given a castle by the City of Cadiz to work in for a few months. He took time out in Cape Cod to make watercolours, and made trips to Nice, Venice, and Estoril for his extended series on balconies overlooking the sea, so as not to forget the lessons of earlier trips to all corners of the globe. A year as professor in Melbourne, a year as professor in Providence Rhode Island. And the point of going away was always to return, to his corner of North East England, the Yorkshire moors and dales, the River Esk.

The activity of making watercolours took a slightly different path by the end of the century. The signs were there from earlier on. The emulating of effects achieved with print production – tightly drawn, with closely linked colours and tones – gave way to the broader marks left by delving into the actual landscape, moving from the notional man in an interior to the notional man in the exterior. The brushstrokes, formerly easier to read as paths, trees, woodlands, hills, water and sky, became abstracted, more like nature itself, more philosophically intertwined with the experience of being in nature, considered as the totality of what is out there. A dialogue with modernism as marking the absent presence of man, or of God, the artist looking up into the sky while recording the land. Watercolour was the medium for these intimations, which became possible only if he left behind his earlier attempts in this medium.

As he explored further, the packages kept arriving in London, neatly wrapped in the same brown paper in which the paper manufacturer delivered the virgin sheets to the artist, 22 x 30 inches of pure whiteness – now populated by washes and marks and feelings and thoughts and promises. A gift from someone who was given something and is simply returning it in a different form. But first he must make it for himself, from scratch, before he can hand it over. To lay down marks and feelings on a sheet of paper, but only those marks that you yourself as a maker do not yet understand. Not to play the same old tune because your market knows what to expect of you, but to walk off in a different direction.

Throughout the eighties and nineties he was moving at a furious pace and it was difficult for me to keep up, let alone his public. The steady flow of superb watercolours en-route towards combative new paintings. Foreign dealers, even those as sophisticated as New York's André Emmerich, were puzzled by this stream moving as deceptively as a river in spate. André, who at this time had not actually met the artist, asked me for an exhibition of new paintings by William Tillyer. In the eighteen months between asking for the show and receiving the

works, the artist had moved rapidly on. André was perplexed by this aesthetic shift but fortunately the show sold out. The rapidity of his transformations was making it difficult to build a base for Willi, because what you saw last year seemed to have no link to what you were seeing this year. With series such as *Hardware*, *Living in Arcadia*, *Fluxions*, *The Kachinas*, *Fearful Symmetries* and *The Revisionist Wireworks*, the revisionist had left his contemporaries in the dust – even if nobody was looking.

* * *

Then, after two or more decades of losing my breath trying to keep up, this serial thinker who worked in prints, watercolours and paintings, not to mention sculptures, glassware, tapestries and ceramics, was suddenly stopped in his tracks.

As we all were by now well into the twenty-first century, William Tillyer, not at rest by any stretch, nevertheless stopped the helter-skelter of picture production. Having taken advantage of every means of rethinking his previous work – pushing the paint around the canvas, lavishly or parsimoniously, cutting into the canvas, building onto the canvas surface, using the canvas or other materials as a porous body, linking canvases together – he stood still. He had produced a group of paintings which held his attention so much that for once he repeated himself, producing another set of pictures using the same technique.

Impatience

Karin and I set out by train to North Yorkshire, for me to see the new work by William Tillyer. I hadn't been to the studio for over a year, so I was filled with trepidation and also excitement. It was an exceptionally cold day, even by North Yorkshire standards, and it seemed the pouring rain would never stop. We arrived soaked through and freezing cold. A nice cup of coffee to warm us up would have been most welcoming and perhaps stop the shivering. For the hardy Yorkshireman this was just another day. Anyway, the studio was filled with these paintings, strewn across the floor of the huge space, or hanging on lines of string and held up by clothes pegs. Many people may have seen this as some kind of bad joke. I saw it as a travesty. He had devoted a whole year to these and this is what he had produced!

I was dumbfounded but also furious. Tillyer's lack of an attempt to defend these paintings, plus Karin's saying she actually liked them made me even more furious. I used my furled up, soaking wet umbrella as a kind of missile, a spear to kill this joker.

Many months later, and it did take me several months, I realised that this group of paintings, which were based on the work of Samuel Palmer, were actually the best of his career. Although there was seemingly not very much on this gridded surface of acrylic paint on a plastic mesh, there was indeed plenty there, a great amount there, if only I had the patience to let the works fall into focus. And staggeringly enough, the series that followed on from them, the *Watering Place*, reached even far greater heights.

* * *

Tillyer had discovered a plastic mesh lying around in huge rolls on the property of his neighbouring farmer in North Yorkshire, intended to keep the sheep in and the foxes out. Willi began to push the paint through from behind, so that it oozed into what then became the front of the picture. Both a projection of paint toward the viewer and a conjuring of the space behind the conventional picture plane, the image controlled and defined by the grid allowed the eye to dance across the surface. Willi, with his dry humour, referred to it as his Seurat period.

Even here he was restless. After a year or two he would push so much paint through the mesh that paint and image would become increasingly three dimensional and physical. The first series was of cloud formations, in the spirit of his hero John Constable, seen through the eyes of a Peter Lanyon and then forging on into a twenty-first century vocabulary.

Following on from this was a small series of six paintings whose inspiration came from a single work, by Rubens, in the National Gallery in London. Willi was intrigued by the fact that Gainsborough loved it too, and had made his own version of it, similarly titled *The Watering Place*. And later on Constable in turn made his version of the same subject and called it *The Haywain*. All of these paintings are in the National Gallery. Tillyer's interpretation – also called *The Watering Place* – retains the mood of the originals, a rustic, leisurely and comfortable scene – a couple of centuries on, with his own hard energy and colouration. At the National Gallery we are in time past, in the company of those

three artists. With Tillyer's series we have returned to our own time, with six large paintings whose imaginative homage to previous masters makes these works their equal. As one might speak of a conversation among equals.

It was at about this time, in the early years of our century, that I began to think of William Tillyer as not only surpassing his contemporaries but as becoming the greatest painter Britain has produced since the golden age of Gainsborough and Turner and Constable. My yardsticks were my eyes, my feelings, and the history of my own looking. It would remain an obstinately personal opinion, from a close knowledge of the subject himself, and a more than basic understanding of his art and that of his contemporaries, for whose work in many cases I retain a deep love and respect.

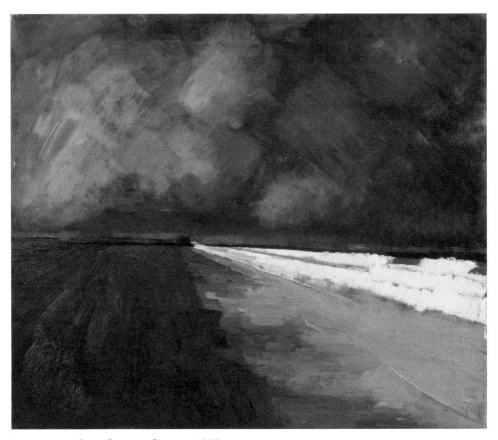

Beach and Sea, Seaton Carew, 1956

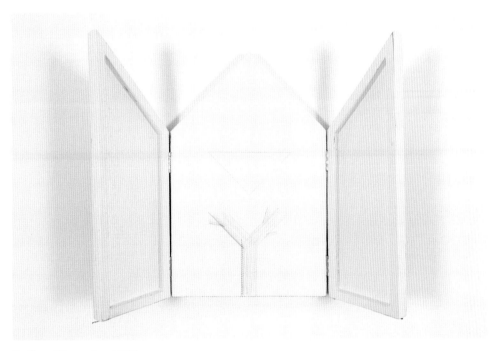

Falling Pinnacle, 1961

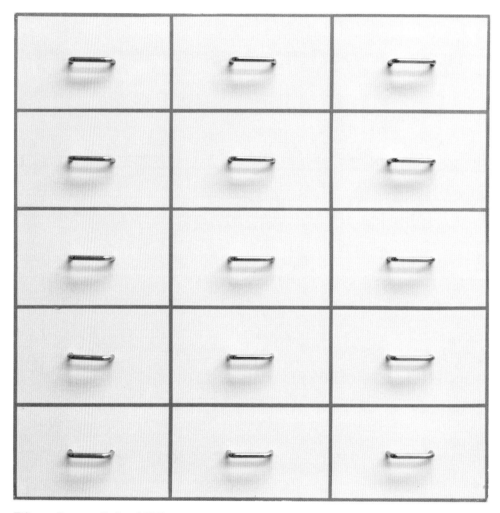

Fifteen Drawer Pulls, 1967

Mrs. Lumsden's, 1971

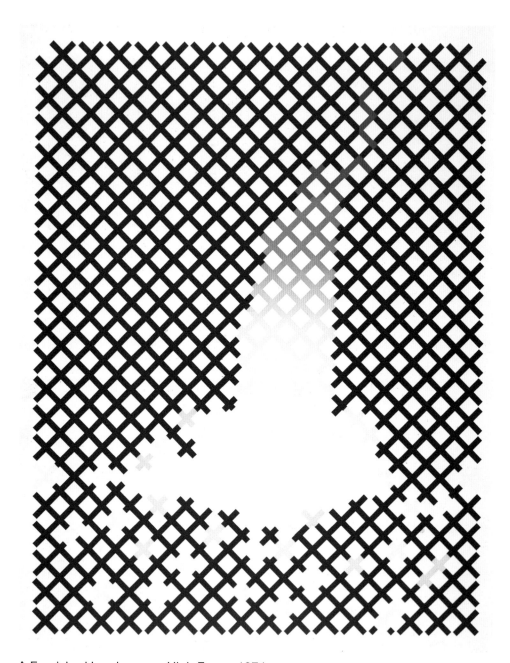

A Furnished Landscape – High Force, 1974

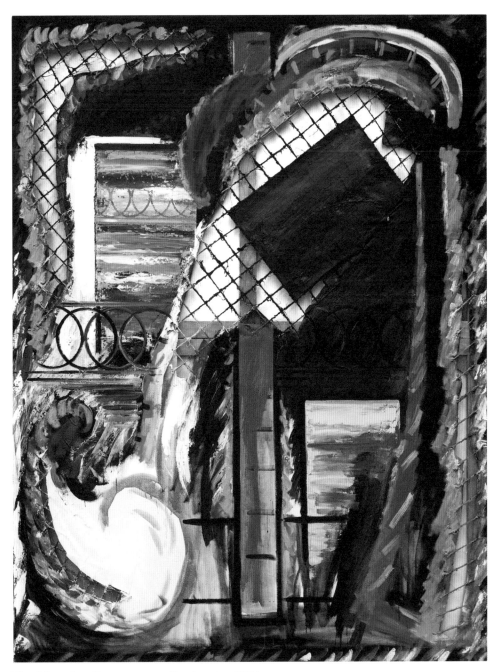

The Victorian Canvasses – Peninsula, 1981

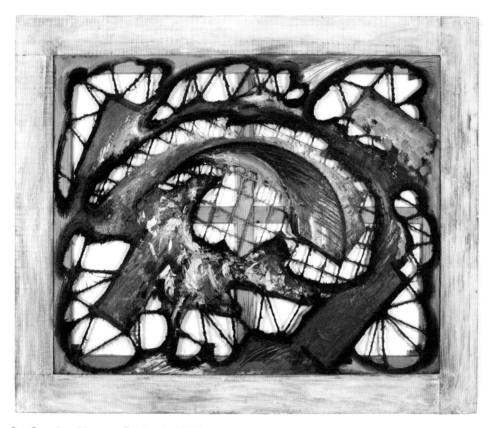

On Coming Upon a Bridge I, 1982

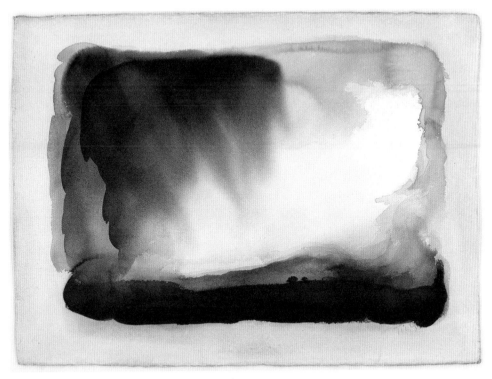

The North York Moors, Falling Sky, 1985

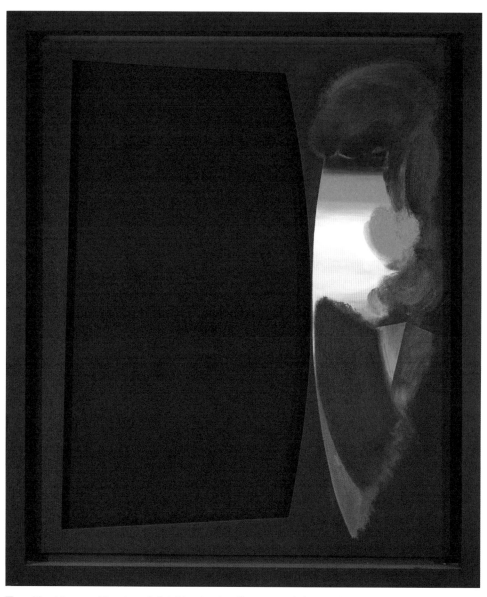

Two Kachinas – The Luminist Meets the Constructivist, 1994

Aluminium Cloud, 2002

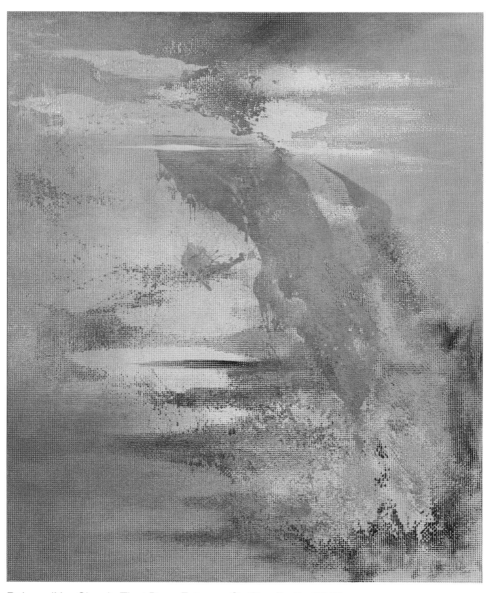

Palmer IX – Clouds That Drop Fatness On The Earth, 2012

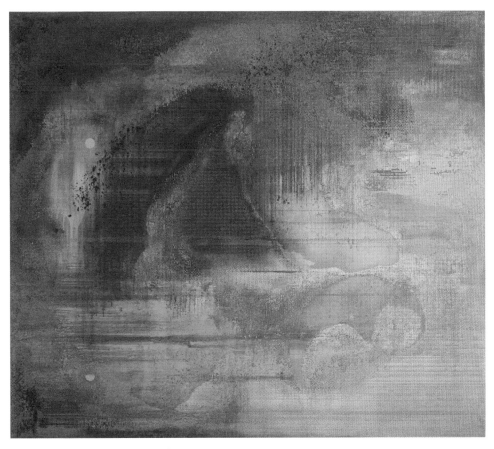

The Watering Place IV, 2013

Articulations – For AO, Nobody, 2017

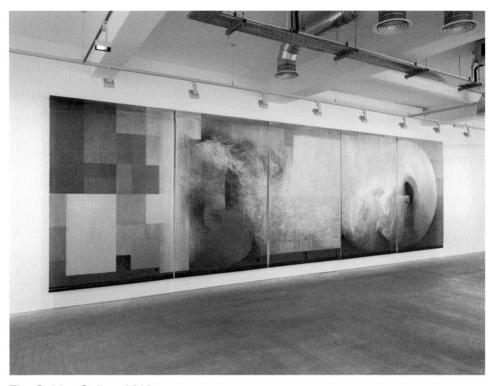

The Golden Striker, 2018

Times change and you and I change

In my mid to late teens I took advantage of whatever the times threw in front of me. I got to know the sculptor, Ivor Abrahams, who lived and worked two streets down from my childhood home, in Willesden. I bought the occasional sculpture from him with my pocket money. I still own them and will do so forever. I got to know Robyn Denny, through the synchrony of that swinging door in the Holland Park studio of Ivor's friend's house. Through some strange twists and turns in the pattern of events, I became an art dealer. I got to know more artists. David Hockney, Patrick Caulfield, Peter Blake, Derek Boshier, Richard Smith. Some still famous, others now forgotten. Having admired them from a distance as heroes, many became my partners in the business of making and selling. Beginning in those heady days, the Prince of Wales pub, the scruffy streets of Notting Hill, the endless afternoons in studios, I have followed their lives and their work. Some are now gone, some have given up the world of art, some have become stars in the firmament. But other changes occurred too, remote from the marketplace and less easily tracked.

As I have said, my love affair began with the Impressionists and post-Impressionists, the most radical artists from a period that spanned the decades from 1860 to the 1920s, with the eventual death of Claude Monet. One figure who emerged before Monet's death, Henri Matisse, resonated and opened other doors for me, and I was happy looking at all of his work, from the turn of the last century until his death in 1954. As a teenager I would copy his paintings, as I had done with earlier artists like Gauguin and Van Gogh and Cézanne. When the huge concentric spiral of *L' Escargot* arrived on the walls of the Tate in 1962, I was ecstatic and took this giant paper-and-scissors cut-out in my stride, and somehow it did not collide with the more familiar images of his precursors. Then it was on to artists of my own time, people who were ten if not twenty years older than me. Looking at art was a continuum, without any gaps or ruptures. I could see the point of them all, whether pop artists or hard edge abstract painters, or those who were more loosely expressive in their approach to paint and canvas.

A new visual world had now opened for me, one which I did not need to see in museums or reproduced in books. I was fortunate enough to witness it coming into being on the artists' own studio walls. I added new names to my museum without walls, those who were younger or still in the shadow of the London art world's limelight, artists like John Hoyland, Stephen Buckley, Howard Hodgkin, John Walker, Marc Vaux, Bernard Cohen, William Tillyer.

The smell of fresh paint was thrilling, the sight of unfinished canvases, the reproductions in magazines. The parties were so exciting, the art talk was so thrilling and the reviews often just a single paragraph in the more serious newspapers, were like a confirmation of the reality I was seeing.

As the sixties and seventies turned into the eighties and nineties, my view widened dramatically. So did my views, my ability to make comparisons. And with comparisons came doubts. Some things began to nag at me, or make me look more carefully. Was I seeing a strange recurrence of the same things? Did it matter that John Hoyland, whose work was so vibrant and thrilling that it walloped me in the stomach, was a footnote to Hans Hoffman and Helen Frankenthaler and Robert Motherwell? Was too much of John Walker derivative of Rauschenberg, Cy Twombly and Jasper Johns? A major British artist might after all be a minor world artist. Was the art of Peter Blake, whom at one stage I represented, too simple-minded, too cute? Did Stephen Buckley have anything to say that needed saying again? Had Richard Smith, who I worked with closely for so many years, run out of an urgent need to make any more work? Had Bridget Riley enough new visual ideas to hold my attention? Had Caro run out of steam and was he more than a footnote to the great American David Smith? Even my hero Robyn Denny seemed to be stalling. Had Howard Hodgkin, who I felt I knew well and whose prints I had published, hit a fallow period out of which he could not climb? Had Frank Auerbach, whose etchings I published, been able to transcend his own work from the fifties and sixties, and had he really added to what his tutor David Bomberg had produced?

Here Comes Everybody

Obituaries of famous artists are easy to write. Their birth announcements much less so.

When I first came across Howard Hodgkin he was regarded as the artists' friend, rather than a practitioner. He was in the shadows of the heroes of the day, who included his close allies Robyn Denny and Richard Smith, but quietly ploughing his own furrow. By the early seventies he had developed a picture that looked very like a 'Hodgkin', and he was careful to keep painting it from the mid-seventies until the end of his life. A compact, moody, jewel-like canvas with strongly complementary colours, surrounded by an equally colourful frame of wood which he would also paint, as part of the composition, rather like Seurat. They were essentially miniatures, rather Moghul, and Howard was to become a superb collector of Indian art. Subsequently he upped the scale of his work, staking a claim to seriousness, and for me they lost their seriousness. I became his exclusive print publisher for many years from 1973, and his fan base grew happily, year on year. At their best, his paintings and prints were diary-like and Proustian, a refined coterie art which obliquely recorded or evoked memories of dinners and parties and trips to India and intimate relationships, a fugitive and highly-charged emotional landscape. For me they were about attractive colours in attractive compositions – an art of the surface, yes, though not in the least superficial. In fact when he made a painting of Karin and me, *In The Black Kitchen*, I teased him and said, which is Karin and which is me? He was not amused. Although he did like our black kitchen on 57th Street and Sutton Place, by the East River.

As I have said, I first encountered the work of Robyn Denny in the early sixties. In time we became friends and by the late sixties, I would become his print publisher and eventually his dealer. I knew Richard Smith from earlier days, and started working with him a little later, in the early seventies. Once again, our partnership began with prints, then drawings, then paintings. If Robyn's pictures were intricately internal and edgily introspective, Dick's were more exuberant and dynamically expressive. I was equally moved by both.

Peter Blake was a close friend of both Smith and Denny, from their days as students at the Royal College. Different again from these two abstract painters, Peter was entirely figurative, and brought his private passions into his art without apology. Rock and roll, jazz, circuses, bawdy entertainment, all painted with unselfconscious originality and immense verve. I became his exclusive dealer for a while in the early seventies, when we explored his world together, not least the rock concerts. He designed the cover for *Sergeant Pepper's Lonely Hearts Club Band*, a collage filled with friends and heroes. Like his pal David Hockney, he was unafraid to veer towards illustration, even if sometimes they have both tacked or veered too closely.

Patrick Caulfield, like Blake, began his career with the great dealer of the zeitgeist, the reprobate Robert Fraser, 'groovy Bob', and Caulfield was another of the fast friends and fellow students from the Royal College. I enjoyed working with him, I loved his company, and his often unforgettable images, with their high colour and photo-realist flair, reducing the modern world to pictorial essentials, still resonate very strongly for me long after his death.

We were all a little in awe of Richard Hamilton – the artist as a gentleman and cool customer, a bit of a visionary, who knew Marcel Duchamp and had even worked with him. He was our elder statesman, an inspiration to so many artists, especially in the realm of Pop, a movement to which he was iconographer by royal appointment. The work has dated, perhaps inevitably so, perhaps defiantly so, but I relished our collaborations.

Allen Jones was the other avatar of Pop Art, and has happily been making pop images and sculptures for sixty years, full of curiously innocent provocation, as with his notorious fibreglass fetish mannequins. A very nice guy.

Joe Tilson began as a Pop artist – hedonistic, optimistic, his art from a background of sixties political activism – but after moving to Italy his canvases became more mythologically oriented and symbol-laden. He too has been making art for sixty years. Another nice guy.

Malcolm Morley, who Peter Blake always referred to by his original name, Mac Adams, was another product of the Royal College, but turned his back on England and made a substantial career in New York in the sixties. The first print I ever produced was by Malcolm, who invited me to a tea party in Chelsea in London in the sixties where the tea was not of a kind I had ever encountered. The work seems silly to me, nowadays.

An artist I desperately wanted to represent was Euan Uglow, whose friends and colleagues moreover kept encouraging me to do so. But he was represented by a friend of mine, so in my book that was that. His subjects, and his objects, were seen with an intent and commanding scrutiny, so that they had an eerie, heightened realism, as though he were descended from Chardin. Uglow was a rare and radical painter, and has been much misunderstood. Many still think of him as an old-fashioned realist. His canvases at their best retain for me a mystical intensity, their discrete planes full of yearning and incessant visual discovery, and I have always considered him an artist of the first order, a true descendant of his hero, Paul Cézanne. Here was an artist worth working for!

Two other English artists were often linked together, and unfairly so, perhaps because both use tons of oil paint, or because both were students of the great David Bomberg – Frank Auerbach and Leon Kossoff. I worked with both and enjoyed that experience.

Lucian Freud was not necessarily the greatest draughtsman but the paintings at their best were very good indeed. He was never my favourite person, and at his shocking worst there was a kind of obtuseness, for all that he was uncannily intelligent and perceptive. He was banned from our house, as my wife found him too menacing. The paintings would sometimes come through 'friends' of his, not art world folk. He was an avid gambler.

I never had anything but good feelings towards Francis Bacon and sold several of his paintings, though I never worked with him directly. He knew I wasn't too enamoured of his signed prints, which to my eyes were expensive and glorified photos of paintings. He would often come by the gallery, for tea and chat, saying he would make some real prints with me, which made me conjure up images etched with the intensity of a modern-day Rembrandt. He said he would make them when he was old enough. In my innocence I thought he was probably old enough already, in his seventies. I liked him a lot. The paintings remain very good

indeed, to my mind, as good as British art gets, though I fear that they are looking a little hysterical in retrospect. Literary people rarely have an eye for art, and yet so many of them have an eye for Bacon, which tends to worry me. We need more time with Bacon, as he would be the first to agree, because these powerful and violent works will definitely undergo more changes. Perhaps becoming more dated, or more confusingly warped in time. I agreed when he told me that we have to wait a generation after the artist's death to judge him accurately. I now feel that perhaps this was a little ambitious and that in his case perhaps we need longer still.

So many painters, so many changes in the way art encounters time.

Time brings its changes in contradictory ways, and often a mere decade is the great decider, one way or another. By the time I got to know and become Victor Willing's dealer, a truly original painter, during the eighties, he was severely handicapped with multiple sclerosis and his large canvases were hallucinatory, possibly the result of the drugs he was taking for his condition. The paintings were wonderful, and he died tragically young, although he had time enough to make memorable and powerful images. Victor's wife, Paula Rego, was a terrific talent but, like Euan, she too had a dealer who was a friend of mine. However much friends like David Sylvester and even Victor himself urged me to take her on, I felt that it was wrong to poach. Within a few short years her otherworldly images, often on paper, became too heavy and doleful for my liking, and I would find the later work too illustrational. I missed the cruel and wild innocence of the earlier images, full of mischief and poetry.

Gillian Ayres was another artist whose early work spoke to me. I got to know her through her husband, Harry Mundy a fine artist who had once shown at Kasmin's. Gillian continued to show there. I found her work from the sixties intriguing and exceptionally good, but felt less comfortable with the later work, as too dependent on Matisse.

An artist of the same generation but with an entirely different vision, Bridget Riley called me to her house in Royal Crescent after her dealer, Alex Gregory Hood, of the renowned Rowan Gallery, closed up shop. We later met in her studio and talked at length. I did not feel confident that I could do the job for her. Her work was always sexy, but today it seems perhaps too sensation-driven and lacking in depth. Put differently, she has gone on to bigger if not better things.

The eighties were a time when I did not like much of what I saw, and found myself being more selective about who I was truly interested in working for. And the recent past was rapidly receding. I would have loved to have worked with Ben Nicholson, but I came too late to be of any realistic use to him, and by the end of the sixties he had done all his best work. There were other beacons from an earlier moment.

William Scott was an excellent artist and I would eventually represent his estate.

Peter Lanyon was and remains a great painter, and at one point I owned the largest collection of his small output. He died tragically young in a glider accident in 1964 when he was only forty-six, leaving a mere two hundred paintings behind. But he was one of Britain's great artists, and he certainly gave the Americans an honest run for their money.

Victor Pasmore was a major artist. My friend, the art historian Norbert Lynton, so often tried to get me interested in his work but I wasn't ready.

Patrick Heron loved art, wrote brilliantly about it and also painted dazzling pictures. But I was never fully committed, although as British art goes it was extremely convincing. He was also a wonderful writer and communicator and one of the nicest artists I ever met. Generous and passionate about all matters to do with art.

Peter Stroud made paintings of great beauty and quietness.
Peter Phillips made glamorous pop art.
Derek Boshier made excellent pop art.
Graham Sutherland tried to match Picasso and failed, but made some good pictures, especially on paper. The most famous and successful British painter in the sixties.
John Piper was famous in the fifties.
John Bratby was the most famous painter in England for a while in the fifties, and produced brilliantly characterful Kitchen Sink pictures.
Josef Herman made dark pictures of Welsh miners. Kingsley Amis hated them. I liked them at the time.
Christopher Le Brun made his name with pictures of horses and now paints abstract pictures.

Buckley Milow Coldstream Andrews Mundy Bomberg Sickert Hitchens Heath Kinley. I ought to mention these, as well as Phillips and Jaray and Vaux and Buckley and Milow and Scully and Kinley and Boty and Mick Moon & Jeremy Moon and Turnbull and House and Morley and Andrews and Creffield and Blow and the Cohen brothers and Troostwyk and Rumney and Sedgley and Kay and Organ and Bratby and Bury and C J Martin and Kitaj and Law and Lim and Kenneth Martin & Mary Martin Bowling Flint Augustus John Seago Sutton Kay Hambling Munnings. . . These and many more. All of them put together made the whole thing possible and real for me. They are my autobiography.

These and many more devoted their lives to their discipline. Some have made fortunes, some remained penniless. They all had a vision, some small, some significant. They have all shown courage and stamina and single-mindedness. I have known most of them and worked with many of them. I have been looking at art for sixty years, but do not consider myself the only eye out there, and have no intention of becoming a legislator. I hope to remain a free spirit with a passionate eye, one who has looked carefully and happily over a long time. 'No power, a little knowledge, a little wisdom, and a lot of flavour', to quote Roland Barthes's great motto for his place in the scheme of things.

By the early years of the twenty-first century one artist stood out to challenge my nagging doubts. David Hockney was such a prodigious talent and prepared always to make an assault on the new. He drew like an angel and his works on paper were wonderful. The paintings of the sixties and even the first half of the seventies were mostly wonderful. But was the excellence inversely related to the ambitions? Was Hockney perhaps a modern Praed, of whom Auden remarked: 'his serious poems are as trivial as his *vers de société* are profound'? With the rider that Auden intended this as no small claim for Praed's work. And hadn't Robert Hughes ended his landmark TV series, *The Shock of the New*, with the words, 'If (painting) no longer has its Mozarts at least Hockney is its Cole Porter, which is no mean thing to be.'

I thought of these artists and their works as my friends, but I too had grown up, and grown away. There was but one figure still standing, because he kept pushing himself, going to new destinations and territories, and making more and more single-minded images in the process. The others had perhaps seen too much glory, and attention had softened their resolve. Perhaps Tillyer showed staying power because he was not allowed into the club and remained where a great

artist is meant to stand, on the outside. The artist must pursue two roles to reach greatness. He must go wider and he must go deeper. William Tillyer has arrived at both of those destinations, where his now famous contemporaries have been content simply to hold onto what they have, many of whom are basically still doing the same picture they started off with.

But Tillyer has been the painter without a signature, the invisible painter. I would place him near the pinnacle of this group. And if he is not quite at the top of anyone's list, I have enormous faith that next year or the year after or the year after that he will be there, because the top is a place of final visibility. He has the rare quality of striving further and further towards his goal, the tenacity and vision to see the challenge through, however uncomfortable the process. To my reckoning, several other artists have come close, but none has been able to pass through these doors since Turner and Constable.

It's not that William Tillyer needs England, it's that England needs William Tillyer

Something else changed my sense of things. Again, the Courtauld crystalised this for me. For this building housed not only a gallery but a house of learning. Academia was just a walk away, even if I neither knew nor cared. What was considered 'important' or 'less unimportant' in modernity was decided there, and many decades later I discovered that William Tillyer would not be considered important enough to be included in their curriculum. I had no idea that institutions could legislate for an unborn posterity as to what in fine art was great, good, mediocre and bad.

Harold Rosenberg, perhaps America's greatest art historian and commentator, said correctly that academia should not comment upon the contemporary in art. I understood the logic of the academy sorting out the story of art from the Lascaux cave artists until perhaps the mid-nineteenth century. After which I did not need academia to tell me what's what. Even now, when I have to wear spectacles to look at those same Courtauld paintings which first inspired me, I hope my heart is still that of a child, that I can still experience those pictures on my own terms, and sort the good from the less good. Even more so with the art that came along after the Impressionists and Post-Impressionists. So today I would challenge any idea of acknowledged legislators. Those are not the people I want to talk to about art. No more than I wanted to talk to my headmaster at school about how much I loved Carol, and what should I do to let her know, though I wouldn't mind asking the janitor for advice. But the point is that I would not have wanted to ask either of them about Gauguin. Perhaps I was actually more in love with Gauguin than Carol – and did not want the spell to be broken.

This is fragile territory. Not the place where, what Rosenberg once memorably called the 'herd of independent minds' do their roaming, but the place where one picture is for one person, now, at this moment, for an hour, for a day, until the next fortunate person can possess it. As the great and wealthy collector Dominique de Menil remarked, you only own a work of art by looking at it.

I was thrilled in my twenties and thirties to hang out with the more glamorous names, to be going to party after party, art biennales in Venice, exhibition openings where you rubbed shoulders with movie stars and pop singers and art experts. None of this came the way of William Tillyer. The glamour would

sometimes come frustratingly close, in the person of Hilton Kramer and the *New York Times*, or Bob Hughes and *Time Magazine*, or when the great West Coast painter Sam Francis bought a Tillyer for himself.

Tillyer's was a boring world, and the parties were always somewhere else. But boring is crucial, and for me his world was about as boring as that of Cézanne and Vollard. I had left my twenties and thirties behind and was interested in different rewards. Just as I found the glamorous waters becoming increasingly shallow, and receding rapidly on the waters of memory, I was to find an answer elsewhere, as we all edged towards the new century. I thought increasingly about Marcel Proust, who retreated from the social world he loved so much to his cork-lined room, where he eked out the great novel of the twentieth century which would depict that very world he had abandoned, and which time itself had abandoned. Being a businessman I couldn't quite match his stance, even were I to have his genius, but I constructed my own imaginary cork-lined room.

* * *

It is all about timing. But you have to trust your luck and seize the day. So, after fifteen years in the market for Modern British art, and a degree of success with the likes of Ben Nicholson, David Bomberg, Peter Lanyon, Stanley Spencer, William Scott, Ivon Hitchens, Graham Sutherland and others, I moved back to where I began my career – in America. After the market collapsed and the lights of the art world went out, from 1990 to 1995, the value but also the very meaning of an art market was put in question. I survived by the skin of my teeth and in 1996 returned to New York, where I was now working on an hourly, daily, yearly basis with such giants as Frank Stella, Helen Frankenthaler, Jules Olitski, Bob Rauschenberg, James Rosenquist, Ken Noland, Tom Wesselmann and Larry Poons.

So the market picked up again, and suddenly, without even realising it, my timing was perfect. I started to buy the work, in every medium he touched, of the true giant of American art, someone who had died over ten years earlier and been tragically overlooked, the great Robert Motherwell. This became so successful that after ten years of work, laying the foundations for the revival of the Motherwell market, by 2015 I was secure and financially sound enough to concentrate my energies, skills, passion and beliefs on William Tillyer.

If I knew then what I know now, I might have done things differently. I had no idea that the museums, the councils, the art world aristocracy, the art establishment, the writers and artists and academics who are in collusion with the establishment, had a collective grip as tight as a vice on what was and what was not art. I was slow to realise this, and stubbornly thought that the good would win through. How wrong I was. The circle became more closed with every passing year. The art establishment linked hands with the ever-growing and ever-more powerful art-fair bosses. The auction houses, quite sleepy when I first entered the art world, with their three hour lunches, picked up speed and accrued power year on year, decade by decade, hiring CEOs who might just as well be running property empires or in some cases small countries. And then, one day, art itself became a new currency, when currency as such or at least certain currencies were themselves in danger.

With Robert Motherwell my task was relatively easy, because he had once been a strong currency, until his death in 1991. All I had to do was to remind the old garde and persuade a new audience as to how great and relevant he was, and not how 'overrated' or 'minor'. The task was straightforward, exhilarating and cleansing to the soul, and I felt that I was taking the high ground, against a pack of arrogant, ignorant, lazy and unimaginative art world figures who mistake publicity for immortality.

But Tillyer was a different proposition. The dice were loaded against us. It began promisingly enough, and it is important to realize that Tillyer began as an insider, in the innocent years of the sixties and seventies. His exhibitions were successful, internationally, his sales were brisk, and the art establishment was responsive and supportive. The Arts Council of Great Britain exhibited him fairly often and even bought his work. The British Council likewise. Sir Norman Reid, then director of the Tate, the joint home of both English and Modern art, came rushing in to the gallery one day. He said he had some money left over from his annual budget and wanted to spend it on prints by Tillyer. The subsequent director at the Tate, Sir Alan Bowness, also came to the gallery, a few years later, and said that there was a Tillyer painting he wanted to buy, *On Coming Upon a Bridge 1*, for the Tate collection. There was only one proviso, Tillyer had exposed the stretcher bars in their raw state for the eye to see. It is without question an uncomfortable work. Bowness said that if Tillyer could paint the exposed stretcher bars he would buy it for the permanent collection. The artist was bemused by the request, since the bare canvas and exposed stretcher were the most important parts of the painting, and it had to remain in its unfinished but finished state.

So sadly the Tate did not acquire a Tillyer for its collection, nor to this day does the Tate possess a Tillyer painting. He would join another great British painter, David Bomberg, who did not live to see a painting by him in the Tate collection. Its subsequent director Sir Nicholas Serota declined to consider William Tillyer as sufficiently 'important'. Serota's reign at the Tate was a long one, during which this painter evolved into a major artist. When I pushed Nick to at least look at the work he replied, 'Bernie, I've seen enough Tillyers.' To be fair, Serota has done great things for art in Britain, added various buildings, opened the shiny doors wide to a new audience, developed a collection which only lacks some of the greatest art produced in this country for decades. He even increased attendance by the millions, even if those visitors don't like or understand art.

There is a magic circle drawn around the vibrant, money making, career brokering and politically incestuous art world of the twenty-first century. If the artist is inside the circle, for as long as he or she plays the game, there is the choice of prestigious venues for exhibitions, there is power and there is money. But the artist who does not care to play or know how to play will not interest the major galleries, will not have museum retrospectives, and will find it hard to buy the materials for his work. In the art world there are only winners, and the winner takes all.

William Tillyer occupies a strange position in this great game, and in my story. He came into my life when I was eagerly awaiting someone like himself. As my star rose, the outsider would be included. This at least was the idea, but the subsequent story has changed my ideas – of both outside and inside.

* * *

If art went 'wrong' with Marcel Duchamp it was not Duchamp's fault. He simply made an art that was meaningful for him, which included turning his back on traditional aesthetic meanings. He worked to please himself. It was left entirely to viewers whether they reacted for or against him and his Dadaist colleagues with their hollowed out beliefs, their provocative interventions, their strategic idleness.

In the aftermath, from the twenties onwards, the teachings and vision of Duchamp were mostly ignored or sidestepped. But after the Second World War and into the fifties and sixties Duchamp became central to the philosophy and practice of artists like Jasper Johns in America or Richard Hamilton in Britain. Others like Jules Olitski or John Hoyland found nothing there to learn from or steal. Tillyer, on

the other hand, both learnt and stole. As T.S. Eliot remarked, 'Good poets borrow, great poets steal', or words to this effect, and Picasso said something similar. Tillyer's work, especially from the sixties, is fairly steeped in Duchamp. But he was merely taking what he needed for his journey, as a young man in his twenties, just as Duchamp took what he needed and left the rest.

As a boy in my early teens, I wondered at this whole activity of paint on canvas. It was fortunate for the textile manufacturer Samuel Courtauld in the late twenties that he could acquire those artists and those works. But it was fortunate for me too, some twenty years later, to be able to wander those cool quiet rooms in Woburn Square. Of the late nineteenth century French giants, some seemed to care passionately for their subject, like Paul Cézanne and his beloved Mont St. Victoire, or Claude Monet and the river Seine at Vétheuil, or the garden at Giverny. Others needed to invent a subject. And what of the co-founder of Impressionism, the elder statesman Camille Pissarro, who came from the West Indies to Paris, at first under the influence of the great Corot, but who would shortly afterwards 'invent' Impressionism. Or the young visionary, Seurat, who invented *pointillisme*, a solution that fascinated and influenced the older Pissarro in the 1880s, until he rejected it as too constraining. There were so many solutions to the problem of how to see the world through paint, or how to see the world as paint.

I would pore over these same pictures without knowing that they were to become my benchmark of what a painting might be. Willi too would have stared at these works, before we met, he from the North East of England and I from the North West of London. In a sense every artist over the past hundred years has stared at these images. They are the bedrock.

As the twentieth century dawned, Matisse and Picasso and many lesser figures carried on where these pioneers left off. Marcel Duchamp at first painted in the same way, and even followed the followers, although he did so for radical new purposes. His *Nude Descending the Staircase* created a sensation when it was exhibited in February 1913 at the Armory Show in New York. The picture's outrage was to use paint and canvas and figuration to express insolently avant-garde concerns – the birth of cinema, the Cubist fracturing of form, the Futurist depiction of movement, the re-definition of time and space by scientists and philosophers.

And in that same year he produced his first 'readymade' – a bicycle wheel mounted on a kitchen chair – which disrupted centuries of thinking about the

artist as a skilled creator of original objects, and elevated an ordinary object to the status of art by the mere volition of the artist. From here on he flatly rejected the activity of painting or drawing, and replaced it with enigmatic objects that outraged the art loving public, especially works like *Fountain* from 1917 which is plainly and simply an upturned urinal. The readymade defied the notion that art must be beautiful. Duchamp claimed to have chosen everyday objects based on 'visual indifference'. In doing so, he abolished paint and paved the way for conceptual art – in the service of the mind, as opposed to a purely retinal art intended only to please the eye.

Willi relished Duchamp, whose work was continuously relevant to him. Perhaps his remote and austere Huguenot background enabled him to recognize the bone dry Gallic humour. But there was more out there to engage the Tillyer mind, and Dada had no monopoly. Many artists have subsequently rowed away from Duchamp's playful redefinitions of art, out of self-preservation. If Tillyer never wholeheartedly embraced Dada or Duchamp, he has never forgotten them. His art would always remember this philosopher of forgetting, as part of what it means to be a modern artist. But the legacy of Duchamp was only part of what would constitute a Tillyer painting.

I myself see Dada and its later art child Surrealism as minor movements, although I loved their intellectualism and showy brilliance when I was in my teens, and even made my own versions of Dalí and Magritte in my school homework books. But within a year or two my tastes moved on to the art of Gauguin and Cézanne and others. Just as Pop Art, which I found so clever and so entertaining when it washed up on these shores, has sadly receded as yet another minor manifestation.

But all of these things fed into my sense of the complex, tentative, reticent and experimental art of William Tillyer, a complete unknown in the art story, who as the decades pass has retold that story for me. And perhaps his greatest quality, which has sustained him for half a century, could also be described as his Achilles heel, cussedness and Yorkshire grit coupled with an inner belief against all odds.

Of course, had I undertaken this text thirty years ago, or even twenty years ago, it would be hedged with apology and doubt. For a start, many other artists were still alive, and secondly, I was working with many of them. Moreover, Tillyer was yet to make his best paintings, and so many 'big names' were then riding high, without

anyone remarking that the quality and ambition of their work had slipped, that they were now repeating their art, producing paler versions of themselves.

Beyond the glare, Tillyer would develop and discover in the silence of his London and Yorkshire studios. And each series – of prints, watercolours, paintings – would press deeper into his preoccupations. By the dawning of this century he had, for me, reached port. But this was not his concern. His challenge lay ahead, inside the studio, not out in the world.

Since the time of Gainsborough and Constable and Turner, when it comes to the visual arts Britain has only had the occasional moment in the sun. From the middle of the nineteenth century until the Second World War France laid down the rules and fostered the achievement. Then New York took on the mantle, until the end of the last century. Where art might happen next will take time to tell. It has yet to happen, and it has yet to choose where to do so.

There have always been the outsiders, exceptions to the rule. Minor artists in their day who come in from the cold and become posthumous giants. Fontana and Burri and Morandi in Italy. Soulages and Dubuffet in France. Just a handful of local names who become internationally significant. These artists made their discoveries quite early in the last century but were to a large extent drowned out by the clamour of the mighty American art machine. Times are now changing so fast, in the macrocosm of global cultural power and the microcosm of the art world, that it is impossible to see where the story might be headed, even ten and twenty years from now. I am not here to discuss the relevance, or irrelevance, of those artists who have arrived after Tillyer and his peers. It is too soon to judge. In fact we are still trying to decide about the artists of yesterday. I would say that Robert Motherwell is likely to become the greatest American artist of his era. Unlike Motherwell, William Tillyer, now eighty, has yet to be intelligently judged, and time is the only critic.

* * *

Before the sixties dealers had little shaping effect on the world of contemporary art. The sixties ushered in a new breed of dealer, Kasmin and Robert Fraser in London, Leo Castelli and André Emmerich in New York, Nick Wilder and Irving Blum in Los Angeles. It was an age of personalities rather than power, oddballs with a fantastic eye, who set the stage for Colour Field painting, for Pop Art, for

Minimalism. Castelli always acted as if the artist came first, in return for which there was a parity of esteem between artist and dealer, a conversation of equals. These dealers would never say 'don't worry, another bus will come along', or 'there are always more artists.' They believed tenaciously in the uniqueness of each of their discoveries.

Lichtenstein and Warhol were perhaps the original brands. They were taking on Pollock, and were soon branded as doing this – rather than branded for doing it. Put differently, the authentic anger soon disappeared, and itself morphed into a new brand. David Salle and Julian Schnabel were the stellar manipulators. The charismatic Castelli could sell anything, but he never 'sold' art, leaving it to satellite galleries to distribute an artist's work and reputation throughout the world. Leo even found a way of selling Land Art, by selling the drawings! Which was of its nature unsellable, because it was already owned by Nature. Land Art would never have worked a decade later, when the monetary battle lines were drawn in the artificial sand for all to see, the new rules of marketability.

There were other old school dealers in those cities, especially New York, where the art of the day was primarily produced, and there were the great if isolated dealers in other centres – in Paris, Berlin, Milan, Rome, Dusseldorf – but they were few in number. By the seventies the idea of art as urgency had passed, most of the huge talents had run their course and the newer movements were cooler in outlook, internally adapted to the idea of a marketplace, whether or not one thinks of these artists as tame reactions to the passionately held Abstract Expressionist ideals of the forties and fifties. The dealers proliferated.

Adaptability produced the machine that helped develop the art monster which roars back at us today. As Motherwell said in 1954, 'A Picasso is regarded by speculators as a sounder investment than French Government bonds. Our society makes extraordinary demands upon the artist: on the one side, to be free in some vague spiritual sense, free to act only as an artist; and yet on the other side to be tested as to whether the freedom he has achieved is great enough to be more solidly dependable than a government's financial structure.'

All art, old and new, was being turned into commodity by the new breed of dealer, and the die was cast, as the eighties unfolded. Many artists tried vainly to shake off the new grip, the overt commercialism of what was becoming a trade rather than a calling. But art was an inexhaustible new hobby for the rich to mingle as

regulars at New York loft parties and downtown clubs and restaurants. While becoming richer. The whole escapade would end in tears in 1990, only to rebound six years later as a far bigger and bolder never ending party, carrying on into the new millennium. It may be that a handful of those artists who emerged after the sixties will survive the deluge, whenever the next deluge occurs, but now is too soon to judge.

As for monopolies, some aspiring young dealers rubbed up against Leslie Waddington and tried to challenge his virtual hegemony in London. The cub dealer Karsten Schubert used to say that Leslie was able to sell sacks of potatoes as art, just as people had said earlier that Leo Castelli could sell beer cans as art. To which Jasper Johns had responded by making a sculpture from two beer cans in bronze – which Castelli promptly sold. The best way to defeat an enemy is to incorporate it.

The new breed of artist, however ironic, was also subtly resilient to irony, with one eye on the audience and one eye on the art, and an uncanny ability to put the two together. In my years as a journalist in the early sixties I could always count on David Hockney for a quote or a story. He could do it on the spin of a coin, as brightly and fluently as any movie or pop star. Artists now had – and had to have – star quality. Tillyer would take too long to answer the question. Where was an outsider meant to fit into the unfolding story, an artist who had not yet seen his name in giant lettering on museum walls, and who was intent on learning and searching? The only success Willi looked for was in the studio. In the words of W.B. Yeats, 'out of the quarrel with others we make rhetoric; out of the quarrel with ourselves we make poetry.' When Timberlake Wertenbaker produced her scathing but insightful play, she had her hero being nagged for not producing more of the conceptual 'door handle' sculptures which had sold so well, earlier in his career. In reality, of course, Willi had never been nagged to return to a former mode, and his brief but profound romance with conceptualism had ended a decade earlier. His studies of man and nature, of Modernism and Romanticism, inside the one canvas, were now reaping their own rewards, however private. In fact, and with a postmodern twist entirely of his own making, Willi produced a magnificent canvas for Wertenbaker's play, which stole the stage. At the same time, the Wildenstein Gallery in their plush Bond Street rooms gave him a spectacular exhibition – including one painting substantially larger even than his painting for the Royal Court. But while others would have nailed this moment in the limelight, or the footlights, Willi returned to his studio to work on a new series, provoked by the Wildenstein paintings, but taking an entirely new and unprovoked direction.

The more he produced, the more he withdrew into his Yorkshire studio. On my visits I would stay at the nearby hotel, or in the impeccable modernist home of the Tillyers. We would trudge through muddy fields of cattle or sheep, past acres of meadows of rape or wheat, lazy lanes filled with bushes laden with berries, or sometimes travel over in his Jaguar to Ilkley Moor, or to Harrogate for scones and sandwiches at Betty's Tea Rooms. He really was no less bourgeois than Matisse.

The point was the ordinariness, the secrecy of the provinces, under cover of which work could happen. The work had its own dramas, of course, but these were reserved for the studio. Rarely did I take to his new paintings in one visit, and it would usually take two or three visits to understand and adjust to the leap forwards. Never once did I expect to greet a new painting as an old friend. It would eventually become a friend, on its terms as much as mine. When his peers in London made a new picture it was greeted with instant recognition, which is the governing passion or mantra of the art market. It is the means by which the market convinces itself. But Willi would push his odds, otherwise why bother making the journey every day to the studio? While others worked towards the next exhibition, Willi worked for the next discovery. And I would prefer to drive from Mayfair to Yorkshire to see a new painting by Willi than cross the Thames to Vauxhall or walk over to Bloomsbury or an expensive East End studio to see the same but different painting by a current art star. Tillyer was more of a scientist than a celebrity, with a touch of the poet, for whom each line is a leap in the dark.

Elizabeth Bishop suggested in one of her poems that 'the art of losing isn't hard to master', and recommended losing something every day. Tillyer has left behind his Yorkshire 'Giverny', which he built and nurtured, without misgiving, downscaling to an apartment in nearby Stokesley and a studio a short walk away. He has always mastered the art of losing, and today it is no different, it is merely half a century later.

* * *

When I turned away from British abstract art, which I saw as tame and tepid compared to American originals from Motherwell and Pollock through to Noland, Oliski and Stella, I really had no sense of where to turn next. So I went back to figuration, and for a short while this seemed worthwhile and even necessary. Going against the grain of art, internationally, figuration was once more emerging from the shadows. But Tillyer was something else, neither abstract nor figurative,

and neither camp accepted him wholeheartedly, for he did not wholeheartedly accept either. Robert Motherwell eventually said about his much older friend, Piet Mondrian, then living in New York, that his purely abstract paintings were finally 'not enough'. Motherwell wanted more, and so too did Tillyer. The hardy abstract painters of the British scene, the Dennys, Smiths, Hoylands, Rileys, all formidable by domestic standards, were not in the end offering enough inside the picture. But was figuration the answer? Tillyer has always been and always will be an abstractionist – and this would upset the supposedly hardier abstract painters but also the hardier figurative painters, the first group leaning more towards formalism and the second group towards painting as an art of messages inside bottles. Tillyer was of course a formalist by nature, but at the same time delivered a deep communicable message hidden away inside the canvas, waiting there for the viewer to find it. This makes his work a slow journey for the art lover, and in times when people have no spare time on their hands, the message remains unopened.

If Tillyer wasn't enough of an outsider already, this compounded his alienation. There were the occasional friendly gestures in his direction, but they never seemed to accumulate. Peter Blake tried, and even included him as a guest artist at the Royal Academy summer exhibition. Patrick Caulfield made a considerable effort, inviting him to events and parties. David Hockney offered a sort of North of England bonhomie. John Hoyland, Robyn Denny and Richard Smith all tried. But he was somewhere else, not comfortable or aligned with the purposes of any grouping. There was a fairly convivial open house mood in the seventies, but by the eighties and nineties the winds had changed, the consensus was more fractured, and this disparate group turned away from a figure who had turned away, and from whom success had seemed to percolate away.

One latecomer to the feast, Howard Hodgkin, who seemed of an earlier generation and had barely been invited to the great party of the sixties, had taught with Tillyer at Corsham. He might have been the most natural of allies, for in certain respects their purposes coincided, but he decided against solidarity. There is a story about this. One day I bought the Oxford Dictionary of Art as a birthday present for my great friend Charles Saatchi, and on my way I visited Howard Hodgkin's studio, who insisted on drawing an impromptu cover for the book. He handed it to me with the ironic words 'Here's your Tillyer'. I gave the present to Charles, who kept the cover and promptly threw away the book, thanking me. Hodgkin thought he was giving Saatchi a Tillyer, whereas Saatchi thought he'd been given a Hodgkin!

The irony is that Tillyer *did* make paintings influenced by Hodgkin, for a brief moment in the seventies, though he might not admit it. Or rather, in the way of art, there was a symbiosis at work, for both Hodgkin and Tillyer had been inspired by Ivon Hitchens early on. There was also a trend at work here, and you might say that Tillyer is an artist who gets under the skin of other artists. Bruce McLean, concerned that Tillyer wasn't getting ahead, said to me one day, 'What's wrong – maybe the name? What about *Bill* Tillyer?' Larry Bell the sculptor, while stoned, suddenly asking, 'So how's Tillyer?' T stands for Elsewhere. Lucian Freud, coming into the Gallery in Cork Street one day, saw a huge Tillyer on the wall and glanced at it for long enough to remark, approvingly, 'It's like a giant palette'. It was in fact, self-evidently, a landscape.

Experimental & Conceptual

Two roads diverged in a wood, and I –
I took the one less travelled by,
And that has made all the difference.
– Robert Frost

If one of the prerequisites of what makes an artist great is his influence upon other artists, then who is to judge, in these times, which artist will be an influence? How to tell if a particular artist is an instigator, or merely the newest link in a chain – in a production line that moved fairly slowly at first, from Duchamp onwards, in the earlier years of the twentieth century, then more and more frenetically with each decade or even every year, when a new great artist seemed to arrive on cue, or when the market needed to consecrate a newcomer for its hallowed purposes.

But Piero della Francesca's greatest moment of influence was in the last century, beginning with his rediscovery by Cézanne, four hundred years after the works were painted. By the same token Cézanne, who was the major influence on artists who followed, beginning with Matisse and Picasso, ended his century as an obscure irrelevance to many artists. Cézanne found something as radical and relevant to him in Piero, as Matisse and Picasso would find for their purposes in Cézanne. This is the chain of being working at its optimal best, the slow tree of influence spreading its branches.

The art schools, many of the newer artists, and eventually the art market, moved ever closer to Duchamps's iconoclastic notion of what was relevant. The time would come when Duchamp, who abolished influence, would himself become the most potent of all influences. Ironically, because Duchamp had been misunderstood, this allowed the conditions for an art that was easier to make, and easier to understand. A more sensation based commodity art would take centre stage. Cynicism and humour were active ingredients, watered down from the more potent and original brew patented by Duchamp, Dalí, Warhol and so on – until we arrived at the terminus, in the figure of Jeff Koons. As David Salle has written: 'If abstract painting expresses the idea "You are what you do," and pop art expresses the idea "You are what you like," then Koons's art says, "You are what other people like." '
I paint what you like, or think you like, or would like to like, says the artist to the market, and the word 'disruption' no longer has any place in the conversation.

Tillyer, heir to the disruptive masters, those who broke down barriers in order to enlarge our understanding of ourselves, would be ushered out of the room before the art public had a chance to notice him there in the first place. Most of his peers have raised their hands high, to alert the public to their presence, and are consequently secure in the febrile market place – or anxiously clinging to the wheel of fortune, which turns more and more quickly. Tillyer has not lifted his hand. Instead he has continued to hold the ragged banner for art, as high as any of his peers, at home or abroad, at a time when it seems in danger of being binned altogether, replaced by more facile, more immediate, more expensive but less emotionally costly versions of artistic expression.

So, if Cézanne had to wait many years after his death before showing the way to other artists, Tillyer may fall into the same category, and must wait for a new dawn, by whose light his vision and greatness can be read. In what I consider a profound book, *Old Masters and Young Geniuses*, David Galenson explained his idea of the two life cycles of artistic creativity, two kinds of innovation. On the one hand, 'experimental' innovators, who work by trial and error, and arrive at their major contributions gradually, late in life. As distinct from 'conceptual' innovators, who make sudden breakthroughs by formulating new ideas, usually at a very early age. Experimental innovators seek, and conceptual innovators find.

In the first group, pride of place would be reserved for Paul Cézanne. Once he had found his path, he simply kept travelling along it, deeper and deeper. He was a searcher. As he said, 'I seek in paint.' The phenomenally gifted Picasso said, perhaps by way of anxious response, 'I do not seek, I find', and again, 'to search means nothing in painting – to find is the thing.' Of the two twentieth century giants, I probably prefer Henri Matisse, because he preferred seeking to finding. The experimentalist would leave the task of finding to his friend, Pablo the conceptualist.

I would suggest that Frank Stella and David Hockney are also of the second group, producing their best work in their twenties. Galenson is no doubt correct in categorising Jackson Pollock as a precocious experimental artist, but for me the Pollock story is more complicated. I do not feel that Pollock got very far with his early efforts, and it was not really until 1947, aged thirty-five, that he found his image, or the style that would take him to a unique place, only to lose faith in the early fifties and turn towards a figurative cul-de-sac, before he killed himself in that tragic car accident of 1956, in a state of drunkenness and loss. What a short but

wonderful five years of productivity, which provoked so many other artists to re-examine their map, if not to follow his lead. Although, as Kenneth Noland said to me, 'We all loved the idea of Jackson, but we couldn't actually use it.'

Tillyer occupies an awkward position in this story, because he made radical and ground breaking works when he too was in his early twenties. But he was not content to sit still, just yet, and make conceptual art, as it would later come to be called in the art world. He had come a long way from his student work of the mid-fifties, the landscapes and seascapes of North Yorkshire, but he had a long way to travel to find the path he would eventually take, and continue to follow to this day. The seeker replaced the finder. And in terms of his reception, William Tillyer must bear the cross of patience, as do all seekers.

* * *

A hundred years ago the world, or at least that tiny portion of it with some stake in the arts, had a fairly clear idea as to where the story had got to, and where it might be headed. There had been the triumphs of Impressionism and Post-Impressionism, and the inheritors of these new truths had already emerged, with the strength of their own convictions. Picasso had already travelled through his Blue and Rose periods, had mapped out and was already leaving behind the newly discovered country of Cubism. Matisse had experienced his Fauve vision, along with fellow explorers like Derain, and he too had moved on. It was France that led the way with these discoveries, unquestionably, taking giant twentieth century strides. The rest of the world of art followed suit and tried to keep up. In fact, a decade earlier, in 1907, Picasso had painted *Les Demoiselles D'Avignon*, a picture so shocking that even he was a little scared by it, and delayed showing it to others. Matisse had already painted *Bonheur de Vivre* in 1905-6 and *La Danse* in 1910. It was time for the reprobate Marcel Duchamp to spring to notoriety with *Nude Descending a Staircase*, which he painted in 1912 and exhibited the following year. There were clear signs, by 1914, as to where the visual arts were heading for the century we have lived through. The Great War complicated but also confirmed this story. But in 2018 it is far from clear where art is heading for the century to come.

Circa 2018, whatever is saleable is important. Avant-garde art has become establishment art. Anti-establishment art has become establishment art. Perhaps the only chance is for 'unimportant' art, art without an establishment…

Gifts and Thefts

In 1983 a wonderfully inspiring book was published. It seemed desperately needed, for reasons which will become clear. The title was *The Gift* and the author was Lewis Hyde. It explained, simply and compellingly, that a work of art is a gift. That the artist is merely a vessel through which the creative spirit flows to the viewer or listener or reader. I gave copies to many friends, passing on the gift, so to speak. But I chose my friends carefully, aware that anyone with a convinced materialistic outlook would find the book at best dull or at worst a joke.

Not long afterwards, a brand new concept arrived, however discreetly, to the effect that fine art had become a new currency. This was neither boring nor a joke. It was quite simply frightening. It did the rounds at the same time that the world learnt of a new money person, a new money thinker called the hedge fund manager. This was not so new, at least to those who knew about finance, and seemed in many ways a new name for a very old idea.

The idea of art as a new currency was diametrically opposed to the idea of the gift, to be passed on, and treated as such. Secondly, if art was yet another commodity to be traded, who was to decide which artists were currency, and what would happen to all those who were not to be counted in as having exchange value?

Worst of all, it was an art world elite, the very figures who neither love nor understand art, who would now legislate for what was good or great or bad. Art as a financier's hobby to please the art makers or art 'thinkers', would necessarily ignore and exclude those with potential to become tomorrow's truly necessary artists.

The idea of an art currency did not catch on, after all, but it did inspire a new type of museum director and collector, blinded by their own confidence and prejudices, filling our museums with the art that matches their criteria. And a new breed of collector arrived, from all corners of the planet, many with staggering fortunes, who knew nothing about art, and did not need to learn, because they already knew enough for their purposes.

* * *

It is not that William Tillyer 'prefers not to', like the stubborn scrivener Bartleby in Hermann Melville's novella of that title. It is not that he actively declines to help others to pronounce about his art, or promote it on his behalf. It is rather that he lacks the capacity to do these things on his own account. It would be like asking someone who suffers from vertigo to build skyscrapers, or asking someone who suffers from aquaphobia to swim the Channel. He is aware of the desirability of these skills, but realises that he does not possess them. He prefers to inhabit a different world, where he is comfortable and at one with himself. His art proceeds from his outlook. It can only flourish if he is an outsider. Paul Cézanne has always been one of his greatest inspirations and tutors, and the more you learn of Cézanne, the clearer the similarities. It is only in that insular realm that these two men can operate, an internal world where you and I are not especially welcome and, more importantly, are not needed. In fact we are a nuisance, and our presence would disturb or destroy their flow of work. For Cézanne and Tillyer, the studio is their sanctuary, as it was for St. Jerome.

Antonello da Messina's small oil on limewood portrait of *St. Jerome in his Study*, in the National Gallery, is an important painting for Tillyer. Dressed in red, Jerome sits at a wooden desk, or rather a platform, filled with the trappings of study, an array of books on the shelves around him. His room is a lofty vaulted interior divided by pillars. Seated on a rounded chair, the learned saint is perhaps at work on his great translation of the Bible into Latin. The artist in his studio. But it is also a living space – a towel hangs on a peg at the left, a placid cat reclines next to the potted plants on the platform floor at Jerome's feet. He has left his slippers at the bottom of the steps. To the left, a doorway opens off the wooden platform, leading to a large square window, and a detailed landscape stretching away to distant hills. At the right, the tame lion, whose paw Jerome had healed, pads slowly towards us along a colonnaded passage. The painting is of a space as much as an individual, or rather the space explains the individual.

I do believe that art comes from a higher place, a platform. For hundreds of years, it was instilled by love and fear of the Christian God, and before that, by the pagan gods and their mysteries. Eventually, in the seventeenth century, with the scientific revolution, this platform of art became a secular space. By the late nineteenth century God leaves the space entirely to the Impressionists and Post-Impressionists, where he only pays an occasional visit. A new type of God appears instead as inspiration – giants such as Wagner and Nietzsche, Freud and Wittgenstein. These geniuses walked art through the early decades of the last century. The second half of the century less confident and more conflicted mortals brought the exemplary word to art – figures like Charlie Parker, Robert Lowell, T.S. Eliot, Claude Lévi-Strauss, Karlheinz Stockhausen, Samuel Beckett, to list merely a handful.

So from Lascaux to Manhattan, over a period of twenty thousand years, we have travelled from cave paintings, in which wonder stood in for knowledge, to the all-knowing and second-guessing art of the new century – an art without wonder, where the rewards are fame, for the few, and the prospect of making a substantial fortune.

* * *

In his spacious studio in North Yorkshire, a brisk hour's walk from his birthplace and less than that to Middlesbrough, the town of his childhood and youth, William Tillyer ponders this chronology, up to the present moment of his marks on paper or mesh. He is by no means alone, among those artists who cared more for history and destiny than for publicity, and he is prepared to pay the price for eschewing fame and fortune. It is a narrow path, stretching backwards as well as forwards, along which he encounters Cézanne and that rare figure, the truly great British artist, John Constable. Both of whom shared the same century, along the same narrow path, but whose solitary steps became broad highways in the landscape of art, for all who came afterwards, and perhaps their road leads to Tillyer and beyond. Only time will tell, but as I look around me, and I have looked carefully, I do not see who else there is at present working with the same courage and conviction and vision.

* * *

The advantages and disadvantages of anonymity. To be an outsider, a free spirit, a contrarian, a nonconformist, a misfit, a quiet man of the North, a man of few words. The psychoanalyst Donald Winnicott wrote that 'In the artist one can detect the co-existence of the urgent need to communicate and the still more urgent need not to be found.' This might account for the fact that we cannot conceive of an artist's coming to the end of the task that occupies his whole nature. Which is why lives of the artists are impossible to write, though reassuring to read.

This is a story in progress, a constant unfolding, like a flower waiting to open fully in the sunshine. There are certainly enough petals showing – but there are more to come. Most of his colleagues blossomed prematurely in the sixties and started to wilt by the seventies or eighties. His own petals would just keep opening, wider and wider.

It was easier for the others, with their smaller and more exchangeable ideas. His idea was already big at the age of eighteen. The viewer can come on board quickly when an idea is relatively simple and clear. But the viewer who has to contend with an endlessly enquiring mind – a mind oblivious to whether you are on board or not – may lose heart, though he or she may equally return in time. And at a time when we are addicted to instant understanding, there are easier choices. Johann Strauss is easier than Ludwig van Beethoven.

History and Hardware

Salmon in the Corrib
Gently swaying
And the water combed out
Over the weir
And a hundred swans
Dreaming on the harbour:
The war came down on us here.
– Louis MacNeice

William Tillyer was born on Sunday, 25th September 1938. As the decade began, war seemed elsewhere. A new edition of Adolf Hitler's *Mein Kampf* appeared in 1930, in unexpurgated form, arriving on book stalls in Britain, price 6d, the profits going to the Red Cross. Although the Wall Street crash, a year earlier, had devastated the American economy and would progressively derail the world economy, there were still some good tidings in 1930, like *The Blue Angel*, starring Marlene Dietrich, which opened in cinemas across Germany. In New York, scientists predicted that a man would land on the moon by 2050. In England Amy Johnson, twenty-seven year old daughter of a Hull fish merchant, landed in Darwin, the first woman to fly solo from Britain to Australia. It was reported that her aircraft, the legendary Gypsy Moth, cost £600 and her journey took nineteen days. She flew blind through sandstorms, force landed in Java where she patched up the plane's wings with sticking plaster and kept Arab sheikhs at bay with her jujitsu skills.

Yes, the war was somewhere else.

But elsewhere soon or later became here, of course. In Britain alone, unemployment was over two million. In an extraordinary election triumph towards the end of the year, Hitler's National Socialist Party increased its representation in the Reichstag from just 12 deputies to a staggering 107, becoming the second largest party after the Socialists. The Nazi vote, an irrelevance just three or four years earlier, had jumped from 800,000 in 1928 to a fearful 6,400,000 in September 1930. Serious economic crisis loomed in Germany, as in Britain and America. By the summer of 1931 the National Socialists had the largest number of seats in the Reichstag.

A somewhat inward-looking United States, under Edgar Hoover, admitted that Prohibition had failed, and should probably be abolished. While the rest of the country was busy falling in love with a four year-old movie star, Shirley Temple, Franklin D. Roosevelt won a landslide victory to become the country's new President in 1932.

Attention began to shift from catastrophes in India and China and Japan, as the problems in Europe insisted. The rumblings in Spain, Italy, Yugoslavia, Russia were spreading across the continent, and would soon take centre stage, with mighty America watching on the sidelines with considerable interest. In fact the entire world now watched with interest, as Hitler became Chancellor of Germany on 30th January 1933, and in short order boycotted Jewish businesses, forced stores to close, sterilised imperfect Aryans, rounded up large numbers of Jews and began sending them to the camps — and announced Germany's withdrawal from the League of Nations.

In July 1933 the famed Bauhaus art and architecture school, by this time based in Berlin, was closed down, its buildings occupied by the Gestapo. That year its director Ludwig Mies van de Rohe went into exile in America, as did his predecessor Walter Gropius, while Bauhaus painters Wassily Kandinsky and Paul Klee fled to Paris and Switzerland respectively.

Many cultivated people would continue to visit Germany in 1934 and even afterwards. W. H. Auden and Christopher Isherwood spent longer than intended in Berlin, during the 'low dishonest decade', if only to read from close up the writing on the wall. Auden summarised it, shortly after he and Isherwood emigrated to New York in 1939:

> In the nightmare of the dark,
> All the dogs of Europe bark,
> And the living nations wait,
> Each sequestered in its hate.

There was no real opposition to the sleepwalking advance of fascism, and disagreement now meant prison or execution or concentration camp. In the summer of 1934 Italy's Fascist dictator, Benito Mussolini, welcomed Hitler to Venice for their first meeting. In Russia Sergei Kirov, friend and aide of Stalin, was shot dead, resulting in the execution of over a hundred others for reasons

unexplained. Explanations were no longer needed. The new reality did not need reasons, and soon the atmosphere of the Great Terror stalked the vast land.

It was not until 1935 that the countries which made up Europe felt that a possible war was at hand. Germany's massive re-armament programme worried Russia. Britain responded with an enormous increase of land, air and sea forces. Germany entered the Rhineland, violating the terms of the Treaty of Versailles. Mussolini's Fascist troops marched on Abyssinia, and with the Italian king now deposed, Mussolini all but ruled Italy as a Fascist empire. In Spain Franco's nationalist rebellion against the young Republic sparked civil war. Idealistic outsiders poured into Spain to take arms against yet another Fascist success and the squashing of a whole people in bloody and horrific conflict. It was couched as a struggle of Communists against Fascists, but it was much more, and symbolically charged, as the young from countries across the globe poured in to engage in a last stand against dictatorship.

In April 1937 Guernica, the cultural and spiritual home of the Basques, was destroyed by the bombers of the German air force, Hitler's gift to Franco. The attack upon an undefended community, on market day when the main square was at its happiest and most crowded, was an unprecedented act of mechanised barbarism.

Within a couple of months of the Spanish atrocity Picasso had completed his massive canvas in memory of the people whom the German bombers and fighter planes had attempted to wipe from memory. This powerful and urgent mural was soon exhibited in Paris, where the message of the horrors of war, and of a war that spoke for all wars, found its anxious audience. At virtually the same time, in Munich, Hitler launched an all-out attack on modern art, in the new art gallery, the *Haus der Kunst*, whose opening was attended by thirty thousand people. Its mission was to celebrate Great German Art and to deride the 'decadent' alternatives. With a touring exhibition of *Degenerate Art*, Hitler – a failed artist of minor talent – mocked the giants of the day, including Emil Nolde, Ernst Ludwig Kirchner, Franz Marc, Max Beckmann, Oskar Schlemmer, Oskar Kokoschka and others. He suggested that Modernism was the counterfeit currency of Jewish art dealers, and that those who gave it their approval should be taken away and sterilized as insane.

The full force of what a handful of dictators could achieve was now dawning, with Hitler driven in triumph through his home town of Vienna, bells ringing throughout the city, people screaming with joy. With Franco's troops winning a huge victory in Catalonia, humiliating and destroying Republican forces. With the new barbarian Mussolini pulling the wool over the eyes of the British people, although the Labour party had the wit to see through the empty words of peace that he offered the Conservative government.

By the Spring of 1938 there was a vaguely worded new ultimatum, issued jointly by Britain and its ally France, that a German invasion of Czechoslovakia would lead to war. This was intimated to Italy in the hope of discouraging Germany from going through with its plans. On the eve of the Czech crisis, a strange exhibition took place in London, in July. The artists included were Beckman, Franz Marc, Kokoschka and Kandinsky – those scorned as degenerate and insane in the Munich exhibition which Hitler had inaugurated the previous year. He joked that 'these artists had to hasten this exhibition because if they wait a year or two they will have to admit our achievements in the cultural sphere as in every other'. But it is these artists who are now in museums throughout the world. And Nazi art is forgotten.

In the early autumn of that year William Tillyer was born, a child in time, on the day Czechoslovakia rejected Hitler's latest demands from Bad Godesburg as 'an ultimatum given to a defeated nation, not a sovereign one'. On 26th September, in the Berlin Sportpalast, Hitler threatened Czechoslovakia with war, saying 'My patience is exhausted.' The French government announced that France would not enter into war over Czechoslovakia. Neville Chamberlain gave a head-hanging radio address: 'However much we may sympathise with a small nation confronted by a big and powerful neighbour, we cannot in all circumstances undertake to involve the whole British Empire in war simply on her account. If we have to fight, it must be on larger issues than these.' On 28th September Hitler agreed to hold a four-party conference in Munich between Germany, Britain, France and Italy. Czechoslovakia was not invited. The four powers agreed that Czechoslovakia would cede the Sudetenland to Germany by 10th October. Chamberlain flew home to Britain and famously declared 'peace in our time'.

William was ten days old when Hitler's troops marched into Czechoslovakia and one year old when Germany invaded Poland, after which Chamberlain finally pronounced the dreaded words to the British people, 'this country is at war with Germany.' His father was whisked off to serve in the Eighth Army desert campaign with Montgomery, to return five years later as a stranger to his son.

When war ended, the long years of austerity began. Tillyer senior returned to his old job at the Cooperative Society, and soon enough the small family would make frequent visits to Glaisdale, from their home in nearby Middlesbrough, and the child would go on fishing trips with his father. Peacetime was being slowly stitched back together.

Three years after the war had ended, they moved from the leafy suburbs to the centre of town. William's father opened a new hardware store in Middlesbrough above which the family lived. He was not too happy at his local school, managed to fail his eleven plus exam, and was sent to an independent establishment in nearby Hartlepool until the age of seventeen, then started his higher education at Middlesbrough College of Art, in 1956, whose pioneering syllabus was much influenced by the ideals of the Bauhaus.

* * *

The days of austerity Britain were suddenly another country, another time. London was reinventing itself, and every newspaper or magazine wanted to spread the news and join in the new normal. We are now in the sixties. Journalists and photographers arrived to get the story, young Americans and Europeans poured in to experience and witness the most fashionable city in the world. The streets were an unfolding movie, in real time, and who could tell the extras from the heroes? The great Italian director Antonioni filmed *Blow Up* in London, in my best friend Martin Kay's studio, a lightly fictionalised biopic of fashion photographer David Bailey and model Jean Shrimpton. Richard Hamilton made a collage entitled *Swingeing London*, and a series of prints featuring his dealer Robert Fraser and Mick Jagger, handcuffed and on their way to court to be chastised for their misconduct around drugs. The movie *Live Now Pay Later* showed and even explained how you could buy just about anything from anywhere and pay another time. San Francisco's Flower Power was putting down roots and sending up shoots along the King's Road, and Jimi Hendrix could be seen every Saturday strolling the strip, bursting with youth and transgression. Drugs were

as hard to find as a blade of grass on a cricket pitch. The Beatles and the Rolling Stones vied for pole position in the race for which group was better, sexier, more relevant, more iconographic. Anthony Caro toppled Henry Moore for attention in the press. Bridget Riley graduated from her apprenticeship in the advertising industry – the spirit of the age – to making Op Art, which in turn was linked to the Mod look patented by Mary Quant. Even teenagers from the suburbs of London and surrounding metroland now knew how to order a cappuccino from the kohl-eyed Biba girl working a Gaggia coffee machine. Even royalty and nobility and aristocracy wanted to be part of the scene and tried to dance. London was calling. The Kinks wrote *Dedicated Follower of Fashion*. The mini was the erotic but anonymous uniform into which every girl could squeeze, and the Mini, at around £600, could be driven by the rich and the not-so-rich alike. The E-Type was a bit steep for me, at £2000, so I had to make do with the ineffably macho pale blue TR4. But you too could be somebody, you were cool merely by virtue of being there. David Hockney dyed his hair bright blond, bought himself a gold lamé jacket and became an art world superstar who could draw your portrait and make you famous even if you were already famous, while his pal Peter Blake with his then wife Jann Haworth designed the Sergeant Pepper album cover. Allen Jones made paintings and sculptures of girls with breasts that defied gravity. Harold Pinter freaked us out with his two weird brothers giving a tramp shelter in *The Caretaker*. Four brilliantly talented ex-students from Oxford and Cambridge gave us the anti-establishment, as a concept, in *Beyond the Fringe*, which changed satire forever, and they all went on to become star turns in their own right. Humour changed. Art changed. Sex changed. Attitudes changed. The champagne flowed, the substances were not-so-discreetly passed around, the people danced until finally it got light outside, and the dull day returned. But some great things got done, and Benjamin Britten wrote his devastatingly beautiful *War Requiem*.

There was more, the real thing often inseparable from parodies of the real thing. James Bond walked off the pages of Ian Fleming and onto the big screen. Robyn Denny and Richard Smith and a handful of other young painters attempted to change our visual habits. Richard Lester came over from America and gave us *A Hard Day's Night*, starring The Beatles in their first outing on film. The consummately arch Avengers came to the television screens. The delicious Julie Christie was 'Darling', the tale of an amoral, narcissistic London model. *Time Magazine*, the ultimate opinion forming publication of the day, ran a cover story on Swinging London, and gave the British government a free advertisement by declaring that this was indeed the place to be. Prime Minister Harold Wilson

understood perfectly that this was a country for the young, and had himself photographed with the Beatles. Tom Stoppard wrote chic parables which put a spin on high culture and made us all feel cleverer.

William Tillyer watched all of this, and took from it just what he wanted to use. His art was subdued, but the sleek monochrome images he was producing had their own glamour, as though they too were secretly breathing the zeitgeist. But secretly he believed with the nonconformist printmaker William Blake that 'Great things are done when men and mountains meet / This is not done by jostling in the street.' It was around this time or a little later that John Lennon took me to Indica gallery to see a new work of art by Yoko Ono. Lennon and me and Yoko in Mason's Yard.

The wind blew with full force through the sixties and virtually blew itself out as the decade closed. A grey cloud was massing. There were small if clear enough signs of change. *Cathy Come Home*, a hard-hitting television film featuring a young homeless couple was so collectively upsetting that it led to a new charity named Shelter. The hippy magazine, *Oz*, took a bleakly cynical turn. Brian Epstein, manager and guru to the Beatles, committed suicide. Tony Hancock, our favourite comedian, killed himself in a Sydney hotel room. The Rolling Stones looked tawdry rather than sexy as they appeared in court on drugs charges. There was the Thalidomide scandal. There was Charles de Gaulle turning Harold Wilson down, again, for entry to the Common Market. There was the Six Day War, thousands of miles away, but sending reverberations which could be felt even on Carnaby Street and the Kings Road. Britain decided to withdraw from East of Suez, and bring its soldiers home, to save on expense. As Philip Larkin remarked at the time, in a bitter elegy, all we can hope to leave our children now is money, without ideals. The pound was devalued, signalling the worst financial crisis for twenty years. Even an inanimate block of London flats gave signals of fatigue, when its corners collapsed and all twenty-two stories fell to the ground. George Brown, one of the most charismatic figures in the Labour government, resigned, on the grounds that Wilson was running the Cabinet in a dictatorial fashion. Abroad was suddenly here again, and on our screens. The assassination of Martin Luther King caused new cracks and tremors in the brave new edifice of free love. Enoch Powell terrified those who lived for a better future with his riveting 'rivers of blood' speech, with its cold fear of Others and its lowered hopes for a multicultural society. Freedom wasn't about to happen to the Czechs any time soon, when in 1968 the Russian tanks rolled in to crush the hopes of the Prague spring. In Grosvenor Square a quarter of a million people marched on the American

Embassy against the war in Vietnam. Even the Beatles lost the plot, opening a Flower Power shop in Baker Street whose clothes were so expensive that it was doomed to fail, symbolically as much as literally. The supersonic Concorde had its maiden flight, but its days were numbered – like many other things it proved too expensive to fly.

One of the enduring inventions of the sixties was publicity. One of the charms of the sixties was its belief in the virtues of visibility, the idea that we could all be famous for fifteen minutes. But the idea that value was visible and that everything had a price tag raised the question of how to assign value to less easily known quantities, such as art.

* * *

My unexpected discovery of the Impressionists and the Post-Impressionists happened in the mid-fifties. They changed my life. Now, sixty years later, I like them more, not because I feel the frisson I felt then, but because I begin to see more clearly, because I see myself a little more clearly. Back in the fifties I never dreamt of owning a painting. They were things of beauty, of no use, objects of desire. They were in fact the only objects in the world without value. Today they have value, and are valued by valuers, at tens and tens of millions of pounds or euros or dollars. This is what has happened, to new art as well as old, since the time of Durand Ruel and Ambroise Vollard.

If art was destroyed by money, we must continue to imagine a world in which this is not the case, a world in which money has been destroyed by art. When her great Menil Collection opened to the public in 1987, the American collector Dominique de Menil was asked how much it was all worth replied, 'You only put a price on art when it's for sale. Nothing here is for sale, therefore it's priceless or worthless, depending on how you look at it.'

What is not for sale – like the paintings on the Courtauld's walls – is worth perhaps nothing, perhaps everything. What cannot be reckoned, because no one has yet put a price on its head, becomes anyone's guess. By that reckoning, William Tillyer is a very expensive artist to buy.

* * *

The pages in the books are blank,
The books that Robinson has read.
That is his favorite chair
Or where the chair would be if Robinson were here.
All day the phone rings. It could be Robinson
Calling. It never rings when he is here.

– Weldon Kees, 'Robinson'

Most people have been to parties, of one sort or other, from the cradle to the grave. This artist has never been to a party. Or he has partied inside his head. I've known him for half a century, a fair amount of time to get to know somebody, but all I can judge is the work. Not the painter, but the picture. He is knowable not for himself but through his work, ambitious not for himself but for the work. In a room or gallery filled with people, the last person you will see is William Tillyer, even if his works are the subject of the exhibition. He does not believe me when I say this. He thinks I say it just to give him a hard time. The characteristics that can be listed as making up this man, this artist, are not such as are directly helpful to a reputation. Cussed, invisible, retiring, stolid, stoical, a quiet manner that actually gives off an image of sufficiency, awkward only in society, uncommunicative, private. These are all ways of describing something difficult to describe. A bourgeois painter perhaps, a throwback to an age when nearly all artists were bourgeois, just as Henry James described the great Honoré Daumier as 'the absolute bourgeois', by which he meant many things, many lost meanings. We have lost touch with this truth, because we have inherited an unshakeable association between the artist and the bohemian, the bohemian and the avant-garde. But the bourgeois artist is a more mysterious, less readable customer.

The young art writer Ben Wiedel-Kaufmann, who wrote an excellent text about the man and his work, confessed, several years later, that it was hard to do, without the help and guidance of the subject. The art biographer and historian, Norbert Lynton, who preceded Wiedel-Kaufmann with a brilliant extended critical monograph on Tillyer, published in 2000, telephoned one evening, in bewilderment, and exclaimed politely, almost in pain, 'But he won't let me in!' When I called the subject of this future biography the following morning, to say you must tell him your story, he seemed confused and said, 'But I tell him everything …'

Is there nothing to tell? Is it all in the works themselves? Perhaps he is just a pragmatist, honest enough to admit that he doesn't in fact have anything to say? Very often I notice a feeling of confusion on his part, the disappointed expectation that you should know what he is thinking, as if there were some magical and invisible wire connecting his thought to yours. But to articulate this sensation would itself be painful for him.

So, to write about him – and this truly is not his fault, if I do so, but my choice – you are on your own. Good luck. And having known him for so long, I am a good candidate – in fact the only candidate – to meet the challenge.

You can get irate, and at the same feel very defensive on behalf of a substantial artist who has been excluded. Were his equanimity in the face of such odds some sort of act, then he has been performing it consummately for half a century and more, and what were the good of that? Better to blow your own trumpet, fame and fortune are strumpets. But wait, is it not in fact better to do things his way? He can be exceptionally clear thinking, at times even tactical, but it has to make sense to him at that particular moment. Otherwise he takes long views. From the very outset he knew what he wanted to do, the kind of works he wanted to paint and draw. He just had to reel it out, slowly, allowing the incubation needed for these elusive but large ideas to become fully articulate. Like the whale being tracked by Ahab. As if Tillyer intuited from the start that it was to be a slow and arduous voyage to completion. There is another similarity here with his great hero Paul Cézanne. Another bourgeois painter. The similarities are striking. They are both highly articulate thinkers and artists, the first expressing himself through anger, the second through reticence.

But there is a larger problem here. We are going through a period where the artist's *voice* is all-important. At the time of the Post-Impressionists there was no art market to speak of. Painters were silent. It was an art of silence. If you needed to use words you became a writer. But today, if an artist is to all intents and purposes silent he or she is thought of as having nothing to say. And as having no value, in all senses of that word.

I have known and worked with a lot of artists. For all their similarities, they were as disparate as any other group of human beings. But Willi has been different, above and beyond the call of duty. He is the only true Outsider. Not in the usual senses. He is an exceptionally fine family man, for a start, which is something I do

not think of as characteristic of artists, in whatever medium. It is a commonplace quality, but rare. And the commonplace, in his case, is quintessential. Even in the market town of Stokesley in North Yorkshire, where he spends most of his life, living and working, he is the man next door. When I think back on my monthly visits to Henry Moore, I was fully aware that everyone from miles around his home and studio knew of him and held him in awe. Tillyer is not known even in this tiny environment. Nobody seems to know his name, or who he is, or what he does for a living. I suppose, these days, in his eighties, this raises no suspicions, because he is probably retired by now anyway, in excellent physical shape, but old.

And yet he is not really old or young, and certainly not retired. He works furiously every day. He cannot wait to get to the studio. He makes paintings the world has not seen, and when a tiny fan club, worldwide, becomes familiar and comfortable with his most recent style, he has already moved on. And you never understand the language of the new when you first encounter it. The situation is frustrating for all concerned. He does a thorough job of keeping things that way. To write a biography of such a person is like trying to lift up mercury with your fingers, or to see in pitch darkness, or have a serious conversation with a hippopotamus. Even Mr. Pooter, in *The Diary of a Nobody*, gives more clues: 'I have often seen reminiscences of people I have never even heard of, and I fail to see – because I do not happen to be a "Somebody" – why my diary should not be interesting.'

The art public does not begin to understand his paintings, although they fall in love with his watercolours. The art world does not consider him. Where after all is he to be placed in the scheme of things? He is not a landscape painter, he is not a modernist painter. He is no one. And yet... This is why I have bothered to write this book, against the will of Tillyer.

If I am to argue, as I believe in all honesty, that he is perhaps the most considerable painter Britain has produced since Constable, how am I to articulate this. Willi, step forward please and help me out.

Amsterdam Aphorisms
Written in the Stedelijk Museum Cafe

It is easy to understand why people only buy what other people buy. Follow the leader. But working out why the leader decides to buy what others have yet to buy is more difficult.

The high road to an elsewhere which is perhaps nowhere. Whether Agnes Martin or Lucian Freud, small audience or big audience. No matter.

The auction in New York in November 1961 of Rembrandt's *'Aristotle Contemplating the Bust of Homer'* was billed in advance as the sale of the century. Twenty thousand people came to stare at the picture during a three day preview. The auction room was reserved for ticket holders only, everyone else crowded into closed circuit TV rooms. The bidding started at $1 million, and was over in a matter of minutes, knocked down to the Metropolitan Museum of Art for $2.3 million, the highest amount ever paid for any picture at public or private sale.

Fast forward to May 2010, when it took Christie's a little over eight minutes to sell Picasso's *Nude, Green Leaves and Bust* (1932) for $106.5 million. In 2013 *Three Studies of Lucian Freud,* by Francis Bacon, sold at auction in New York for $142.4 million, after ten minutes of frantic bidding between seven hopefuls. In 2015 *Les Femmes d'Alger* sold for $179 million in New York. And in 2017, Sotheby's sold Jean-Michel Basquiat's untitled skull painting from 1982 for $110.5 million to an adolescent Japanese billionaire. These are by no means the highest sums – discreet private sales have generated far higher figures, for works by Gauguin or Cézanne or Rothko or Pollock. But the 1961 Rembrandt sale was the beginning of something.

Money and art, we say, as though this were self-explanatory.

Until perhaps the eighties, most galleries and museums were empty. In Italy you had first to find the museum – un-signposted, unless it was the Uffizi – and then keep returning until its doors happened to be open. Ancient streets empty under the midday sun. In churches you had to stuff dozens of tiny lire coins into a machine to switch on the lights, usually for less than a minute, and fumble with more coins to keep them on. Sometimes you had to ring the bell next door to get a yawning verger to open the church for you. You were often completely alone, squinting upwards at the frescoes, and often in the dark.

But there were signs of change, much earlier. Lengthening queues to see art. When the treasures from Tutankhamun's tomb came to the British Museum in 1972, 1.7 million people stood for hours in the rain. When you got inside, it was packed with people steaming like cattle in overcoats. Everywhere the glint of gold. And a glint of hysteria for something else, something hard to name. Tutankhamun stamps, Tutankhamun pencil sharpeners, Tutankhamun vacuum flasks, Tutankhamun cocktails, Tutankhamun slippers.

If you cannot create magic in your studio, then you do not need a studio, whether it is a modern day version of the bohemian attic, a shining new space in an industrial estate, a corner of your bedroom, or a field. If none of these suffice, become an art dealer.

What to make of the bizarre combinations of works amassed by individual collectors. What does it mean to love the work of Robert Motherwell *and* Ai Wei Wei?

Why do people 'like' so many artists? Is it because they don't 'love' any of them?

When does a painting become a picture? A picture is the result of painting.

By far the best work by Riley, Hockney, Caulfield, Blake, Hamilton, Hoyland and so forth was done in the sixties. For Auerbach and Kossoff it was the fifties. Bacon managed to span the forties and fifties. Hodgkin was the seventies. None were able to improve on their early form, and the results are date stamped. A decade is a long time in art.

The making of art has changed, since the sixties, and is now principally done to gain attention, to gain a fortune.

Many of today's famed artists will end up becoming tomorrow's pretend art, like pretend poetry, pretend love, pretend kindness.

There is something honourable and spirited and independent minded about collecting prints, rather than paintings. Print collectors are so often delightful people. But they are easily betrayed – by artists. The great print curator at New York's MoMa, Riva Castleman, a devotee of Tillyer, has referred to the 'spurious traditions of the French school, which allowed artists to produce printed versions

90

of their paintings.' Bacon 'prints' are merely glorified photographs. Stella would get the master printer Ken Tyler to make his art for him. Dalí would sign blank sheets. Nolan, Australia's most famous painter, would double the edition size under the guise of artist's proofs. Hodgkin's hand-coloured prints were hand-coloured – by the printer. On the other hand, when it came to print-making Rembrandt produced Rembrandts. And Tillyer produces Tillyers.

The world of printmaking remains even now a terra incognita for him, to be explored, beyond oil or acrylic or watercolour. With its translucent veils, often using only one ink to suggest a range of colours from the lightest gossamer silver to deeply interlaced encrustations of darkness. Printing is both a close and a distant relative of Tillyer's works in bronze and silver, tapestry, glass, pewter, stained glass windows, and his rarer works in pencil or pastel or photography.

Paintings in private houses have an honourable past. William Hazlitt, England's first great art critic, was not above tramping up to the doors of great houses and demanding entry, in order to gaze upon what he already knew to be there. He would say, 'Throw open the folding doors of a fine Collection, and you see all you have desired realised at a blow – the bright originals starting up in their own proper shape, clad with flesh and blood, and teeming with the first conception of the painter's mind!'

Hockney recording nature is like Paul McCartney writing opera. Tillyer recording nature is like John Clare recording nature. Hockney's nature reflects back the colour supplements, Tillyer's is a Modernist mirror of Nature itself.

The Stedelijk café, the herd of independent minds. The sophisticated café of the MoMA in New York, the herd of independent minds. The Tate restaurant, the herd of independent minds, ditto Istanbul, Los Angeles, Paris, the smallish international travellers' club lounge of independent minds. Stay quiet in those museum cafés and listen to the art prattle. Nobody dares to take away the bottom brick, which says that Mondrian, Malevich and Kandinsky are the founding fathers of modernity. Otherwise the entire edifice would fall down. Please don't ruffle their feathers, their belief system, or they will all burst into tears. Let them enjoy their dietetic salads and egg white omelettes. Save them from heartburn, and above all from a change of heart.

They walk the halls of art and have no doubt that Jackson Pollock and Mark Rothko and Barnett Newman are the greatest, because how otherwise could there be so many biographies and books about their art, and such a phenomenal price tag on their works, and so much space around them in the air-conditioned palaces of post-modernity?

Malevich, Kandinsky and Mondrian were perhaps greater teachers than makers of pictures. There is more substance in the idea of Pollock than in the paintings of Pollock.

Who would dare to doubt the existence of God in thirteenth century France or Spain? Who would dare to doubt the greatness of modern art – in its received form – in the twenty-first century?

Artful dodger, who takes your wallet without you noticing, the art of crochet making, the artistic baker and flower arranger, the art of making pasta, the body artist who entices you with her wares in a shop front window in Amsterdam. Art Blakey is an artist with his drum kit, Art Farmer with his flugelhorn, the artisan making wonderful objects from fine wood or stone. The art of a winding row of trees near our house in Southern France, curving out of sight. The art of Arthur Rubinstein which gave us Chopin. The art of Constable that helped give us Monet and Delacroix, the art of making money out of art. Better the Artful Dodger. Better the faker of paintings than the maker of yet more marketable paintings. Artifices, artifacts, tightrope artists, con artists. High art and low art. Art for the people. Art for God and art for money, artisans, art as hobby, art world, art market, art galleries, all for the love of art.

'We can be heroes, just for one day' - David Bowie

I cut my teeth on contemporary art, properly avant-garde art, in the wild jungle of New York in the late sixties. I had in my own way absorbed the shock of the new through those months, before returning to London to try and make my way with new art. I had been familiar with recent old art, Impressionism and Post-Impressionism, the miraculous Picasso and Matisse, and on through the magical worlds of Soutine, Modigliani, Chagall, Miró. Thanks again to the Courtauld collection. One museum can provide a liberal education, and we need the museum with walls, as well as the virtual museum without walls. Because to possess a work of art you need to learn it, and you can only learn to love it by standing in front of it.

I was also equally at home with art of my time, my eye educated through friendships with David Hockney and Dereck Boshier and Bernard Kay in Notting Hill, Ivor Abrahams and Leon Kossoff in Willesden, Kim Lim and Bill Turnbull, Tess Jaray and Marc Vaux in Camden Town, Robyn Denny, Dick Smith, Clive Barker, Peter Blake… so many of them.

But in New York this bubble world had burst wide open, although I could not quite register this at the time. Hanging out with Andy Warhol at his factory or that infamous watering hole and gathering spot called Max's Kansas City. Regular visits to Claes Oldenburg in his studio, who once gave me one of his Ray Guns to hold and it was like grabbing a giant cock – Sigmund Freud rather than Lucian Freud. He liked me because I had a funny English accent and especially because I had read a few books. Jim Rosenquist took me to a dazzling party at the newish Whitney Museum on Madison Avenue, to which he wore a sharp dinner jacket, but if you looked closely it was covered in burns, marks that looked casual and unintentional but were obviously done on purpose, to shock all those nice ladies at the Whitney who were doing voluntary work and just liked being part of the art scene. Jim would gently mock them but they adored him, for being eccentric and funny – and for being a terrific painter.

I seemed to know them all. Andy, Donald Judd and Dan Flavin, Leo Castelli, Dick Bellamy, Sydney Janis. The young Richard Serra who was making great new work, the British expatriate Malcolm Morley, the first artist I would ever publish. There was the hysterical and exotic Lucas Samaras, the neon sculptor Steve Antonakos whose drawings I bought in quantity, even when I had no money. The scruffy

guy in black, Joseph Kosuth, and the cute looking and dynamic ball of energy with his curly black hair, Larry Poons. John Hoyland who I knew from London was a regular visitor to New York at the time, introducing me to Mark Rothko and also Barnett Newman. The sculptor Lynda Benglis, doing wonderful work but who would have to wait several years for success, no doubt because she was a woman. There was the great Mark de Suvero. And there was Frank Stella, who was making those glamorous and eye popping *Protractor* paintings, based on the semicircular instrument used for drafting angles, vaultingly decorative and daring, my favourites of all his paintings. There was the scary but endearing John Chamberlain and his sculptures welded from bits of cars, or Walter de Maria and his colleagues making their unsellable Land Art, moving earth and tracing lines through the Nevada desert or extending a vast spiral jetty into the eerily dead waters of the Great Salt Lake. And there was the explosively fertile Robert Rauschenberg, already a legend, who I would later represent for a couple of years, and his assistant Brice Marden.

William Tillyer knew none of these downtown figures, but when he came up those stairs in Mount Street in 1969 and unzipped his portfolio I felt that I had possibly found a voice to match theirs. An artist who drew upon the decorative language of Matisse, the inventiveness of Picasso, the intellectual play of Duchamp, the visual precision of Mondrian, the private topographies of John Constable, and who saw no reason for not speaking all of these disparate languages, if this is what it took to say something new. And who had worked out that to do so you needed to be outside London, or New York, or LA. And at all costs avoid becoming a Royal Academician. Never to acquire any laurels on which to rest, or adopt one style, one idea. In a sense we were well suited. A pair of outsiders, rather than outsider and insider. Gentile and Jew. Pondering together these matters of belonging, beyond what Sigmund Freud called 'the compact majority'.

In effect, I never really belonged in Bohemia or post-Bohemia, among the more fashionable artists and dealers of the day. I probably convinced myself that I fitted in, but my interests lay elsewhere. I did not really know what to make of what I saw in Warhol's Factory or in the other elsewheres of the art crowd. I felt I belonged more with the people, or with the avant-garde scene, and I felt rather less crazed and strange than much of what I was witnessing. William Tillyer was never part of that world, even in the years when he might have been accepted. He was the true outsider, outside the faux outsiders, who were in reality insiders, whether they were treading a secret path to becoming Royal Academicians in London or

walking on the wild side in New York. Two sides of the same coin. Tilllyer's place would not be secure for many decades, neither appealing to bourgeois tastes nor comfortable with the hairy ambivalences of New York. He had his own path to forge, where nobody went.

In art world terms, Tillyer was an ordinary man. A journeyman artist, with the ethos of an artisan. Like Paul Cézanne or, later on Matisse, two of his most revered heroes in modern art. Cézanne's ordinariness now casts a larger historical shadow than Gauguin or Van Gogh, and Matisse casts a larger shadow than Picasso. This is one of the mysteries of aesthetic judgment, which is a child of time. The road is long, and slow.

The Gossip

'the "clat fart" shop: that is, the gossip shop'
– D.H. Lawrence

The art world, like most closed systems and worlds within worlds, runs on gossip, and in strange times Gossip Central becomes the place where art is made as well as sold. The news on the Rialto in Venice was gossip. There was gossip in ancient Egypt and ancient Rome. The wealthy and powerful have always needed to be told the names of the greatest sculptors and painters, in order to immortalize themselves in marble and paint.

Gossip is always of greatest value to those who need the short cut, for reasons of profit and skulduggery. But short cuts are useful only to the few. Today millions of people can gain from gossip. And get burnt. I love the story by Scott Fitzgerald, entitled *May Day,* when in the late twenties regular guys were getting richer and richer by the minute, investing in the stock market – waiters, head waiters, even Fitzgerald's shoe shine boy, all getting the gossip by the minute in Manhattan. Of course they all lost their trousers in 1929, especially the shoe shine boy. The South Sea Bubble of 1720, whose oxygen was gossip, made the King of England and his subjects richer and richer, until it too ended in tears, before the investors could jump ship. 'The vast inundation of the South Sea', wrote the poet Alexander Pope, 'has drowned all, except for a few unrighteous men – contrary to the Deluge.'

Today, in the extended post-Warholian moment, the unrighteous have time on their side. With the proliferation of the media, from newspapers to radio and television, to the internet, the word can be spread not in months or weeks but in seconds. In the art world today reputations can be made in minutes and where judgment was once the preserve of kings and queens, popes and bankers, now it is for all. But is it accurate for any longer than it takes to be invented and spread in the first place?

Gossip in the sixties accelerated exponentially. Warhol understood this, he benefited from it, he manufactured it in his Factory, and in his brief life sowed the seeds for what was to come. The Gossip would soon decide what was cutting edge and what was mediocre, and the present tense became the only tense. It ruled on matters of aesthetics and it ruled the financial consequences of those decisions. It created a vast amount of room for a few artists, and no room for any others, in Europe and America, even across the globe.

Old-fashioned 'clat fart' was good for small towns and villages, where locals wanted to keep up to date with who was behaving badly with whom, who was moving in or leaving. But for the future health of the international art village – however international, it remains a village – it is of little use. Because tomorrow has no use for today's gossip, and tomorrow is all important, and tomorrow arrives very soon!

* * *

There is a lot to be said for that old restaurant. The proprietors have been there for many, many decades. The menu never seems to change, even though it does change. The chef never lets us down. The pots and pans, nearly as old as the establishment, do the job as well as ever. The chairs and tables are the same, and are still perfectly adequate to their purpose. We know what to expect from this restaurant, good food, excellent service, discreet waiters. The wines are always far more than just drinkable. The maître d' may even send you on your way with a smooth cognac. And so it should be with your favourite artist. If he lets you down, it is because he lets himself down. Which is not to say that he shouldn't vary the menu, or even change it every day.

* * *

They say society gets the art it deserves, and this seems truer today than ever before. With money in plentiful supply, a global market and an audience who have in many cases earned their vast fortunes too easily, it is unfair to expect the artists of the moment to reach deep inside to produce their work. It is enough to produce a response to the pressure of demand.

I am more and more convinced that attempting to judge an artist's work as early as twenty-five years after his death is a little on the optimistic side. When Francis Bacon explained this to me he was talking from a position of maturity. But I am older now than he was then. Perhaps those extra few years have made me wiser on this issue. So I think it foolhardy to judge as early as a quarter of a century after the fact. Surely those who look with any discrimination must by now be placing Matisse above his friend Picasso. Or perhaps it is still too soon…

An artist is no more than a labourer working in the field, a scholar in his study, a watcher of the skies, when a new planet swims into his ken. This is one way of

explaining inspiration – that it comes from within, but feels like something coming from without. Tillyer is such a toiler, in his studio. And most definitely a watcher of skies. In the fifty years I have known him, he has never lost the inspiration, the flow of new ideas, new colours, new compositions, a new subject to explore.

The visual artist, the working painter or sculptor, has one problem which the composer or writer is spared. Other than the need to provide, the artist needs to buy the costly materials of the trade – the paints and canvas and brushes, the paper, the studio with proper light, the requirement to travel. And, increasingly, these 'materials' include the need to mingle with the world.

Only in fairly recent times has the artist come out from the privacy of his studio, or the conviviality of his studio – think of Courbet's great painting of 1855, *The Artist's Studio*, bursting with people – so as to be seen, as an actor in the spotlight, on or even off stage. Whether a natural performer or not, he or she must submit. If called, they will be handsomely rewarded for appearing, and will become considerably richer than their dealers. But the work will leave the studio prematurely. Think of Picasso's *Demoiselles d'Avignon*, their faces turned to the wall for nine years, seen only by trusted friends and peers.

Sadly the contemporary international audience will extract the work from the artist, separate them, and symbolically take away the thing that put the artist there in the first place. He may try to fend them off, he may fool himself that he has kept them at bay, and kept his concentration intact. To the casual eye, the pictures and sculptures are as good as ever, even better than the earlier work. Which would be nice, were it true, to have your cake and eat it too! But in time, often posthumously, it becomes clearer that the art became less clear, less honest, less necessary, less real.

Only recently have I joined the villains. Anxious to see the completion of *The Golden Striker*, a new thirty-foot painting by Tillyer, on which he had already spent two years, I reminded the artist that Michelangelo only took four years to paint the Sistine Chapel. Within a month I received the painting. But I suppose, if the Pope had the right to nag that one artist, perhaps I was in my rights to nag the other. Perhaps not a villain really, just an art lover with perhaps too much enthusiasm.

William Tillyer occupies a strange but fascinating position in the art of our time, being a senior practitioner who took up position in the mid-fifties of the last

century. By the time he appeared in the story Francis Bacon had nearly completed his greatest works, Henry Moore likewise. Ben Nicholson had been a heroic figure, who together with his wife Barbara Hepworth broke the mould of English art by bringing an international sensibility, with extraordinary purity of purpose. Peter Lanyon, William Scott, Victor Pasmore and others continued along this path, resourcefully and successfully – and visibly – through the fifties and even into the sixties.

Tillyer was fully versed in the achievement of those earlier artists, as well as in the vision of his contemporaries – Hockney and Blake and Caulfield, Denny and Smith and Riley. But when his contemporaries reduced their play of possibilities, because the age demanded an abbreviated ambition, Tillyer embarked on what seemed a perverse enlargement of possibilities. He had always loved the paintings of Constable and Gainsborough and Turner, and nurtured a private passion for minor British landscapists, such as Cotman, Crome and Bonnington. He saw clearly that in these watercolourists there lay a possible reconciliation of Romantic truth to nature with Modernist truth to materials, as the critic Peter Fuller would point out.

In his quiet manner he would also constantly return to his abiding heroes – Piero, Poussin, Cézanne, Matisse, Picasso, Duchamp. But his path was more difficult than that of his immediate peers, more full of indirection. Whereas they found their style and subject, one after another coming into harbour like a fishing fleet, he would thrash around in open waters for several more decades. For one thing, he needed to align past and present, and the different versions of the present, to understand them in terms of each other – the Dutch from Pieter de Hooch to Mondrian, the Americans from the Luminists of the 1870s to the newly formed galaxy of Rauschenberg, Stella, Lichtenstein or Olitski, and how those in turn followed on the heels of earlier giants, Pollock and Rothko, Motherwell and Still and Newman. To make a new kind of art, taking into account such a vast genealogy of cause and effect would necessarily take a lifetime. Perhaps his predecessors in this respect were Picasso and Rauschenberg, two artists who also attempted to embrace the entire story.

In this extended period of self-discovery, he would find few admirers. His work did not appeal to a broad general public as it became increasingly difficult to enjoy with ease, and it did not find favour with the cognoscenti because it seemed insufficiently difficult to reassure the elite. David Hockney with similar ideals would

immediately succeed, because the broader public could understand his beguiling and fluent paintings and drawings and etchings, and the art world accepted and embraced him for his huge and incontrovertible personality, which make it hard to ignore or dismiss his work. They might sneer behind his back, for making an art that was too easy on the viewer, but confronted by his presence and his success, they had no choice but to accept him with open arms. Tillyer was less of a worry. They could dismiss him without negative consequences for their own taste forming careers. Moreover, whereas Hockney met his viewers halfway, Tillyer would not budge an inch from his programme, and the price to pay was painful. The only thing that kept him going, year in year out, decade after decade, was self-reliance and a quasi-mystical belief in his aesthetic star, which continued to shine brightly, and the urge to make the work that completed this singular vision.

The Slade was a more introverted and serious minded place than the Royal College. The Slade was less plugged in, and it would take William a little longer to catch up with developments across the Atlantic. Whereas he would have to learn gradually about this cultural turn – from the intense and muddy Abstract Expressionist canvases of the fifties to the clear and extrovert imagery of Pop Art, Colour Field painting and Minimalism – Richard Smith and David Hockney had a head start. They were already there, on the spot in the glamorous modernity-cauldron of America. And the elder statesmen Eduardo Paolozzi and Richard Hamilton had crossed over even earlier. Tillyer would not get there until the seventies. He would have to learn about the new American art by report, through publications such as *Artforum*, *Art News* and the occasional in-depth articles in *The Times* and *The Guardian*.

Although he has become a deeply travelled artist in the intervening decades, his provinciality early on kept him somewhat apart from his more sophisticated peers. Even Allen Jones and Joe Tilson, both Royal College students, would go West. Anthony Caro, starting off as Henry Moore's assistant, had by this time become a good friend of America's greatest sculptor, David Smith. Painters such as Lucian Freud and Frank Auerbach and Leon Kossoff did not get to New York either – in their early days – but they seemed not to heed or need that energy, as they ploughed their forthright and individual furrows. Their art remained muddily introverted, even when they began to brighten their palettes. They would stay true to a surly insularity and look back to British artists of an earlier time, like David Bomberg, or to European masters from much earlier, like Goya and Rembrandt, for their inspiration.

Tillyer on the other hand always needed to be aware of other realities in order to define his own, though he would never align himself with either the glamour of New York or the turgid if often brilliant academicism of London. As a result he found himself in neither camp, in whichever direction he turned. There was one other artist in a similar predicament, Howard Hodgkin, who turned to Indian art and Matisse for his source material. These two isolated home grown modernists had much in common, though they never made common cause, and by the mid-seventies Howard would tie his colours to the mast, in more ways than one, while Tillyer continued to search and experiment.

The Abstract Expressionists and their successors in America were surrounded by scores of gifted lesser known artists who gave fresh energy and impetus to the work of the major players. This is an essential part of the economy of any movement worth the name. So too in England there were many more names that deserve our retrospective attention, and at the time they all needed each other. So it is important to remember John Hoyland, John Walker, Peter Stroud, Bernard Cohen, Sean Scully, William Tucker, Phillip King, Harold Cohen, Malcolm Morley, Ivon Hitchens, Peter Phillips, Gerald Laing, Gillian Ayres, Harry Mundy and the rest. Without a good memory there can be no true act of judgment.

* * *

I have met and worked with many prominent artists, over many years. Very few had the ability to keep quiet and let you decide for yourself. But there were a few. I think of Euan Uglow and Robyn Denny and Leon Kossoff, whose pictures remain miracles for me. And Tillyer, who pontificates even less. The humility of this handful of artists has remained so unusual as almost to be mysterious.

Robyn and Euan and Leon worked within a narrow range, a concentration which matched the intensity of their vision. William Tillyer needed to see the world through the eye of a needle, and express it through a grid, seemingly cerebral and even expressionless, and yet a pictorial space which opens outwards onto a view of landscape and the natural order. It also opened inwards, creating a space behind the picture plane which evoked past worlds of perspective and illusion. To understand the grid or lattice you need to return to Constable, via Cézanne. But equally, you need to allow for Tilllyer's obsession with James Lovelock's Gaia hypothesis, a unified theory still to be proven but showing every sign of being scientifically correct as well as intuitively true. And allow for Tillyer's ongoing

argument with Modernity, which remains the bedrock of his vision. He admits to the influence of architects as much as painters – Glenn Murcutt's corrugated sheds, Calatrava's bridges, Lloyd Wright's Fallingwater – and the influence of music. The grid and the lattice are rational and architectonic forms which incorporate the compositional geometries of John Cage or Steve Reich.

In the seclusion of the studio, punctuated by travel, Tillyer can pursue this complex world of correspondences. Studio and world, a rhythm which interposes here with elsewhere. He is far from dismissive of the viewer, but the search is conducted in the first place for himself, with no audience looking over his shoulder. He is not an entertainer or a juggler or a trick cyclist. He is a figure in the landscape, seen from a distance, like those solitary figures and scarecrows in the landscapes of John Sell Cotman. And if the human figure as such is often excluded from these landscapes, it is we who are present as witnesses, and Tillyer is present as observer. The silence, the patient experimentation, the loyalty to the genius of place all link him in my mind with John Constable in his different setting, along the River Stour.

Please do not understand me too quickly

Painting has often been on its last legs, especially in the twentieth century. There have been many false starts, wrong turnings in which bombast tried vainly to solve a dilemma. And yet we must believe that defeat has been staved off, or held at bay. Even the *New Spirit in Painting* exhibition at the Royal Academy in 1981 did not manage, with its cack-handed or even handed kindness, to do irreparable damage.

William Tillyer was still in the shadows through the eighties and nineties. Put differently, he was working better than ever before, and he was not alone. In Germany Gerhard Richter was attempting to keep paint on canvas alive and urgent for a new century. There were others. But for me, it was the obscure Englishman miles from a metropolis who understood the dilemmas – as well if not better.

Were you to write Tillyer into the story of art at this point – in the same conversation as Smith and Denny & Co. – it would be too weird and disturbing, because there is no reception history. It would be like airbrushing someone into a photograph, even if Tillyer had been airbrushed out of the photograph in the first place. His absence has been a comfort to many, his presence would be disruptive, for the larger story of reception would have to be dismantled.

All that was silly and superficial and naively cynical from sixties London continued to percolate long afterwards, and has contributed to what we are left with today. Those who made an effort to dig deeper — Bacon, Freud, Auerbach — let themselves down, though Kossoff held his ground. So society got the art it deserved, as they say, which ushered in the shallower and infinitely more knowing art that reigns today, the hall of mirrors in which we wander.

Lonely are the brave

When I spent time researching colour theory in the library of the British Museum, in the mid-sixties, I found that the most inspiring writing on the subject was not by Johannes Itten or Joseph Albers, those Bauhaus teachers, or even by Kandinsky, but by Johann Wolfgang von Goethe. Even today, in little Britain, when I am wrestling with the notion of excellence — this painting, not that painting — I find myself turning to the great German. He always seems ahead. 'Only after some years will it be possible to have a conception of that new art entity which is being founded in Paris.' This was in 1798, a century before it became a truism.

At that point in my life I was writing a novel about an artist in the making, whose hero or anti-hero dreams of abstract paintings in the sky, hanging there larger than life, larger than possibility. This was before Jules Olitski attempted those very paintings. And anyway I had never heard of Olitski, a very considerable artist, though I would come to know him well a few short years later as his world dealer.

It may seem fanciful to place such international stars as Olitski alongside William Tillyer, whose artistic premise is as modest as Constable's. But humility can lead to greatness. Art feeds off many things – including disaffection with art. It was Gerhard Richter who said, 'Painting pictures is pure idiocy.' Cutting-edge sixties Americans such as Dan Flavin, Robert Morris, Larry Bell, Sol LeWitt and Donald Judd — the last great theorist and artist — abandoned painting for activities which might be termed post-painting. Boxes in the desert air, an austerity which courts disaster. In the story of art the centre and the margins are always trading places, and it is hard to know which is which.

There is art, and there is world art, and there is art world art, but only art world art says 'you had better like this, or you are in the wrong place.' A few practitioners from that period remained loyal to making a picture, and Tillyer has left himself with more chances than most for greatness, with his innocent eye, his openness to an abstraction that is neither abstract nor figurative, something visible only from the vantage of obscurity. It is uncomfortable to be in the wrong place, but this may in the end be the only place from which to act.

Tillyer, like all grown-ups, may be weary of the world, but he leaves his cynicism on the other side of his studio door. While cutting themselves off from their own past, artists like Stella must keep on telling us what they have left out. Tillyer, by

allowing everything in, may yet have the answer for a tomorrow of possibilities in the sphere of paint. Nor has he cut himself off by resorting to a winning formula and painting endless variations of it. He has never brooked the challenge of painting a picture unlike any that he had made before. He has no interest in marking time, because he is too busy searching.

William Tillyer might have become a shopkeeper, like his father. He might have been miserable but reliable, working for Middlesbrough Council or in one of the many local factories. He might have embraced either of the two alternative destinies that he saw as possibly lying ahead of him, farmer or monk. But the case was otherwise, or rather the calling was otherwise.

Tillyer quarrelled with himself during these decades, and though he never became the farmer or the monk, he has brought aspects of each into the life of a modern artist, a hint of working the land, or of religious community, the taciturn sense of a calling. The art that he makes never tries to cajole the viewer, but simply offers itself for attention. It does not grab you by the collar, but suggests that you may wish to look at this thing more carefully. And in time it wins you over. Tillyer's surfaces beguile and admonish, admonish and beguile.

David Hockney's wonderful works are in the main entertainments, and this may conceal an anxiety – perhaps too needy to keep an audience happy, perhaps too needy of an audience to keep themselves happy. Graham Greene consciously wrote 'entertainments' such as *Our Man In Havana*, *Stamboul Train* and *Travels With My Aunt,* in contrast to his serious and more philosophical fictions like *Brighton Rock* or *The Power and the Glory* or *A Burnt Out Case*. There was a clear division of creative labour. Tillyer may in principle think of his watercolours as entertainments, and of his paintings or sculptures as more philosophically engaged. But he has crossed and re-crossed these borders often in the past twenty to thirty years. A watercolour may become loaded with secret meaning. A painting may veer into lightheartedness or whimsy or caprice. It is a sign of his maturity as an artist that he has the confidence to break down barriers within his work, to disrespect genres as barriers.

For the flow of ideas, inventions and images is indeed seamless. They grow in groups and then mutate from one group or series to the next, without repetition. I was lucky enough to witness a similar chain reaction occurring in the work of Bob Rauschenberg, although the ideas and images repeat themselves, and have a

certain unexamined thinness which no longer holds my attention. With Tillyer the river in spate is also being closely and constantly monitored.

Partly he is held accountable by the variousness of what is out there. He notices the leaves on trees, the angular shapes of buildings against deep foliage, the rolling outlines of moors, red hedges, yellow fields, the round air. He sees greens in a hundred shades, and blues, the numberless varieties of cloud formations, the animals at pasture, even if he does not include them. Or he finds his own purposes confirmed by the compact marvel of the Kachina dolls of America's South West, packed with the significance of the Hopi people's relation to animals, to crops, hunting, birds, medicine. His art remembers a single tree in Yorkshire or a single cactus in Australia. Or a vintage Mustang, that was once mine and then his and eventually became a wonderful etching. Small things and big things, observed under conditions of anonymity, as if to be seen would falsify his connection to what he sees, whether natural or man-made.

The herd of independent minds

A few years ago I took time out to write a book on the American artist Robert Motherwell. Its premise was that he was possibly the greatest figure of the movement now referred to as Abstract Expressionism, or, as he himself more wisely named it, the New York School. But people do not enjoy a change of view, they prefer the comfort of what has been decided on their behalf. The world of art – now truly a microcosm of the wider world in which we live out our lives – is content with the status quo, to leaving things just where they were. And this is a form of forgetting.

So a situation has evolved where the reception of art is split in two. The first part is the art world, which has made some fairly debatable decisions about modern art, especially contemporary art. There is plenty of sanity and scholarship around, but perhaps now is the time for overhaul, for a fresh viewing of the works themselves. The status quo tells us that within a few years of Henri Matisse and Pablo Picasso, in the early decades of the twentieth century, three courageous visionaries appeared, the Dutchman Piet Mondrian, and the Russians Wassily Kandinsky and Kazimir Malevich. And a fourth, the Frenchman Marcel Duchamp. Of course there were others. But these four are said to have paved the way for art and its possibilities after Picasso and Matisse.

I too was swept along by the logic of this argument, the vision of these masters. Today, I look at their works, in museums, in galleries, in books, and occasionally on the walls of collectors, and I am no longer so certain. I admire their bravery, against all odds, in Paris, in Belgium, in Moscow, in Holland. I believe that they were indeed visionaries and teachers who managed to blow so many old and accepted ideas out of the water. But were they themselves great artists? If so, I don't really love the actual paintings and sculptures as much as I ought.

The uncomfortable feeling that one has to let Kandinsky go, that his pictures are to be admired rather than loved, and the same for Malevich, and for Mondrian. The end of the affair.

I mentioned before that there was a split. On the one hand the art curators, the dealers, the experts and authorities. And then there are the rest, which includes everybody who does not give endless thought to modern art, with its rhetoric and its arguments, but takes for granted that continuity must matter in this as in every other sphere of human activity.

William Tillyer believes completely in these founding figures, considers them the cornerstone of his practice as an artist, but in many respects he belongs on the other side, with the assumption that great art may be ahead of its time, but should in the fullness of time sit comfortably with the art of an earlier age. He believes, with T. S. Eliot, that no artist has his complete meaning alone, and that 'the past should be altered by the present as much as the present is directed by the past.'

It is a magical thought, but it takes a lifetime to absorb and accept it into our lives. Without Picasso, Matisse, Mondrian, Malevich and Kandinsky, Tillyer's work simply would not exist in its current form. But Tillyer is steeped in tradition, and this is perhaps why his time has not yet arrived.

* * *

The wonderful parties and previews and private openings at the Castelli and Emmerich galleries in the sixties and seventies and eighties, where celebrities would mingle with art world intellectuals and artists. That was long ago and the sifting of talent carries on. A few of those names may yet be mentioned in the same breath as Picasso and Matisse. If not, at least the parties were great. Gatsby's parties were better, but that was fiction. Perhaps the Castelli and Emmerich parties were actually fictions too.

I wonder which late twentieth-century artist would benefit from his own museum, for whom a dedicated museum would create a new and permanent audience. Some artists have them already, for instance Clyfford Still, or Fernand Léger or Victor Vasarely, though these delphic shrines – like all shrines – seem to raise more questions than they answer. Frank Stella could possibly sustain the challenge of a solo museum. A museum dedicated to the work of David Hockney could look joyful, and the populace would adore it. Henry Moore would look wonderful. I cannot envisage a John Hoyland museum, or a museum of Robyn Denny, or Patrick Caulfield. In fact, the idea of an entire museum devoted to any artist from the second half of the twentieth century is daunting, for the art as much as for the audience. I feel confident that when William Tillyer comes to his final days he would survive a museum devoted entirely to his own work and it would look magnificent.

Once the herd of independent minds has moved on to its own eternal pastures, the pictures have to survive on their own, for an audience with no vested interest

in the artist's posthumous reputation. It is still an extraordinary experience to wander the rooms of the Van Gogh museum in Amsterdam, or the Picasso museums in Paris and Barcelona and Antibes and Malaga, to stop and stare at painting after painting.

If a movie can no longer find an audience, the distributors take it off their stocks. If a book cannot find a readership, the publisher lets it go out of print. To convince music lovers that a composer is still worth hearing, a promoter may need to fill a concert hall. A dealer can claim that an artist is still relevant merely by finding a collector or two to keep the reputation alive. But in time the artist will be judged by a different or indifferent posterity. And if a museum wants to take an artist out of circulation they will simply put the works in storage. It is just a matter of time. And time, again, is the greatest critic.

If I have been harsh on what was produced in the twentieth century after Picasso and Matisse, it is because I consider that these giants have been let down or even cheated by what came afterwards, with notable exceptions. Always the optimist, I would like to think that there will be a new art, a new vision founded on the rock of a thousand years of making images.

England is a difficult place in which to make advanced art, and it seems less and less clear that there was an English avant-garde. The reasons for which are even less clear. It might come down to the fact that the English tend to be wary of the new, or — which is the same thing — un-shocked by the new. There will always be attractive views of leafy country lanes, or glorious vases and flowers, or pictures of animals, especially domestic varieties. These pictures can be seen in small and friendly galleries up and down the country. Resistance to the new has a lot to do with the English hating to be made fools of, so that an image which breaches the proprieties of colour and form seems like a joke, probably at the viewer's expense. Then there is the English love of rank and order, and rank has rarely embraced the new. Or it could be a memory of the Reformation, in the sixteenth and seventeenth centuries, when unforgivable things were done to those who preferred not to embrace radical change. After which a moderate consensus prevailed and the English knuckled down to a century of convalescence, reinventing themselves as a polite and commercial people, and then as an Empire, in which everyone spoke English and there was no need any longer to accommodate strangeness. Or it could be all of the above.

So we feel more comfortable with a painter like Van Dyck in the sixteenth century — or Lucian Freud in the twentieth. You know what you are getting. Good, solid painting, where you can see what's what and get to grips with a subject on canvas. Most of the early modernist British painters were born with a blind faith in all things French, and French trust in the visible, from Poussin and Chardin and Claude onwards. They only foundered in their loyalty when America took over in the forties.

So, in England now, to make an art that goes against tried and tested values requires a rank outsider.

William Tillyer has no quarrel with these thorny questions and in fact comes across as oblivious to the whole business. But he finds distance a useful asset and carries on searching and experimenting, looking and learning, studying and absorbing, keeping himself to himself, a lone figure molding science and poetry awkwardly into art.

* * *

Then there is the issue of art and social class, art and pretension. I knew Howard Hodgkin, an extremely successful artist, critically and financially, who would hold his hands up in space to frame a square, to suggest a possible composition, but also to convey his aesthetic and intellectual credentials. I didn't see him for a few years, so maybe he stopped making that aerial gesture. Besides he had no need of it, for his art would sell faster than he could produce it. On the other hand, Francis Bacon was completely unpretentious, so is Leon Kossoff, and so in all fairness was Lucian Freud. I never saw one drop of pretentiousness in David Hockney. Or in Henry Moore, though this goes without saying. Or in Robyn Denny and Richard Smith, who had no time and no desire to play the role of artist. Or in William Tillyer, although he slightly overdoes the simpleton bit, a little like Paul Cézanne. But this is their trademark as authentic outsiders, even if I do get frustrated when Willi pretends not to get things. It matters to him, so I accept it. Cézanne was far worse, and would have driven me crazy. That was a different era though, Willi!

Very often William Tillyer and I have different opinions and views. Often he will introduce me to a new name or a new idea. More often than not I am delighted by the suggestion and it lodges in my mind. It may be a name I know, but to which evidently I have not paid sufficient attention. It would be nice to think things could work the other way around, and I could propose things to Tillyer that took root. For instance my passion for Delius is something that Willi is unpersuaded by. Well, if Delius were alive today he might not love the paintings of William Tillyer. There are universals, but taste is not one of them. In fact, of late, Willi has begun to cherish the music of Delius, or at least has gone so far as to make a series of watercolours in response to it.

With Tillyer there is a kind of dissenting taste in play. In his art and its ethos there is perhaps a memory trace of the Industrial Revolution, or a memory of the Crystal Palace exhibition of 1851? He was raised in the cradle of English industry, after all, and Middlesbrough was a frontier town. His father's world of hardware – string, wire, hinges, handles – was steeped in manufacturing. His grandfather was an engineer who worked on the Forth Rail Bridge. Besides, there are Huguenot forbears, and a strain of non-conformism and reserve, well suited to a landscape of hard-worked rivers and iron hills. Hockney is working class, but Willi is middle class, from artisan stock, which of course connects him to the radical tradition.

Like William Blake he is a printmaker, an etcher, a self-reliant spirit on the edge of things, and a visionary. His landscape echoes with past visions of England, its hermitages in parkland as much as its bridges over canals. When I first encountered Tillyer, in 1969, it did not cross my mind to think of John Constable. Nor throughout the seventies, even though he had contributed to a portfolio that I published to commemorate Constable's centenary, which was launched at the Tate Gallery. In retrospect, the dozen or so watercolours, with their resplendent green alongside their darker and more ominous greens, the honesty and directness and lyricism, all of this had the feel of Constable.

But this did not occur to me, and many other names came to mind for inclusion in the great lineage of British art in advance of the name Tillyer. By the nineties, after the massive exhibition at Wildenstein Gallery in Bond Street and other exhibitions in Europe and America, I began to see the possibility of Tillyer being counted among the greats, although privately I already counted him. The nineties only proved to me that he was a great original, in terms of skill, originality, aesthetic ambition, feeling for light and colour and composition. But this would still have seemed far-fetched, when one thought of the other contenders. When the new century arrived I could look back on a half century of his work, and trace the slow and steady progress — slow in terms of Picasso and Matisse, but rapid if compared to his contemporaries in Britain. And as they slowed down he began to begin to pace ahead, like a wiry long distance runner. He is of slight build, but as tough and practical a Yorkshireman as you are likely to come across. He had a lot of ground to cover and a lot to prove, to himself and, just possibly, to the art world. The hundred paintings he produced at the start of the new century, the *Hardware* series, made up my mind. The title a fierce nod to his father, the work itself a lexicon, an anthology of his concerns, of all he had achieved and of what he planned to achieve.

Crooked Art Dealers

The most effective dealers are the crooked dealers, because they know that nobody actually needs art – they own this basic truth. As Robert Hughes remarked, 'In art, a fair price is what you think you can get. Every dealer observes this rule', though some have pushed it too far. Frank Lloyd, for example, whose motto was, 'I collect money, not art.' I loved Lloyd and he liked me too.

The greatest or at least the most successful art dealers of the last century were probably Joseph Duveen and Frank Lloyd. Duveen realised a simple fact, or two simple facts. In America there was a lot of money in private hands, and in Europe there was a lot of art in private hands. Through the services of Duveen the two shook hands, and Art crossed the Atlantic. As the American tycoons died, their collections were bequeathed to public galleries, providing donors with immortality – the Andrew Mellon collection in Washington's National Gallery of Art is the representative example. From which we are all the beneficiaries.

So successful was Duveen, between the wars, that when Frank Lloyd opened his first art gallery in London in 1946 there were only slim pickings left. Moreover governments in Europe were now passing laws to restrict the export of old masters in private hands. So Lloyd invented the idea of 'modern masters', of which there was of course a limitless supply. His parents were antique dealers in Vienna and died in the camps, which perhaps taught him his chutzpah and his awe of expediency. When the Germans annexed Austria in 1938 he moved to France, then to Britain, changing his name from Franz Kurt Levai to Frank Lloyd, because he held an account with Lloyds Bank. After the war he founded his gallery, dealing in Modern British art, and called it Marlborough, because the name sounded grand enough.

By now New York was taking over from Paris as the financial centre of art, and in 1963 Lloyd opened a gallery on Madison Avenue and 57th Street. The new art machine was in motion, and New York artists became the new trophies of the rich. Among Lloyd's painters was Mark Rothko, who was to make him famous, or rather infamous. When Rothko died in 1970 he left behind nearly 800 paintings. All of which were in the possession of the Marlborough gallery. In 1971, Rothko's daughter Kate sued the executors of her father's will, claiming that they had disposed of his paintings to Marlborough for substantially less than their worth, for strategic reasons and financial gain. A hundred of them had been sold for a mere

$1.8m. Others were sold by the gallery for a high commission. The case lasted eight months, and revealed for the first time the financial workings of the new art market.

The case was lost and the liable parties – Lloyd, the Rothko executors, the gallery – were ordered to pay more than $9m in damages and fines. An appeal failed. Later it transpired that Lloyd had continued to sell some of the paintings despite a court order forbidding a sale, and had tampered with the gallery's books to cover up the deals.

The point of the story, perhaps, is that the Rothko Affair did so little lasting damage to Marlborough – which remains one of the world's biggest art dealers – or even to Lloyd, who was let off instead of going to prison, and went into tax exile in the Bahamas. In other words, the art market proved itself once and for all to be impervious to scandal. In fact the art market thrived on scandal, and this has remained the case.

In its prime, the system worked and still works as a pas de deux between savvy dealer and savvy artist. Honourable dealing only makes both parties disappointed, with a sense of being left behind. The New York dealer, Michel Cohen, who traded heavily in Sam Francis, Joan Miró and many others, had a terrific eye, oozed style and panache, and happened to love the work of William Tillyer. He wanted to work with me, but I was uneasy about the idea, however attractive and suave and glamorous a fellow Michel was. I avoided the issue. A year or two later Michel ended up in jail, although he managed afterwards to escape from a prison ambulance, and decades afterwards is still at large in Cuba or Brazil. No one really knows.

There are artists who fake themselves, there are genuine fakes, and there are dealers who are fakes. But being a crook is by no means inconsistent with having a genuine eye, and a genuine love of art. This is the conundrum. Once I was taken for dinner by Doug Christmas, whose reputation always preceded him. He too had a great eye, the largest gallery in New York and the largest gallery in Los Angeles. His reputation for shadiness was inseparable from his reputation for discernment. Over dinner in Chicago, where we both happened to be at the time, he said he wanted to show William Tillyer. Again I was flattered and again I shied away. I knew the story, the stylishly dressed gallery owner with the divining rod, but I also knew the reputation, the dealer who never pays his bills.

One day Sam Francis and I drove to Sam's Los Angeles gallery, and he walked out with various works of art under his arm, quite openly. I was young and a bit speechless. Sam later explained that Doug owed him money and this was the only way he could get it out of him. Sam was as savvy as any dealer, and knew how to look after himself. Ed Ruscha also knew how to look after himself. He once told me how he went into the great Alexander Iola's gallery and demanded payment at gun point.

The more mysterious and suave the dealer, the more success comes the way of the artist. None of this was Tillyer's style, or my style, but we had our moments. My friend Bjorn Bengtsson never had a gallery of his own, although he sold more art than any other Scandinavian gallery owner. He admired Tillyer and in the seventies and in the eighties he would sell literally truckloads of Tillyers. Leading up to the collapse of the market in 1990, the Scandinavians and Japanese were buying art by the yard. I was slightly involved with some of those Scandinavians and, to put it mildly, they liked complicated arrangements. A short and stocky Swede with boundless energy, Bengtsson placed Tillyers with the grandest galleries throughout that vast region, and would also sell directly to the most glamorous clients, like ABBA or the chairman of Volvo. I always felt that this human barrel of dynamism had the whole place sewn up, and it was our good fortune that he loved Willi's work. One summer he handed over his stylish holiday home — a jutting red roof in a Scandinavian landscape — to Tillyer, who in turn produced a large series of watercolours and paintings.

Bjorn was a true maverick, and, like virtually all of us in the art business, was in deep trouble in the early nineties, having a terrible time with his bank. He was a trained and qualified lawyer. I told him not to take on the banks because they will always win, but he went into battle and died of a heart attack afterwards. A good man, a romantic figure and an art-world original. All of the great art dealers sailed close to the wind. Willi was not of the right temperament for those brigands, so success had to wait, and sometimes waiting is the better part of valour, artistically if not financially.

The price of everything

The intellectual and analytical part of his mind is constantly working away, among the yellow cornfields and the purple heather.

Art is part of the world. What has happened to the world in the past thirty years — the worlds of medicine, travel, banking, cooking, sex, terrorism, science, snooker, robbery, politics, tourism, eating in and out, religion, music, literature — all of this has also happened to art. And all of it is legitimately art's province.

In Piero or Poussin or Rembrandt you can feel the weight of belief, in the canvas, in the paint, something that travels from the maker to the viewer. Even if you are not a quattrocento Christian, you can feel the authenticity of the subject-matter. Today we have to believe in something else, in what Kundera called 'the unbearable lightness of being'. But even in this dispensation there is a difference between a truthful and an untruthful depiction of the human condition.

As people became richer and poorer and the world became more globalised and flattened, as time itself both shrank and expanded, the recondite hobby of fine art had to keep up. All endeavour became compartmentalised and the notion of the universal genius disappeared, or went into hiding. Piero della Francesca is replaced by Jeff Koons. The solitary figure retained by a duke in the remote fastness of Umbria becomes the metropolitan aesthete, the knowing practitioner, an autonomous player who constructs shrines to money rather than to his patron or his God. Not entirely autonomous, of course. As Piero needed Giotto, Koons needed Warhol. But whereas Piero's patrons were not about to put his paintings on the art market, now or at any future date, the Koons collectors are gamblers, speed merchants. Warhol, a true artist, may have depicted commodity, but he did not really grasp or envisage total commodification. Nor did the original collectors of Warhol in the sixties envisage such a world. The Koons crowd on the other hand know the score from the start – they have built obsolescence into their very sense of things – and Koons is of course a former Wall Street trader, the ideal apprenticeship for a contemporary artist.

Piero and Koons are merely convenient names for two camps. The Renaissance maker had to deal with avaricious popes and bankers and their idiosyncrasies, whereas the modern artist has as his potential patron the entire planet, which is heating up while we watch and sit back and wait for whatever gargantuan moves happen next, for better or worse.

We are all in this together. And if we know the value of everything we know the meaning of nothing. And this knowledge we share strangely separates us rather than joining us together.

So back to the pastime of art making and art viewing and art buying. It is not the global geniuses of New York, Tokyo, Beijing, London, Los Angeles and Mumbai — whose gigantic ideas are the same idea — but a lonely figure in the middle of the landscape in Yorkshire in England who actually has the big ideas, because at this point only the local has a chance of being universal. In more recent times it took the curmudgeonly and tragic bourgeois peasant, Cézanne, to split the art atom. Or his disciple Henri Matisse, similarly alone, in the lotus-eating forgetfulness of the Baie des Anges in Nice. Or perhaps his disciple Robert Motherwell in his solitary nocturnal studio in Cape Cod, just a few hours from New York. The loners are the real legislators, travelling incognito. Far away from the city and the agora or marketplace, these agoraphobes avoid the trap of friends and colleagues and sponsors. Even our very own local hero, John Constable, sitting and painting the River Stour in the early nineteenth century, inspired by a small river but one that he knew and loved with deep passion, was able to make the small into something truly momentous.

The Momart Fire, 2005

In 2005 the Momart fine art warehouse burnt down. A great event, a great act of art criticism on the part of the fire. At first a complete shock to the system. We knew that these things were fragile, but were they perhaps also expendable? My fears that I might have lost all of those large scale works by Stella and Tillyer. Then the damage report, a devastation for all concerned. The loss of such wonderful art by Willi, though I was cheered by what I would make on the insurance of all those giant Stellas, those melting metal indulgences. It made me think about what I really value for myself, for its own sake. It opened up unusual perspectives on how honest with myself I had been and could be and should be. How much art can we do without? And a new perspective on which art ought to sell and which art ought not to sell. And how I too had been cheating, even if I preferred to occupy the high moral ground. And for some reason I remembered Socrates, when he was told that a certain man had not been improved by travel, replying, 'I am not surprised, for he brought himself along.'

So who had been improved by art? Not me. Nor the collectors – despite the accumulation of wealth – not the artists, who over several decades had been hardened by the market and by the guesswork and second guessing of purely formalist considerations. The Tillyer paintings, a failure in the art world, were to me a success in the world of art. Which is why I felt the loss of his art to the fire so bitterly.

Conviction is not everything. Both Stella and Tillyer are convinced of their art, but Tillyer is humbled by the fact. When Frank would go into his studio, full of assistants, he would be partially protected from the anxiety, but Willi's studio is the seat of anxiety. If Propertius was right when he said 'let each man choose the road he should take', then Frank may well have taken the right road. Willi definitely did. But the wealth question was cast into a lurid new light by the great art bonfire.

For William Tillyer, art making is natural and it will always continue, as long as you can get a stick and make marks in the sand. And each and every work produced by Tillyer is meaningful to him and close to his heart. When I explained to him that we had lost *Urban Dream Fallen Star* in the fire he showed no emotion and took a very stoical position on it. If I was pained by this loss, I had some insight into his loss, though he showed no feelings at the time.

* * *

There are so many theories and suggestions as to when the first work of art was made. Some suggest the sticks of ochre engraved in Blombos cave in South Africa 75,000 years ago. Others rhapsodize about the painted pebbles of the great caves of Mas-d'Azil, in the Ariège, from the Franco-Cantabrian region, in the Mesolithic period. The great British Museum exhibition of *Ice Age Art* in 2012 seemed to suggest dizzyingly that the first works of art were made by animals, rather than hominids, and using animal materials such as bone, horn, hide. Whatever the case, it was a very long time ago, and is all very interesting.

As to helping us with the great questions of art, however, the obsession with origins seems like irrelevant conjecture, although it is probably sacrilegious to say so, as far as the serried ranks of historians and archaeologists are concerned. Be that as it may, if we fast forward to the thirteenth century, at the portal of the Renaissance, we start to look at works which can be dated accurately, and that are signed by their makers. They of course were looking back to Ancient Greece and Rome for their inspiration and standards. Great art never appears out of thin air. The Renaissance artists came from the Romans, who came from the Greeks, and further back the mists seem, well, misty.

Those masters from Italy and France and Germany and Flanders produced the Renaissance, which in turn produced Poussin and Cézanne and Matisse, who in turn produced William Tillyer. The meaning of a work of art is always another work of art. It is a two-way process. The modern artist has to absorb and use all of what came before.

* * *

The Warhols seemed 'right' in the New York of the sixties and seventies, just as Meissonnier and Bouguereau seemed right in the Paris of the 1860s and 1870s, just as John Bratby looked right in the London of the fifties. It seems as if the permanent artists are those who looked 'wrong' in their time, out of joint. Sometimes the fashionable artists of the day disappear and then return, at a later date, but usually as curiosities. It is not the case really that Tillyer doesn't look 'right' yet, constructing a visual language that may be ahead of its time, but it is certainly the case that the art establishment has decided he looks wrong in his own time. If it is cruel that a great artist has been excluded from the story of modern art, it is wonderful to know that he will be given his place in the pantheon, all in good time.

The galleries and exhibitions and museums are packed. Nevertheless, it would be interesting to know the proportion of British society with an interest in art, let alone modern art, or contemporary art, the art of their time. It would be interesting to know what the artist truly thinks of his position in society. More than most successful artists, William Tillyer lives in the world beyond the gallery system. Does he feel that he connects with more than the few? Does he dream of a bigger audience? Does he feel that art will matter in the new century? Is he tempted to try and make an art that would have a far wider appeal, like Hockney or Lowry? Does he have strong thoughts or views on these subject, or is he happy to work with what is there?

It is easier to be considered a failure in your own lifetime. The road downhill from a place of high recognition is harsher than the laborious climb towards recognition. Better the artist with his passions full and his bank balance empty than the other way round.

* * *

If Constable was indeed a scientist, as he said he was – and as I believe he was – then William Tillyer is a scientist too. And scientists share their ideas, as poor people share food. As the rich man does not have enough money to share, so today the famous and successful artists do not have enough ideas to share with their community. To remain a famous artist is to keep fellow artists at bay. Any small idea he may stumble upon he hides away in the crypt of his castle, until he has used it up, squeezed it dry and painted it out.

All Vincent van Gogh ever desired was a community of artists in Arles, though he had to make do instead with Paul Gauguin for a few tempestuous weeks. So too, the Bauhaus artists wanted to share an aesthetic ideal which was also an idea about living. As small steps grew to giant strides with the Impressionists, their ideas and practices were discussed and explored in common, and the result was a great moment, an explosion, in its way as large as Rutherford's. So big that it fed into the future of art and still reverberates today. And again, half a century afterwards, another group of artists in Manhattan would share their discoveries and passions, however disparate they actually were, no matter how much they fought and bickered. And the Abstract Expressionist idea gave birth to yet another aesthetic moment, which resonates till this day. None of these groups were to receive fame and fortune in the heat of the moment, because these things, these

ratifications were irrelevant to what they were looking for or trying to achieve. What mattered was to keep the conversation going.

It is lonely to be brave, it is brave to be lonely, and sometimes entire groups were lonely together, their doings blissfully unacknowledged.

* * *

At different times modernism has been banished as a word, as has the debate, Did Modernism Fail? Possibly by the twenty-second century we will be asking, Did Modernism Exist? It certainly did not exist in certain totalitarian states in the twentieth century. It certainly existed in so far as it produced giants like Mondrian, Kandinsky and Malevich. Without whom Tillyer would have had a tougher road to travel. But too many artists clung to it from the sixties onwards, like a safety belt or a lifejacket in choppy seas. A safety belt helps the production of good art, possibly, but to throw it away allows the possibility of greatness.

The mid to the late twentieth century art thinkers created a place for art to hide, a corner of world culture in which to sit comfortably, an armchair from which to pontificate and profit. But there are different kinds of hiding and different sorts of secrecy. There are artists who hide as their only way of giving, like Cézanne. And then there is hiding the little you have, hiding the little you have from each other.

What began as a war with the bourgeois mind, coming on the heels of Romanticism, ended as a safe haven for professional artists. In reaction to Modernism, figuration had a field day in the late years of the twentieth century and early years of the present century.

Tillyer watched all of this, with his innocent eye, and understood that neither camp had the right answers, and so he kept travelling to the next inn. The post-modernists did not approve, or trust his integrity, and the general public had no blueprint for the jarring atoms of his art, where landscape sits comfortably with abstract form.

Perhaps the greatest artist America has so far produced, Robert Motherwell, understood eventually that enough was not enough – that what his friend Piet Mondrian was then producing in New York would not get us there. Motherwell needed more. The art world continues to revere the great Dutch expatriate for

his austere transactions of horizontal and vertical lines on a field of primary colours. These precious and fragile works from the 1910s to the 1940s remain a touchstone, and the art world speaks of them in hallowed halls and in hushed tones. Mondrian has been joined by Malevich and Kandinsky, as icons looking down on the unholy world of contemporary art.

William Tillyer counts himself among their admirers, and draws inspiration from them even today, as from the great prankster Marcel Duchamp. But as another great modernist, T.S. Eliot, said 'we shall often find that not only the best, but the most individual parts of a poet's work, may be those in which the dead poets, his ancestors, assert their immortality most vigorously'. Willi is as comforted by the presence of Piero della Francesca and Cézanne as Eliot was comforted by the company of Dante, and as Dante was comforted by the presence of Virgil on his journey through the underworld. But most of his contemporaries have misunderstood modernism in this crucial respect. They think that killing off the fathers will somehow make room for the great entrance of the new.

We should all give two cheers for Britain's figurative painters, from Bacon to Auerbach, who took on the mighty Europeans and Americans, and also for those idealistic spirits — from Ben Nicholson to Robyn Denny and Richard Smith — who persevered with their local produce, but we should give three cheers for the outsider William Tillyer, who walked a lonely path towards a visionary goal, which could be baldly stated as 'from Piero to Tomorrow'. And while they become increasingly tamed by Time, his pictures are opening new doors.

The third cheer is for looking backwards and forwards. What he added to the story of modern art, is something that his hugely successful and more famous colleagues on the international map, artists such as those humanists, Stella and Richter, were unable to bring to the story. An imagery that breathes humanity, rather than formalism and glamour and sensation, paradoxically by bringing a natural order back into the manifold artifices of art.

* * *

You come off the A20 autoroute, three quarters of the way from Paris towards the Euro Tunnel at Calais. You drive through a couple of tiny villages and across a few miles of verdant green fields, fallow land, sheep and horses and cattle standing quietly. It is peaceful and beautiful, and flat. Willi used to take his grandmother

there once a year, to the corner of a foreign field where her husband lies, along with thousands upon thousands of other soldiers who gave their lives to Europe after 1914. You pass the multitude of graves which stand there like a frozen white army. Willi learnt about pain and loss from his grandmother, with the hovering and answerless question, is there an art to equal this? William Tillyer has devoted sixty-five years of his life to producing an art which makes no effort to record the pain of those endless fields. That is not his job, but it is the backing to his mirror. And his own art draws its honesty from this sense of art's limitations.

He spends his day working, which is why he has no career, you might say. He is always somewhere else, not with you. He is walking around with it in his head. No meetings, no selling of ideas for a show, no status and no standing. He is a reluctant iconoclast, unwittingly accusing, sometimes infuriatingly opaque.

William gave up the Christian religion in his early teens, at around the same age as I gave up the Jewish religion. I continue to be religious with a small 'r', and I am convinced that he too is religious with a small 'r', though he will not be drawn on the subject. I sense a strong religious impulse in his way of being, and in his work. For me this is a dimension of his art, and one that is completely lacking in nearly all of his contemporaries, whose work falls either into formalism on the one hand or illustration on the other. Both of which render the viewer passive, whereas here you must search, as the image itself searches.

The formal religion of his early years has been replaced by a spiritual force that drives his entire work, though again he would resist this idea, or at least resist any of the formulas one might find for describing it. But it is there all right, and he leaves it to others to wrestle with the terminology. It might be easier to describe in secular and holistic terms, such as you sense when you walk with him across the heather and the rough shrubbiness of the North York Moors. He equally denies that his art serves any ecological agenda, but the paintings are redolent of a sense of threatened place. Ecology was originally a kind of extension of Darwinian theory, resolutely secular, yet based on a sense of the natural order which can be accessed only through an act of faith. And so, the Gaia Theory, which has long interested Tillyer the man and Tillyer the artist, is a belief in a self-regulating system, at once manifest and transcendent. So Willi treats the land with corresponding care, and it communicates back to him the conviction of an overarching meaning, which in turn enters the paintings. It might be described as the sense of time translated and rendered as a sense of space. This is a challenge

to our belief in time as of the essence, to which he offers an alternative, if you can afford to slow down and look for a while. Just as it is worth taking time out, to be with Constable on his River Stour, so too with Tillyer on his River Esk.

A fairly senior person from the Tate Gallery was in my room one day. We were having a leisurely coffee and chat. He had been staring at the Tillyer painting on the wall facing him and finally asked me to explain it to him. 'No', I replied.

William Tillyer paints things you cannot see and then, one day, you see them.

Many of Tillyer's discoveries have found a willing market, the work of a moment catching the mood, but he cannot differentiate between 'saleable' and 'unsaleable'. They just work for him, and he will move on when the time is right for him and for him alone.

David Hockney is always entirely convincing about his passion for his newest work. In fact he can be convincing over and over again, and you are convinced. The charm and charisma are contagious. The store of conviction is apparently limitless. David is like the man who will fall in love with a new girl every year and convince us that this one is the realest thing, the love of his life, the best and most beautiful. He is a serial monogamist.

I thought, why not choose an easier subject for a book? Hockney for example, only too happy to help you with glittering insights as to why his art speaks to others. Or Howard Hodgkin, the delicate skein of whose dreams and memories, transmuted into beguiling images, can be transcribed and written down. Or Frank Auerbach, whose purple passages of thick paint attempt to transfer angst and deep emotion of all kinds, an entire autobiography committed to canvas in thick impasto, all of which can be described. But I suppose that was the whole point for me – to wrestle with an absent subject, the drama of which would interest me, if no one else.

'I work obstinately, and once in a while I catch a glimpse of the Promised Land.' – Paul Cézanne

I always picture William Tillyer's unworldliness as a place, a Yorkshire of the mind. A physical but also imaginary device, such as Cézanne was also marvellous at creating. Yorkshire – Aix en Provence – the River Esk. At some level Tillyer's unworldliness must connect to his not inconsiderable worldliness. The stranded Huguenot is intriguingly at odds with the lover of fast cars, from the Ford Mustang of his thirties to the Porsches of his eighties. The connoisseur of modern architecture, modern music, modern furniture. In fact, in many ways, he is the most worldly person imaginable, but it is his private affair. Worldly people usually need to tell the world how much they love it. They need to be reassured about their worldliness. That's how you get the showiness. But the idea of a secret love of the world, a love that dare not speak its name, is another matter.

Self-effacement is not the best road for making a career, but here again, in his case it is not a career but a journey – an older meaning of the word 'career' – where the scientist and the poet travel together as one. There were the youthful landscapes, the pared-down expression of Yorkshire walks and experiences. But this experiential way with paint on canvas was shortly to be reversed by the 'conceptual' works of the sixties. It is unusual to start your journey as a conceptualist, rather than arrive at it as a later and more distilled phase in your work.

Moreover, William Tillyer never left conceptualism behind, even in the most Romantic or glamorous of his images. Whenever he returns to the sky and its formations, its clouds dropping fatness, there is always as much Duchamp lurking there as there is Constable. The scientist and the poet walk in step, and are looking at the same view. Like Duchamp and like Constable. When you wander over the moors with Tillyer, he may pluck a sprig of heather from the tough earth, and will hold it firmly but considerately in his hand, as if it were a fragile piece of porcelain or Roman glass.

Nobody can tell if he would have shed the unworldliness had he been embraced by a wider art community. Perhaps it was just a ploy, a polite excuse for staying away from city lights and spotlights, so as to appear and disappear at times of his own choosing. Cézanne would go up to Paris, but he loved his Provence. Tillyer will always willingly come down to London, but he loves his Yorkshire, its dales

and moors and coastline, its compact villages, the plain speech of its places and people. The wish to be a painter was always the wish, as he put it, 'to live in that country and as it were to post my work back to London.'

* * *

In my teenage years, I would spend perhaps a hundred hours a week dancing and drinking endless quantities of Coca Cola, with Mary and Carol and Jane. But I had a secret second life. It began with jazz, and I would discreetly acquire every new LP by Dave Brubeck, Miles Davis, John Coltrane, Thelonius Monk, Gerry Mulligan, The Modern Jazz Quartet, Duke Ellington. In the sanctuary of my bedroom, in my parents' house in Willesden, in North West London, I would play these records endlessly, and line them up, face outwards, slowly poring over at the names and the cover art.

All of these LPs came from the same small record shop, along the road from our house, beneath Kilburn tube station. Mr. Hill was the owner, and one day he asked if he could play me a piece of music he thought I would like. He steered me into a back room, turned on the music, then left me alone. It was authentic gospel music, and I drifted off into another world. The music ended, the LP stopped turning. I was mesmerized, and in some sense lost. I went back into the shop and he could see that I was in thrall. I did not buy the record, and nor did he really intend me to buy it.

But a few weeks later he asked me if he could play me something else. Again he switched the turntable on and left the room. It was Frederick Delius, and the music surrounded and washed over the world around me, the life ahead of me. It seemed to have prophetic force, whereas music often induces an obscure nostalgia for an unlived past. Certainly the acoustic world of this reclusive Yorkshireman prepared me for my first encounter with another Yorkshireman, self-effacing and reclusive, who, in time, would make pictures that are for me the visual equivalent of Delius' music.

If Turner at one stage needed to have himself strapped to the mast of a ship to feel the blind energy and terrifying sublimity of the sea, so Tillyer has stayed chained to his theme, his vision, his vocabulary, his subject, his emotions, his art.

John Constable, a self-effacing figure like Tillyer, was on easy terms with his own greatness, but was accepted in his own country only when he was well into his fifties, when the French, led by Delacroix, first acknowledged his greatness. The French painter's formative years were decisively marked by his discovery of Constable, three of whose works were exhibited in the *Salon* of 1824. The revelation of Constable's dashing rapidity, his ability to preserve the freshness of the sketch in the final painting, the wholeness of his response in paint, would help to set French art on a new path which led to the Impressionists.

* * *

One of the problems of British art in our time has been the symbiosis and steady convergence between artist and collector. A new knowingness and professionalism seeped into the work itself, in which the artist must establish a reliable and consistent signature, to supply the wealthy collector's need for art as speculative investment but also as a hedge against uncertainty. Reputations evaporated for those artists who could not establish a stable currency.

Even a talent as prodigious and strong-willed as David Hockney would be distorted by a market which translated the enfant terrible of working class Bradford into an entertainer in classless and weatherless Malibu. The audience has become so powerful that it shapes the art and its surfaces. Howard Hodgkin would have enjoyed this dilemma, but his talent was smaller and his images too obscure for the collecting public, so he had to become a more rarefied art world figure, sophisticated and house trained.

Frank Auerbach took a different approach, a line of greatest resistance, as an isolated producer in his garret, like Achilles sulking in his tent – but handsome and rugged enough for an audience which needed to believe it could tame what was wild. So he saw his paintings rocket in value from the eighties onwards, as this former student of David Bomberg became the reclusive hero, where all that counted was his humble Camden Town studio and an endless supply of tubes of oil paint – a throwback to *La Boheme*, but without the anguish of his former tutor or the bankrupt marginality of his hero Rembrandt. The signature became the work, and as his paintings began to look increasingly turgid, their prices rose and rose.

This state of affairs is a dangerous place for an artist. The more he understands the mentality of the new breed of collector, the more he thinks he will be able to drink from the proffered cup, the cup of fame, wealth and ease. Just for a while, so that he can sleep better and dream better, be courted and respected, indulge his signature talent. Rather than pass on the gift, to sell it instead, for a high price, even if the cost of doing so is not less than everything. They won't notice the difference, he says to himself. They won't see that I'm not there in the paintings anymore. I'll just make the paint thicker, add more yellows and cobalt blues and hot reds. It will be all right. I still believe in myself. Look, that one over there, the big one against the wall, it's as good as anything I've ever done, even in my hot youth.

Koons could be right. The game is up. The West is over. But it will take twenty years or a hundred years for the record to stop spinning. So let's carry on.

* * *

A hundred years ago, an art uniform – the beret – was de rigueur, until it was appropriated by all kinds of intruders. There have been many art uniforms. Van Gogh dressed out of solidarity with the coalminers in the Borinage. Daumier's smock was a sign of solidarity with the dispossessed labouring classes after 1848. Picasso favoured a Breton sailor's striped shirt. Then there was the beatnik look, the bohemian look, the cloak, the cape, the white laboratory coat. Pollock wore lumberjack shirts. Derek Jarman describes how Hockney's dyed blond hair and gold lamé broke not only with the idea of an artist, but with the norms of masculine appearance in the sixties: 'When David dyed his hair blonde, he lit up more than his bathroom mirror. It seems such a small gesture now but then it broke every convention of the ghastly fifties. The grey suits and black shoes, stiff collars and ties, the tight furled umbrellas of the middle classes barely ruffled by the wind of change, a fucked up closet culture where queers were bashed in the tabloids.'

But what is the art uniform of today? The suit and tie, perhaps – Gerhard Richter wears a suit to paint, his brushes handed to him by fastidious assistants. Jeff Koons wears a shiny, tight business suit to strut his stuff as artiste provocateur. The suit is subversive in its own way, ironically insisting that the artist is a new breed of suave professional. But what does the Outsider wear? He has no uniform, because he belongs to no club.

* * *

I cannot think of a single major British artist who has benefited from the luxury of the establishment's blessing in his or her own lifetime. Francis Bacon came close, keeping his distance as a debauched untouchable, though he saw the dangers of success – with his edgy Colony Room toast of 'champagne for my real friends, and real pain for my sham friends' – and I believe that he too was caught up in the treacherous English fog of niceness or sycophancy joined to ignorance. In the interviews with David Sylvester there is a nagging anxiety that, despite all his intelligence and sly resistances, Bacon had been drawn too much into the system. Perhaps Lucian Freud, as big a gambler and hedonist as Bacon, was able to establish a more aristocratic distance, but I don't think he had quite the talent or vision of his former friend. Henry Moore got further away from the pack, of course, though he too, over the course of his long career, would often need the establishment to bless his ambitious sculptural wishes and enable them to become reality.

But Willi had not been given the chance to turn his back on the art world establishment, because it had already turned its back on him. So, with money enough to buy materials and feed himself and family, and enough sustenance in return for his art, he set up as a professional outsider. No poison entering the soul, no corrosive official occasions to attend, he was allowed to walk on the earth without any ball and chain. Even if, as the Roman satirist Persius reminds us, 'You cannot say "I have broken my chains", for a struggling cur may snap the chain, only to escape with a great length of it fixed to his collar.'

Were he now to receive the attention that is rightly his, perhaps his immune system is strong enough to withstand the poison the art establishment administers in controlled doses of carefully measured praise, or in more dangerous doses of extravagance.

The heather is soft beneath his feet, miles of rich purple heather, as far as the eye can see. Jogging over the ground that is so sponge like, with the sensation of running on miles of cushions. But stick your forefinger into it, just an inch, and you come to the hard sandstone.

Cézanne was amply rewarded with indifference, but towards the end of his life was able to say that he felt he was making progress, in a conversation with Vollard in 1896: 'I work obstinately, and once in a while I catch a glimpse of the Promised Land. Am I to be like the great leader of the Hebrews, or will I really attain unto

it? I have a large studio in the country. I can work better there than in the city. I have made some progress. Oh, why so late and so painful? Must art indeed be a priesthood, demanding that the faithful be chained to it body and soul?' William Tillyer is one answer to many of Cézanne's questions. The art is knowable but the artist unknowable, and in any case the public is indifferent to both. But where the former would vent his frustrations and his capacious anger, Tillyer safely disposes of his feelings and channels them into making his art.

* * *

Formerly a single museum – a home for British art and a home from home for European art – the Tate was awkwardly split in the early nineties, so that Tate Britain became national custodian of British art from 1500 to the present day. With the reverse effect of what was intended. Rather than British artists seeming stronger when seen together and cut adrift from the continent, they seemed lonelier and diminished. Ben Nicholson was more exposed as this country's token late modernist, and without the context of Picasso and Matisse, Mondrian and Malevich, his work could not stand up to the scrutiny involved. In his time he was a European and a Modernist who could fight his corner and even on occasion be exhibited alongside Picasso. Today he must stand on his own and be counted. Sutherland suffered even more severely by the comparisons. And Stanley Spencer was revealed as, strictly speaking, an English eccentric. The rest were done away with, like the light infantry at Agincourt.

The sixties brigade, fresh from the Slade and the Royal College of Art, and from all corners of England – Robyn Denny, Richard Smith, David Hockney, Peter Blake, Bridget Riley and many lesser names – seemed to have more of a fighting chance, but these too were overshadowed. Not by Europe but by America. It is always the way, of course, and a museum cannot arrest the tide. Even the larger-than-life American heroes of the forties and fifties – Pollock, Rothko, de Kooning and the rest – had to make room, however begrudgingly, for a rising younger generation who fought with and against them. Jasper Johns and Robert Rauschenberg, Helen Frankenthaler and Sam Francis to begin with, then Frank Stella and the advance guard of Pop Art, Roy Lichtenstein, Andy Warhol and Tom Wesselmann. The comparisons with Britain – and how suddenly the cosmopolitan can appear provincial – were both fraught and fertile.

During the sixties, even if they were in the shadow of the Americans, English artists were riding high, by association. And London of course had its own authority, re-labelling imports as its own produce, with the help of the two most talked-about art dealers in town. If you were to make it, you needed to show with Kasmin – well-read and well-travelled, charismatic, offbeat and idiosyncratic – or you needed to show with Robert Fraser, elegant and stylish in his Mayfair gallery, where the Rolling Stones and the Beatles were regular visitors and clients, and the telephone lines to New York were open. If Kasmin knew Frank intimately, Robert knew Andy intimately. The stage-set conjured by these young entrepreneurs dripped with sex and drugs, parties and intellectual chatter, and the major European and American collectors were merely equals of these darlings of the current art world. There were other dealers, of course, like the discreet Tooth's Gallery, which dealt in older art. We didn't really go there much, if at all. But it was a better address for an artist than having no address at all. Everyone needed a dealer.

* * *

The ways of getting art noticed were becoming ever more sophisticated and confusing. One weapon wielded by all artists who arrived hard on the heels of Abstract Expressionism was a vibrant palette. Stella, Warhol, Lichtenstein, Judd, Flavin, and in England Hockney turned up the volume with each decade, until by the present century it was positively deafening. You needed to combat the competing cultural noise of television, or Hollywood, and divert the attention of the rich from the shop windows of Bond Street, Faubourg St. Honoré or Fifth Avenue. If acrylic was invented to combat the noise, it was also part of the noise. As artists developed a wealthier clientele their prices rocketed, and they could collect a further fortune by making signed souvenirs of their work, in the form of etchings or lithography or silkscreen prints.

* * *

It is salutary to stop for a moment and wonder why art, or painting, is being made at all today, and for whom. Formerly, for many hundreds of years, it was for God. Then it became a light to shine inside the maker's or viewer's psyche, an enduring way of asking what life is about, what our lives are about. But that too seems like a long time ago. Now it seems to be about nothing, which is a good subject, were it to mean more than clever ideas to fill museums, or a machine for printing money.

Art is the one creative endeavour where someone can flourish with meagre talent and become rich and famous. Artists certainly need enough to live, as do the rest of us. The rest is a diversion, part of the wrong story.

Let us revisit some of the stories

There was the work of Auerbach, made with grim conviction and stubborn authority, as if there was a prize for seriousness and that this meant getting closer and closer to Rembrandt, simply through impasto, whereas there is actually a consummate lightness in the Dutch master's brush. Auerbach led and championed the school of the hard-won image, soon to be followed by his friend and former colleague, Leon Kossoff, another student of David Bomberg. But Bomberg had more bravura, and a defter touch.

David Hockney did provide all those missing intermediate chords, but at the expense of making substantial paintings. His works always had a glamorous, illustrational surface, but as he got older the cheekiness gave way to stolidity. The images became more earnest and the light touch, the disenchanted and enchanting quality that saved his surfaces from superficiality was gone. David's truthfulness to his art was paradoxically a desire to please, a visual conversation full of in jokes, a form of light music. The works were always compelling to look at, even when he decided to return to nature, painting the neighbouring woods close to his family home in Bridlington. 'What fun!' is the most appropriate response, and Hockney elicits it from sophisticates and from *le grand public* in equal measure.

Howard Hodgkin, with less of a natural talent, came with a useful and exciting new approach in the late sixties, which reached its peak in the late seventies. The small picture, an antidote like a dock leaf applied to the wound of those tough big pictures of his heroes, Robyn Denny, Richard Smith, and even the younger John Hoyland or John Walker. The 'intimiste' won the day, and his delectable beautifully coloured miniatures were as fresh as their paint. It was not long before the art market started to snap them up, creating that most desirable of all commodities, a shortage. A waiting list was formed, the 'rarity' became sadly formulaic, and when Howard wanted yet more art-world attention, the canvases became larger and larger, less and less convinced of themselves. But Howard's market waxed without waning – the television and newspaper interviews, the knighthood, the OM, the highest order in the land.

Patrick Caulfield arrived with great promise. And his art dealer was Robert Fraser, which linked him to Jim Dine, Ed Ruscha, Claes Oldenburg, Richard Hamilton, Peter Blake and Warhol. In some circles he was regarded as our Roy Lichtenstein,

but if his outlines reminded people of the great American Pop artist he had in fact taken a different path. The early years produced wonderful pictures, sly and witty. There was a steeliness about Patrick, and despite the phenomenal amount of alcohol he consumed, the pictures would always keep their edginess and aplomb. Although he was close to all the others, there was a touch of the stranger about him, which would stay to the bitter end. If there was one running mate and fellow painter he stayed close to, it was his sometime drinking partner, John Hoyland.

Like Caulfield, Hoyland burst onto the scene in the early sixties, and was taken up by the mighty Marlborough Gallery. Those early Rothkoesque canvases, often huge in scale, inspired awe in those of us who were still Atlantic virgins and had yet to cross over to New York. Nobody in London's drab post-war world had seen such energy and glorious colour, such a thrilling feeling for colours situated in space. But there was a developmental problem. Perhaps there was no future in doing ever bolder, ever brighter and – especially – ever looser versions of this idiom. His paintings moved away from the earlier colouristic subtlety and understatement, they became messier and more garrulous. The pull of exotic places was in part responsible, and Hoyland's was a curious case of travel narrowing the mind. In fact, if there was one figure whose development persuaded me to turn my back on abstract art, sadly it was John, rather than Robyn Denny or Richard Smith. I turned briefly for sustenance to the figuration of Lucian Freud, but it was never really my cup of tea. And my vision was fully restored only when I returned to New York in the mid-nineties and became the world dealer for Frank Stella.

There were some wonderfully anomalous talents in the London art world. Not least Victor Willing, to whom I was introduced by the art critic John McEwan. He was married to the gifted Paula Rego. I represented Victor, and there many in the art world who nagged me to save Rego from her dealer Edward Totah. There was a general sense that being represented by Edward was a form of concealment. But I liked Edward and I would not take her away from him, even though Rudi Nassau and David Sylvester, and Victor himself implored me to do so. Edward died from a cocaine overdose, and Rego's work became emphatically figurative. The new departure and its gigantism did not appeal to me, but Marlborough loved it, took her on, and turned her into an art world star.

Perhaps the outsider's outsider was Euan Uglow. I owned a lot of his work. He was a sort of a magician, who took his cue from Cézanne and was taught by the

wonderful figurative master William Coldstream. But Uglow's path was entirely his own. His heavily constructed, delicately and tenderly executed canvases are an authentic vision, his people and objects have a realism in which the coalescing of discrete planes is articulated by an astonishing colouristic gift. Their realism was breathtaking, and it felt curiously abstract, as though we were seeing the act of seeing itself, broken down into its constituent parts. Again, I was urged to take on Euan, but I was not going to take him away from William Darby. I could have worked wonders with his art. I knew I could. But the price was too high, and in the end, as in the beginning, you have to live with yourself.

Near misses and paths not taken are part of every story of a life in art. Bridget Riley had, in the early nineties, invited me to her studio, after the closure of the Rowan Gallery. I had known her since early days, but had never thought of representing her. I could see she had a considerable place in the story of contemporary art. But I felt that it was linked to my past, the innocent sixties, and I was not convinced by most of what came later. I went along and was surprised, because I did very much like what I saw. The conversation turned to business, and Bridget as always had very definite ideas about her work, her place, and especially her prices. I asked rather than told her the prices. She said the large canvases were forty-five thousand pounds. I suggested that they might start at a more friendly level. She was adamant. I felt that I couldn't really help her. A financial mistake, because a couple of decades later they are worth ten times more. But what a gallery like Pace or David Zwirner can do, in the way of alchemy, I could not do. At the time I felt sure that Robyn Denny and Dick Smith were the more substantial artists, whose prices were much less, and were virtually unsaleable. I certainly think that to this day Marc Vaux is the superior artist to Bridget.

Another younger painter, Sean Scully, had begun his career at the Rowan Gallery, but moved to New York. He had been influenced by Richard Smith, had been a good friend of Bridget Riley and in the eighties he would take the art world by storm. He had invited me to his studio when he fired Leslie Waddington. I liked the work, though we never saw eye to eye. He had constructed a vivid persona – had read *Ulysses,* had a black belt in judo, had floored the villainous McVicar to settle a dispute while drinking at the bar of the Chelsea Arts Club. Scully would end up with Timothy Taylor, a lovely man who started his career at my gallery and remained there for seven years, until he was poached by Leslie, then opened his own gallery a little later. And now Scully shows with Blain Southern.

William Tillyer watched this merry-go-round of changes, always from a fixed distance. He never planned the distance, rather it seemed planned for him. Part of his education in art involved watching colleagues thrusting ahead, watching the progress of this novel phenomenon, the art career. Until finally, as the twentieth century drew to a close, the tortoise became the hare.

Abstraction

The writings on history are often entirely subjective, whether it is written by the victors or the vanquished, the winners or losers in a war or battle. A different nation will write down a history, where the facts can be considerably altered by sentiments and pride. The history of art likewise will be subjective. However objective the critic or historian would wish to be, he will put himself, to some lesser or greater extent, into the actual story.

A history of modern art will become even more blurred because it does get personal, written through the eyes of people with varying emotions, beliefs, passions, perspectives – and eyes!

And to attempt a history of contemporary art – the art of our time, where the writer is perhaps a chief witness – is plainly impossible. The history of contemporary art is written when the paint itself is still wet, even if the advent of acrylic paint, which dries in an instant, has weakened the analogy. And so William Tillyer could be perhaps the greatest British painter since Constable. He could also be the worst. The decision is as wide open as that. The second suggestion is quite absurd, while the alternative is at least in the realms of possibility and obviously I believe I am right in my beliefs.

There seem to be six giants in the twentieth century arts, who stood head and shoulders above their peers and each of whom laid foundations for all who followed, some of whom were giants in their own right. All six arrived very early in the new century. They were Pablo Picasso and Henri Matisse, Marcel Proust and James Joyce, Igor Stravinsky and Arnold Schoenberg. Of course you could propose many alternative names from different fields, Kafka, Duke Ellington, Einstein, Freud, Wittgenstein… and the list may be endless. But it would be hard to dislodge any of the six giants I have proposed in the arts. And what all of them shared, in their respective fields, was a pioneering commitment to new forms of representation. There are so many great figures, although on such a distinguished level there seem to be very few.

But back to the rather small but significant world of modern art, William Tillyer, like so many important painters, is an idealist and also a great believer and champion of Modernism, including one of its most important discoveries and inventions, Abstract Art. While many followers of Malevich, Mondrian and Kandinsky have

simply ploughed that rich and fertile field, Tillyer has loved it and needed it, but also has the intelligence and inquisitiveness to reach beyond its confines, out there into the unknown, where most successful artists dare not go, as it would probably undo what it has done for them.

While Mondrian would lean on theosophy, Malevich on suprematism, Duchamp on alchemy, Kandinsky on spiritualism, to drive and produce their art, Tillyer honours all these art world heroes of yesterday, but takes the road further along, not by making small and tentative steps where the masters had left off but by thrusting forward, using all they had offered and taught but also adding the advantages of his own vision and the world around him. He never had any intentions of joining the dullards, those artists who found a mediocre art with an easy market, and sit on their laurels. His quest was always to go where nobody had been before, to paint for the future.

If the European visionaries had managed to inadvertently lose the general public by its austere and intellectual approach to the making of a modern art, those who followed in the sixties and seventies, after the thirties, forties and fifties, the advance of Surrealism, Dada and Abstract Expressionism, had magicked an artwork that was glamorous beyond belief, highly intelligent and sophisticated and at the same time remained in the great pantheon of art history. I'm talking about Jules Olitski and Larry Poons, Frank Stella and Ellsworth Kelly and Kenneth Noland, and several others. The thrilling shift in the art story attracted the attention of leading art writers, art dealers and museum curators and directors.

And so Colour Field and Minimal Art was right for the moment, of the Zeitgeist, and exploded onto the scene. Whether you find those paintings more or less wonderful than their rival, Pop Art, is a matter of personal taste, but there was no doubt about it, that it was new and thrilling and dynamic is beyond a shadow of a doubt. But that was the sixties and seventies of the last century. From that point of time right up to today an army of artists, from every corner of the globe, have found a considerable place in the market, with their tame and lazy additions to a great moment. Don't rock the boat. If it ain't broke, then don't fix it. Although Tillyer had no choice but to rock that boat and attempt to fix it. He had no idea about the trouble he was causing and how unpopular it would make him. If I had not learned the lessons and pain it put upon Paul Cézanne, I would have cause for concern for William Tillyer. I don't, because I feel deeply time will catch up with him and his huge advances in art, however long it may take.

I find it quite astonishing that those artists who follow in the tradition of abstract painting are, in the main, content with making the most minor contribution to this noble invention. A discovery which is now a hundred years old. I simply cannot fathom how they are not prepared to attempt new creations from this grand tradition. If there are just no paths forward, I would expect these painters and sculptors to search for a new path forward. If they cannot find one, then they should at least have the dignity to move on in their lives and take up fly fishing or collecting butterflies. Although the money and fame are so tempting, and so I do understand their dilemma.

And then there is figuration, with a completely different set of snares, and problems that seem no more and no less than the path of abstract art. The two approaches to art making seem diametrically opposed. I sigh deeply at the very thought of this direction of figurative painting, and feel that the thought of anything worthwhile can come from this actually concerns me even more than the alternative path of abstract art.

When I think back on that evening, when I had two masters of painting, John Hoyland and Lucian Freud under our roof, greeting each other as brothers, it was a touching moment, and a huge thrill for me personally. That was the eighties. I was a lot younger, as they were too, and a sense of bonhomie permeated the air, two titans hugging each other in our dining room, with mutual love and respect. They are of course now both dead. But to re-enact that moment today would be strange indeed. Whose art would I now side with more? Whose pictures would mean more to me?

Tillyer was travelling through the South West of America at that time, in the process of making astonishing watercolours of the Grand Canyon and Monument Valley. If he had been present in that moment, eating and drinking with us all, I would have no doubt that I would have him placed as number three in this intimate group. Neither an abstract painter nor a figurative painter, but one on an exceedingly slow path of abstraction, of attempting the seemingly impossible, of merging the two traditional forces into one. If we could re-enact that encounter once more, adding this third painter, I would probably place him already as an equal to them, and with the forces of history, plus his and their progression until this very day, I would place him supreme.

I considered the original pair as having lost their way and easing into a form of aesthetic desperation, and the outsider now in full throttle and looking ever forward to his late, great years. Perhaps some other artist will be able to make something new from the embers of abstract painting, or something new from the embers of figurative art, although I myself have yet to see this happen.

There seems to be too much analysis nowadays on abstract art, where the most minute step forward is worthy of an extended article in a newspaper, magazine, or even a magnificently produced book, perhaps to justify the ever increasing prices. It seems to stultify the energy and spontaneity and innocence needed to keep the work alive. Endless tomes, filled with praise and erudition. Every mark, every shape, every colour is regarded with the utmost importance and significance, usually outperforming the actual work of art it is defending. Of course, these excellent scribes, these samurai of the twenty-first century, are only called upon for their magic in words when the art is of significant financial value to warrant their time and skills.

Abstract art should be allowed to fail too, because that is the only way it can remain vulnerable, and win.

William Tillyer has been greatly influenced by William Morris, the Victorian artist and socialist intellectual and close friend of John Ruskin. Peter Fuller loved Tillyer's watercolours, which he saw as being in the romantic landscape tradition, but sadly never really understood the depths of the artist's more significant works, the paintings.

If Peter had thought more carefully about Morris' work as an artist and writer, he would have discovered that Morris, born one hundred years before William Tillyer, was extremely concerned that his enormously influential and commercially successful wallpaper designs should not be too abstract, nor too figurative. In other words, he didn't want them to drift into decorative attractive patterns. Nor did he want them to become replicas of the world outside. Perhaps he was the one man who pre-empted where William Tillyer would go, more than half a century later. He was searching for order, imagination and beauty, and saw these as requiring all the resources available to the artist as maker, and to the intelligent audience.

Like Tillyer, Morris had thought of becoming a priest before he eventually settled upon art. And he wanted this world to be a better place, using all the resources of art and industry, to create a republic of Arts and Crafts. Just as Tillyer's vocabulary brings together a physical metal grid and a Romantic vision in the same picture.

Some painters in the first half of the last century stumbled on the idea of switching paths, from figurative to abstract. Others reverted back, from abstract to figurative. In hindsight it seems clear that this small number of artists realised that something was wrong, or missing, in either choice, but failed to realise that the choice itself was the problem. The dilemma at that moment in time was clouded by confusion. But it was an inspired and intelligent ambition.

Tillyer dealt with the problem head on. It was as if he saw the huge dangers lurking ahead, along either of the available routes. The figurative artists continued on their path, as the abstract artists did theirs, many of them building up strong followings, and markets, along the way. But eventually, neither would offer a sustainable future, at least in my opinion. Left out on his own, with his own devises and deep beliefs, he slowly but surely forged a new painting – an abstraction. A picture that failed both opposing camps but one that made an alternative path, and perhaps the only possible one with a great and relevant future. It was an uncomfortable path for the academics, the market place, even his fellow painters. It was no less awkward and visionary as that of Paul Cézanne from the previous century. But it was a giant step, like his master's. Not tentative and cautious like Ben Nicholson and Ivon Hitchens, two artists he greatly admired and had leant on decades earlier, but a leap of faith.

But with the English having as much interest in art, and especially abstract art, as the French have for cricket, the task was even greater.

Abstract as a mantra. All the pawns have been swept from the board. Killed by the bishops and knights. Even the king has hidden, to avoid the impending disaster. He alone could see what was coming. Abstract art will surely buy him some time – a half an hour on the board, or perhaps a generation or two on canvas. Or to change metaphorical tack, the winds will lift again, and so the ship can sail safely back to port. Abstraction as perhaps the only antidote, a new path forward. Once upon a time it was the high road, the royal road. Cézanne took us by the hand along it, and Matisse and Picasso took us further still, until they too had to step back towards something not entirely abstract, to breathe some air into the

adventure. But those high-altitude purists Mondrian and Malevich and Kandinsky did not need oxygen, kept forging ahead, and left us with no air, just ideas. Tillyer has, on his own terms and in his quiet way, breathed air back into the picture, with an abstraction which includes the viewer in its idea of itself.

To make an abstract picture today is not difficult to do. No more difficult than to make a figurative picture. To forge a strong and meaningful connection between the two needs courage and conviction, concentration and solitary time with your project. Most do not have the courage or vision to go there, to attempt anything so demanding. William Tillyer has gone there, and he started on this path from the outset, some sixty years ago. For Tillyer using abstract elements in a painting is as natural to him as using figurative elements. As using found objects. As using a brushstroke as a sign of a brushstroke and using a brushstroke as a sign for a tree. A puddle of paint as a cloud.

William Tillyer does not make figurative paintings. Like Hockney or Blake or Freud. He doesn't make abstract paintings like Denny or Smith or Riley. His domain is the gap between. They could loosely be referred to as abstractionist, which is a rather simplistic way to see it. His area is an art which meets up with science and poetry. In the seventies, in the early days, we would describe it as an area of art where Mondrian meets Constable, or where Romanticism meets Classicism, or perhaps more accurately, Modernism. That description sort of made sense then, getting on for half a century ago. In the most obvious ways, this is still sort of true. Nowadays the story is a great deal more complex, and in there, somewhere is where the art lies. It is sad to spell it out too much but better still to let the paintings express for themselves, a space where the artist meets the viewer, who hopefully is interested to go. The rewards are huge and also seemingly endless.

Abstract and Abstractionism are just labels, just words. As Impressionism and post-Impressionism were only tags used in the nineteenth century and Abstract Expressionism was in the twentieth century. It is that need to put something back into the picture, to give it a new life without becoming an art world spinning top or gyroscope, just turning, turning, turning, just spinning, spinning, spinning. Artists as diverse as Robert Motherwell in America and Ivon Hitchens in England understood this dilemma. William Tillyer has acted on it.

Judith's Story

Judith is Yorkshire through and through, born and bred. She too was an only child, sympathetic to William's ways, his character, his weaknesses and strengths.

Judith, like her future husband, did not get to know her father until she was six years old. During the war years Tillyer was brought up by women — by his mother, her mother and her mother's mother. On his return from Egypt, where he was with the 8th Army at El Alamein, William's father would seem to him 'a bit of an intruder'. His father was a Jack the Lad, over six foot tall, handsome with rich black hair. He soon reasserted himself as head of the house, would whisk his wife off to dances and take his son fishing. Back home he opened the first of his two hardware stores in Middlesbrough, travelling great distances around the county and visiting local farms in his van. It was a confidently lower middle class provincial life.

Judith's background was not quite as comfortable, though she always had shoes on her feet to go to school, while many of her classmates would have to share or take the day off so that a sibling could go to school instead.

Middlesbrough was a relatively new town, put on the map by the opening up of the railways and especially the short stretch of track that went famously from Stockton to Darlington, and allowed Middlesbrough to become one of the steel towns of the 1850s. It was also the first major British town and industrial target to be bombed during the Second World War. The town was poor, though its ironworks, steelworks, ship building and chemical plants made a sturdy contribution to the nation's prosperity. What it was given in return was yellow air and winter smog.

She too was encouraged at school to consider making a life in art. Aged fifteen, she left and started making window displays at a posh department store in the town. The window dressing paid for three years of evening classes in drawing. Other artists have started with window displays as a sideline, think of Rauschenberg and Jasper Johns and Andy Warhol over in America.

In 1958 the two youngsters found themselves at Middlesbrough College of Art, Judith in year one and William in year three, his final year before going off to London and the Slade. 'I didn't actually get to know him until 1960 and would

admire him from afar.' There was competition from other female students, and when she eventually got to know him properly she was working as a waitress and chambermaid at a hotel up in Edinburgh, and Willi was in London. They met at a party in Middlesbrough on one of their visits home. Willi was a penniless student. He went up to visit her, she staying at the hotel she worked in, he staying in another hotel where she found him a cheap room.

Willi took several jobs to make ends meet in London. Barman at the Studio Club in Swallow Street, just off Piccadilly. Assistant at C&A selling men's suits. Working on a building site, his leaking shoes covered in plastic bags.

Judith had already fallen in love with his paintings when they were still in the North East. There was a series of works, of pebbles on a beach, with the sea lapping around them. They were already in the green and blue which are among his usual colours to this day, their abstract qualities inspired by the work of Victor Pasmore. 'I know the catalogue he produced for his final year show which exhibited those works, but he destroyed the actual paintings.' Their loss was heartbreaking for Judith, if necessary for the artist. The catalogue was called *Land, Sea, Air,* and the title alone showed the direction he would take in years to come.

One work in particular, *Pink Sky at Night, Shepherd's Delight*, was a shop showcase, a cabinet constructed as a grid, each compartment of which was three inches deep and contained a pretend cloud made with blue grey plastic, against a pink velvet background. Like a Joseph Cornell box. What happened to it? He destroyed it. Why? He was a perfectionist, and from an early age knew what he wanted. His childhood bedroom was triangular in shape, and to make a small room larger he painted a skyscape on the ceiling. Early on he began painting his life, and in the background he would have Radio 3 playing, as he does today.

Judith is still angered by the loss of those idiosyncratic pieces that her husband created sixty years ago. And she is quietly frustrated by the art establishment. Willi loses whatever anger he might possess as soon as he enters the studio, and Judith is the first to know that no one can tell him what to paint. But she knows that he values her judgment. When they tease each other their Northern accents become more pronounced. Two folks from tough minded Yorkshire, who don't suffer fools gladly, for both of whom there are things more important than recognition.

Post Post-Cubism

At some point, between the wars, art had the last of many disagreements with the public over its aims or intentions, and the public turned away. Mondrian, one of the heroic forerunners, may be chosen to represent the parting of the ways. An inspiration and friend to many younger aspiring modernists, from Motherwell in New York to Ben Nicholson who met him in Paris, he produced an austere body of work which the public may not have liked but which influenced every advanced artist since the twenties and now adorns the walls of progressive museums throughout the world. Mondrian is an essential figure for William Tillyer.

The public said no, the artists, or many of them, said yes, and followed the path of Cubism through Mondrian to its logical end point, which is probably Agnes Martin, Robert Ryman and Brice Marden. And again the public says no and the art world says yes.

There were also artists who said no, like Freud, Bacon and Auerbach, who more or less turned their backs on it all, while local heroes such as Denny, Smith, Riley, Vaux embraced it as the right road. William Tillyer said a big Yes to Mondrian, but he also said yes to many other things. And this has made the difference.

He pleased nobody by taking a middle path, though veering closer to Modernism with its promise of a better art for the century to come, which was also the dream of a better world. There were other exceptions to the rule. David Hockney would flirt with every style, before opting with dash and alacrity for the figurative path. Hodgkin would vacillate for longer, ending up in a kind of no man's land of highly intelligent decoration, marinated in mystique. At their best, however, the paintings were never less than lovely.

An artist like Peter Blake embraced Dada, through which he filtered his love of fun fairs, pop, movie stars, with perfectly respectable results. Bridget Riley would opt for a life of sensations, as Keats put it, a purely retinal world of giddy and eye teasing Op Art experimentalism. Euan Uglow made marvellous pictures in a style entirely his own, a continuation of his master Cézanne into a realm of painterly rather than hard-edge hyper-reality, forging an existence in which the love of life – especially great wines – and a monkish austerity somehow combined to enable his miraculous pictures. Patrick Caulfield, who was rather less discerning in his choice of wines, would embrace aspects of current movements – to which there

are sly references in his paintings – and produce a joyous body of work which recorded in vivid shorthand the world around him in all its democratic variety and contradictions – posh cafés and rough corner caffs, hotel foyers, still lifes, summer lunches, a vision of ordinary places and pleasures eked out to painstakingly high standards.

They all were true to their craft and their inner voice. William Tillyer likewise, though his vision made considerably more demands, needing more time and concentration to articulate itself. In his curiously unknowing manner, and without any agenda or deliberate choice of path, he accidentally purged so much of what was occurring elsewhere in the art world, as a reluctant revolutionary.

Either he does not know or does not care. Making statements in paint is not his path or mission. The vision lies somewhere else, moving forwards while looking backwards, towards and away from Piero and Poussin and Cézanne.

* * *

A quiet but radical development occurred, as the twentieth century dawned, and it occurred in the South of France, through Cézanne in Aix and a fairly obscure painter in St. Tropez named Paul Signac.

Within a few months of these quiet figures showing their discoveries, younger arrivals – and rivals – were already developing what they had witnessed in the South. Picasso and his friend Braque would give us Cubism, Matisse and his friend Derain would give us Fauvism.

What was so irreversible about this step forwards was that from now on – more than ever before, in art's long story – we would leave behind images that were a visual reflection of what stood before the artist's eye, and enter treacherously exciting waters where the viewer, the critic or the collector, even the mere bystander, would all have a part to play. We were encouraged by this new art to use our imaginations. A Pandora's box was opening, however hesitantly, and there was no going back. It opened more and more widely, releasing its contents with the force of a hurricane, with irresistible momentum and dramatic power.

This began in earnest when advanced artists began to break up the picture plane completely, or replace the view in front of them with blocks of colour, or even with

a single colour. Malevich's *Black Square* of 1915 and its variants were both an endgame and a pretext. The first 'isms' would be followed by many more 'isms' as the century progressed, some great, some good, many dubious, many faintly or even necessarily absurd. It was the century of manifestoes. The hurricane would not abate, nor the hurricane of curiosity, as the art public expanded out of proportion – sometimes just to stare – and the money eventually poured in from every direction to seal modern art with a new and hectic destiny.

Its destination was increasingly the museum. In practical and perfectly bourgeois terms, you could stick a Cubist painting on the wall, or stick it in your cupboard. But what was to come – Donald Judd's giant stacks and boxes – often needed a museum, and there is no shortage of museums, public and private, to house museum art.

And from where do we stand today? It can seem like the party is over, that we have ended up with nothing, or at least nothing to compare with the wild if muted promise of 1906 and 1907. On a bad day, it can seem like we have been painted into a place of false values and expensive art, a hall of mirrors. On a good day, we feel a bracing need to look at those isolated figures who are investing art with new promises, far from its well-lit centres. And in this sense, if no other, William Tillyer is not alone.

* * *

The arrival of Tillyer in the sixties and seventies coincided with the market growing from small to big, then accelerating to enormous in the eighties and beyond, interrupted only by the catastrophic collapse of the early nineties. We had no idea that the rules would change beyond recognition, giving rise to the market and the artist who understands more about the market than about art itself.

A few collectors would stumble upon Tillyer, as if by accident, and buy his paintings and watercolours and prints. If they didn't really understand his aesthetic, at least this left him room to get better and better, and find new meanings for a future audience.

David Bowie

After his sadly premature death, the Bowie estate sold off his art collection, including his Tillyers. One of which was the magnificent large canvas from the nineties *The Luminist Meets the Constructivist* which I subsequently bought back at the auction.

Bowie on his *Earthling* cover: 'I've made a Tillyer,' he said to me.

'Bernie?
'David?'
'Are you there for a while? I'll just pop over for ten minutes. Got a lot on today.'
Three hours into what was meant to be a brief chat, David, who has been staring at a large, brand new painting by Tillyer, says he will buy it. I say it has come straight from the studio, that I have already fallen in love with it, and have decided to keep it.

He explains to me that the gallery is a shop, and that goods are for sale. The conversation travels from humorous to impatient to persuasive to possessive and a few other moods along the way, on both sides. But he has made up his mind. As have I. Finally I say, 'OK, just take it.' He refuses and wants to buy it. I cave in. I hate selling any work by Tillyer and this one meant more to me than most. But then I could not think of a nicer man to sell it to than David.

David looked into pictures, rather than at pictures, with great care. I hate talking about art, but with him it was always a delight. We could wander around the same subject for hours on end. One night at home, my wife Karin fell sound asleep while we talked through the night.

There were just four years between us, and of course I was flattered that he should want to learn from me on the subjects that were my passion. The child in both of us was still strong. His dream of driving his new love, Iman, down to Cornwall in the red E-type, which he had held onto for so many years. His huge enthusiasm about the smallest things. So I learned a great deal from him. It was he who said, 'Go to South Africa as quick as you can and make an exhibition of the artists you see and like.' I obeyed orders, fell in love with the country, and it turned out to be the most highly visited show I have ever put on.

I started the magazine *Modern Painters* as a platform for the art critic and my dear friend, Peter Fuller, who died tragically in a car crash. David wanted to be involved in some way. He read every issue from cover to cover, would eventually contribute to it, and was no sleeping partner or celebrity director. I introduced him to Karen Wright, who I had by now made the magazine's editor. She commissioned him to write several articles and do extended interviews on artists. He was hands on and extremely active with ideas and promotion. He would come to all of our editorial board dinners if he was in town, as each new project was bandied around. I had always dreamt of having a publishing company, to make books on art which would not easily find a home elsewhere. David came up with the name, 21 Publishing.

I saw less of him when he moved to New York, but those years remain a wonderful memory for me. The world is now a poorer place.

Aesthetics

As I write this book, I haven't really the slightest clue who I am writing it for, other than myself. Tillyer, like any good artist, does not in all truthfulness have a clue as to who he is painting a picture for. The artist who already knows his viewer will be a hack or an entertainer or an illustrator.

For an artist to be financially successful in his own time means that his work is understood in its own time, which means that he will not be ahead of his time – a journalist rather than a poet. Although it is possible for a great poet also to be a good journalist – Edward Thomas, Edgar Allan Poe – and perhaps a great entertainer or illustrator can also be a great artist, like Hokusai in Japan or Oscar Wilde in England. It is a fine line, but one that can be crossed or even re-crossed.

* * *

Alexander Gottlieb Baumgarten was born 1714 in Berlin and died in 1762 in Frankfurt. He coined the term 'aesthetics' and was the first to argue about it as the projection of a sensuous understanding on the part of the spectator. He developed the term to mean the study of good and bad taste, by which he meant good and bad art, so linking the question of taste with the question of beauty and permanence. Baumgarten found beauty in ancient Greek architecture, Tolstoy in Russian peasants singing authentic songs and Tillyer found it in Charlie Parker. What did these differences mean?

Soon after Baumgarten's death, Kant would denounce his so called aesthetics as an impossible science, and in 1781 would suggest that Baumgarten's endeavours were futile, as his supposed rules and criteria were merely empirical. But in 1790 Kant in his *Critique of Judgement* would employ the word 'aesthetic' to mean the estimation of the beautiful, as a knowable category.

Tolstoy took on these German intellectuals, and contested that Baumgarten's sacred words – Good, Truth, Beauty – had no application to the debased nature of contemporary art. In fact Tolstoy would come to think that art itself was insignificant, and the great bearded elder denounced it as 'the empty amusement' of the idle rich.

While Willi's champion, Peter Fuller, would have agreed with Baumgarten that good art was made by good people, and bad art by bad people, Willi would remain quiet, for deep down he knew that this was probably not the case. Anyway, Willi would not use the word Beauty, as too muddled, even if his work always remains in close proximity to the world of sensation.

Francis Bacon would tell me that he found beauty in the cancerous mouths of patients in the last stages of advanced syphilis.

Far from Russian thinkers and German philosophers, although joined to them by a bridge of Enlightenment aspirations, was the young and dynamic country of the future, America. Where Ralph Waldo Emerson and his young protégé Henry David Thoreau would rethink aesthetics in ways suited to their wild landscape and frontier nation, enabling the art of such painters as Frederic Church and Albert Bierstadt – the Lewis and Clark of painting – who depicted the savage beauty of Mexican nature from the tropics to the arctic, and were part of the wilderness they portrayed.

The Luminists and the Hudson River school made courageous and light filled paintings, often on a gigantic scale, works that would later resonate deeply for William Tillyer, especially during his year as a professor at Brown University. The American sublime enlarged the franchise of the beautiful, its wilderness often sitting uneasily with inherited ideals of proportion and scale. And the American future would continue to disrupt European proprieties throughout the coming century.

According to Johann Joachim Winckelmann, the great eighteenth century German art historian and archaeologist, the law and aim of all art is Beauty alone. But he had not encountered the heresies of Marcel Duchamp, or the persona and art, the persona-as-art, of Andy Warhol. Or the demolition philosophy behind all the various imperatives to Make It New. We have ended up today with museum after museum in which paradoxically the New is all-important, and the old and ancient have been relegated to rooms unvisited by the art lovers. But somewhere in the wreckage of ideas, what Winckelmann and Baumgarten were trying to work out when they talked about Beauty may become relevant again.

Asides

Russian peasants singing at his daughter's wedding were for Tolstoy truer than Beethoven. Tolstoy goes to the woods for inspiration, to write about art, but finds none. He rejected Impressionism in 1890.

Should art make sense and have meaning for the peasants? Art has always been for the elite, even if it is today a belated elite, a land owning elite, or a trash elite, meretricious and visually undereducated. Symmetry. Perfection. Beauty. Grace. Church and Aristocracy. Gold and Silver. Power. Money. Exclusivity. Globalisation. New World. New Markets. Diversification. Hedge Fund. Curator. Tate Director.

Is art at its best really and truly universal? Should an Icelandic collector have a Tillyer or Warhol pinned to his wall? Or an indigenous soapstone sculpture of a bear or fish? Conversely, if an artist tries to make an art for everyone, he will surely fail. Mark Rothko came to believe that he was expressing his deepest self in the floating veils of colour with which he imbued his canvas, his stacked horizontal bands and rectangles – and that his art addressed everyone, always insisting that ordinary viewers were the proper audience for his paintings. He said 'A picture lives by companionship, expanding and quickening in the eyes of the sensitive observer.' He may have been right to believe in the universality of his art, but in respect of what came to be known infamously as the Rothko Legacy and the shenanigans of his art dealer and executors, he was posthumously deluded, and the very people he despised won the day.

Towards the end Rothko, for all of his life a displaced Russian emigré, would say of his work: 'I have made a place'. William Tillyer, the provincial master, might say the same thing but mean something different – that art needs a local habitation. And this is why he has become a considerable artist.

However political or globalised we become, however much we want art to be relevant to the pain and unhappiness and unfairness of the world, the artist's job is neither to preach nor to entertain, but to bring a new beauty into being, even if, in the words of W.B. Yeats, it is a 'terrible beauty'. Which means not treading where others have trod before. In other words the artist has an obligation to reinvent.

The last century began with new ideas which took time to percolate, nurtured by small groups, Fauvism spreading through Matisse and friends, Cubism spreading

152

through Picasso and Braque and friends, fishermen casting their lines back in order to throw them further forwards. Look carefully at early paintings by Matisse, such as *Luxe Calme et Volupte*, and you see late works by Signac. Look at early paintings by Picasso and you see late works by Cézanne – not forgetting Lautrec, Van Gogh, Gauguin, Degas and more. And so too with Tillyer, in whose work you can see Duchamp, Cézanne, Mondrian, Turner, Seurat – a promiscuous cargo. But like his heroes Matisse and Picasso, he eventually produces entirely personal works. He graduates from borrowing to stealing, as T.S. Eliot would say. Tillyer took longer than necessary, because there was more to absorb. The early twentieth century masters were at least spared having to absorb the twentieth century. But they established its principles of eclecticism and experiment. And Tillyer learnt this lesson, among others. While his contemporaries make one painting last a career, he stands by the great and original modernist inheritance of restless enquiry.

* * *

Tolstoy raged against his own caste, the upper classes, the privileged, the well-educated. Against the rituals of appreciation which were also rituals of exclusion – the ballet or the opera, the hushed silences of the art galleries, the latest novels, the elite importation of Frenchness, of Flaubert and the latest French poets. If Tolstoy did not understand Baudelaire and Verlaine and Mallarmé, how were the peasants meant to understand? Where were the peasants to be seen in any of this?

I believe he was right to complain, and what has transpired in the century and a half since the publication of his book *What is Art?* presents a far worse case. At least the upper echelons of Tsarist Russia had some ability to comprehend and appreciate the high culture of their time. The replacement of the castes by the self-made man, the atomised individual, has created an art which is not answerable to anybody at all, and has progressed from being incomprehensible to the common people to being incomprehensible to everyone. It says 'I am whatever you think I am', or I am whatever you think will improve your portfolio. Incomprehensibility is the authentic sign of exclusivity, and is therefore to be encouraged. In a sense, the proud collector is now alone with a work specifically produced for an audience of one, the secret subject of which could be entitled *Portrait of the Viewer as Owner*. Which suggests that he is the butt of a joke. The joke of the blank canvas, the all-white painting, the grid in feint pencil lines on canvas. The joke is on us,

and I mean all of us. The money available for the making of this late twentieth century art, which continues today, is seemingly boundless, and increases with every season. Self-indulgent museums are opening all over the world, in formerly remote places. Remoteness is not an issue, for the private jet or chauffeur is never far away. Ordinary viewers are welcome, but these museums big and small are essentially for the private delectation of their patrons, a nexus of interest which sustains the value of what has questionable value.

* * *

Making art or artefacts has always been mingled with power, not least the power to command a price. Even the caveman must have had mixed motives with his cave drawings, beyond warding off evil spirits, and would perhaps receive fish from neighbours for decorating their caves? Obviously in Ancient Egypt, or Greece and Rome, there would be some form of remuneration, land and privileges for instance. Today the artist as professional, the producer of art in exchange for wealth, has become a highly sophisticated service provider. The crucial bridge was crossed when the artist, rather than producing meanings, became part of the production of meanings around art. Duchamp inadvertently started all of this.

In modern times, Andy Warhol was entirely serious about art, and about his own art. He wanted to think about money and fame through art, to explore their convertibility. But he thought of this in terms of transgression, and his art is about transgression rather than about money. Her certainly sniffed the future, as a world without transgressions. And those who followed missed the point, or had fewer qualms, as careers were made or broken depending on whether the cash flowed or did not flow, as art critics and museum directors and collectors jockeyed for position.

Roy Lichtenstein went from disappointed and frustrated outsider, biding his time outside the force field of Abstract Expressionism, to a true insider. Once again, by the time I came along, he had swung from intruder in the early sixties to being intruded upon in the late sixties. Both Warhol and Lichtenstein were shy and private men who allowed irrelevant meanings to accrue and swirl around them, and for the first time in the history of art this essential absence of the artist from the work led directly and indirectly to financial and critical acclaim.

Many, in America and Europe, and as far away as Australia, benefited from the art world doors swinging wide open. It is important to remember how late the real money came to the Abstract Expressionist generation – their dealer Betty Parsons remarked that she had difficulty shifting their stuff even at the end of the fifties. But the artist as entertainer and self-publicist moved inexorably into the art arena, and the emergence of figures like Jeff Koons became thinkable and then possible and then real. They could be brazen about it, they could be subtle about it, but just about every celebrated artist caught this mood. And we are still in the age of the artist as entrepreneur and entertainer. It would be unfair and incorrect to say that there are no successful alternatives, but they are becoming as rare as public telephone boxes.

In the post-war period there are new forms of elitism, whose shared feature is that they are also, paradoxically, compromises. The public imagination is captured not by the art itself but by the surrounding publicity, the vast prices, the high-profile institutions fighting for their place in the queue to exhibit an art which needs gorgeous rooms in museums designed by the most famous architects of the day in order to sustain its self-belief and conviction.

The great Tolstoy saw advanced art, elite art, as inevitably turning artists into prostitutes, cut off from their real audience. He was writing in the 1890s. It is often said that society gets the art it deserves. I think Tolstoy's desire for art to reach all levels of society is utopian, because it assumes the impossibility of the thing it advocates. And it assumes the impossibility of change. But some artists have successfully crossed and even re-crossed fixed barriers. Tolstoy derided Monet for his unintelligibility, but Monet's art now speaks to a large audience. John Constable has gone from a mildly successful landscape painter in his day, collected by an elite, to a monumental figure in modern times, revered by the general public as much as by the cognoscenti, who now allow him into their pantheon. I believe that William Tillyer is England's greatest painter since Constable, and that his public is vast, even if it has yet to encounter his work. It is money, paradoxically, that prevents change, because it always wants to preserve the status quo, and to dictate taste in the process.

The successful artists of the past few decades are intelligent, worldly and adept at arguments which substantiate their own position. They can confuse you into thinking that Franz Hals and Rubens and Rembrandt all had assistants, and commissions from the rich and powerful, and that current practices are simply a continuation. As if the possession of assistants and commissions were somehow a guarantor of integrity. If that were the case, there would be hundreds of geniuses in the art world today.

The Art of Wisdom

I am of my time in being completely committed to the idea that the work itself is all important, and that the story of its making or meaning is of secondary significance. It is my own meanings that change what is there on the wall, and in time a painting will often get better, as you return to it and able to read more into it – as you learn your way around it, as you get older and hopefully wiser. Botticelli's *Birth of Venus* or *Primavera* have become much more beautiful and wonderful since I first set eyes on them in Florence in the early sixties. It would be fair to say that if a picture does not get better over the years, then it is probably not a great picture.

But sometimes the change has entirely to do with me rather than with my understanding of the work as such. I find it hard to fall deeper in love with an arrangement of squares on a canvas, but perhaps I was never in love with it, and admired it for its value to the story of modern art. David Hockney's *A Bigger Splash* remains a visual treat for me, perhaps because it reminds me of myself when I first saw it at the Kasmin Gallery in the mid-sixties. But the best pictures of Matisse, Rembrandt, Poussin, Cézanne, Piero della Francesca, Gauguin, get steadily better and better for me, deeper and deeper, more and more fruitful and giving.

When I first set eyes on a new painting by William Tillyer I am either thrilled or I may need a period of time before I experience the thrill of recognition. But once I have received the initial electric charge, however wordless and inexplicable, from this moment begin the pleasures, the meanings, the questions. For there is so much more than just the first encounter of paint on a material ground. There are the work's embedded encounters with modernity, the fascination with the cosmos and the landscape, with aspects of chemistry and physics and biology, with modern and ancient philosophy, with modern music and architecture. All of this comes into play. The information is there, hidden within the paint itself. So I get the first thrilling sensation of encounter, but with time I gain a meditative tranquillity from the work, which enriches my life, operating upon me in the same way as those works from earlier times.

Emerson

'It is fit that man should look upon Nature with the eye of the Artist, to learn from the great Artist whose blood beats in our veins, whose taste is upspringing in our own perception of beauty, the laws by which our hands should work.'

'The greatest delight which the fields and woods minister is the suggestion of an occult relation between man and the vegetable. They nod to me, and I to them. Yet it is certain that the power to produce this delight does not reside in nature, but in man, or in a harmony of both.'

But is it we who make the connections, who do the seeing, unaided. Rather than an escape into aestheticism, beauty is the result of seeing beyond illusions by means of one's spiritual centre and self-reliance.

I am writing this book for me alone, just as I have learned to understand that the true artist makes art for himself, not for entertainment and certainly not for a potential market. William Tillyer paints for himself. I have observed and listened to a hundred or more supposedly serious artists, who perhaps began with the ambition of making art for themselves and ended up by making art for others, if they were lucky or unlucky enough to find their market. Many tried to find a public or a market which tragically eluded them. If you are able to sustain making art for yourself, you can attain to the bliss of which Emerson or Wordsworth spoke.

If you entertain for an audience, which may or may not be there, you have failed yourself, unless of course you intended to be an entertainer or an illustrator all along, and then your marks will become merely illustrational.

Thinking of Harold Rosenberg

Duchamp, turning a urinal upside down and renaming it *Fountain* opened the floodgates on an unsuspecting art world. His slender asides and question marks have been amplified and distorted, and others have taken them to their supposedly logical conclusion.

When Rosenberg made his subtle distinctions about the need for art to retain at least some old values within new aesthetic orders, I did not want to listen, back in 1968, when he dismissed an art connected to packaging, whether a Pollock exhibition or a Claes Oldenburg happening. But I was twenty-five and Rosenberg was already sixty. Today I am in my seventies, Oldenburg is in his nineties, and Rosenberg is dead, and I am old enough to see that I was wrong and Rosenberg was so very right. Andy Warhol would continue to avoid paint on canvas, to produce thousands of screen prints of famous people, even teaching Bob Rauschenberg to apply the technique to canvas, short cuts to making an image on canvas without the labour and mess of paint. Yes, Rosenberg seemed horribly out of date, really a bit of a spoilsport, when everyone was having so much fun.

From time to time I would delve into Rosenberg's writings. Even as recently as the early years of this century, it was hard to swallow his vitriol towards pop art, when at the time I was James Rosenquist's dealer. If I had any doubts I would brush them aside. My visits to Jim and also to Bob Rauschenberg, to their homes and studios in New York and Florida, would continue. But I had doubts. I was carried along in the wake of their personalities, and the fame and glamour attached to them and their work. But when I checked myself, as to what I was really thinking, it was the glamour that would linger, not the work. And who for that matter was Tillyer to compete in my sense of things with giants such as these.

In the end it was not a competition, or a contest. It was a question of taste, in the deepest sense, the realisation that Tillyer's work connected more substantially. As fond of the Americans as I was – of their work and also as individuals – or their glamorous counterparts in England, the Hockney's and Freud's, it was this 'quiet man of the north', as my friend Bryan Appleyard referred to him, who was making the more meaningful work. Now that I am older than Rosenberg was when he made those astonishing interventions, primarily for the *New Yorker* magazine, I feel

that he was right, all those years ago, and that all I needed was to know myself better and have the confidence to go with my beliefs, at whatever cost financially or in terms of my standing within the fashionable art community. I have never been short of anything, but was nevertheless far short of a final integrity. I had to get rid of the safety net, the life jacket, the crutches, the gatherings and the parties and labels of belonging – and stand alone, in the hope that just enough people would see what I was seeing.

Those close to me often refer to the fact that I never write about an artist's actual works. And that is because I have little interest in doing the art talk of the art community, who in Wordsworth's words 'murder to dissect'. I have no desire to scrutinize the music of Frederick Delius, the films of Renoir, the writings of Joyce or Hemingway, the paintings of Cézanne or Matisse, in order to persuade myself or others of their value. Someone else can dissect Tillyer for posterity. I just want to love the paintings and be left alone with them, rather than be asked what they mean, or how exactly they achieve what they achieve. It's bad enough having to sell them, without having to explain them, which would mean explaining them away.

You used to get wonderful old jazz fanatics in the sixties who loved jazz, wordlessly, and were coolly bemused by those philosophers who would take out the intestines of the music, to stop it moving, because they were frightened of an art that was essentially improvisatory. Time has proved the old jazz lovers right and the professional jazz thinkers wrong, as by the seventies, after half a century of thrilling music, the intellectuals and aficionados managed to divert jazz from something vital into something meaningful, at which point it lost its way, and its meaning.

Modern art at its greatest was only one moment in the story of art, which can be traced back thousands of years, and in its prime it knew itself to be that. But there were those who destroyed its innocence and left us with theory, which has drained post-modern art of energy and turned it into an arid game of justification, which in turn transformed the art itself, so that white canvases and grid paintings rule the day, along with all the other by-products and distractions, all in the service of mind games and the arcana of the marketplace.

Those who would disrupt this self-regulating machine will be dealt with. Trespassers Will Be Prosecuted, or made to feel they are at the wrong address and have stumbled into the wrong *vernissage*. Those who wish to join and are willing to be briefed are welcome. And money helps, as long as you keep quiet when your views don't quite match those of the regime.

These are the rules of museum art, and once inside you become aware that it is in fact a playground with no rules.

Fragility and Self Doubt

To persist for one year without assurance from your peers or your intended public is tough to bear. It needs self-belief and character. To persevere for a decade requires more than just these qualities, and exceptional stamina. To sustain half a century shows signs of delusion, or an extraordinary capacity to stay true to yourself and your vision, not to be rocked by the lack of an outside, beyond yourself and your gallery, your family and the few crumbs of appreciation thrown sporadically in your direction over the decades. Even if your dealer shows complete belief in you as an artist and in what you make.

And if all these circumstances conspire to raise self-doubts, that is good too, because doubt itself is an aphrodisiac for the real artist, the essential condition for certain kinds of insight and illumination.

Formerly obscurity was something of a job description for the artist, and also a form of solidarity. Tillyer lives and works in a time when there is more money and fame and false admiration than ever before. But there is also an antidote, the awareness that money comes at a price, as do accolades.

* * *

It is good and healthy to have lots and lots of new art, small ideas but ideas at least, all going through a mulch, to come out the other end with, perhaps, if we are lucky enough, a handful of true artists, or perhaps just one. The delight of sowing ideas, spreading out, taking root, offering new paths to allow excellence to be nurtured by the few, this is the responsibility and reward of the few.

If there is smoke coming from those distant hills, transmitting a pattern, the stage-coach driver with rifle in hand must assume that there are Indians, probably massing and about to go on the warpath. When Sir Norman Rosenthal told me two or three decades ago that Marcel Duchamp was the most important artist of the twentieth century, I should have read the smoke signals coming from the art-world hills. Matisse was to be relegated, even if Picasso would remain impregnable. By this point the irrepressible sixties affinity for colour and form – and beauty – was long gone, and 'idea art' reigned supreme. A doctrinaire age was upon us. Tillyer, who is steeped in Duchamp, would nevertheless put Matisse at the top of his list of twentieth century heroes. Put differently, Tillyer could have

sat still with his sixties work, his conceptual moment, and made a career of it, but he needed more. So he gave free rein to other and incongruent factors, and this has been the path to his achievement, which is to make an art which enriches the legacy of Duchamp and Picasso and Matisse, and Mondrian and others too. Which in turn could only deepen the art world's distrust and confusion as to who Tillyer was and what he was up to.

* * *

Tillyer needs to wrestle with the visual – with form, colour, sensation, landscape and the past, or outer space – in tubes of paint. He struggles with and through paint, as others struggle with ideas, mathematical formulae, how the brain functions, or how people should live with each other.

* * *

If you wine and dine with your clients, you will eventually make art to please your clients. Van Gogh had no clients. Andy Warhol made commissioned portraits, of anyone who could afford them. Howard Hodgkin was on intimate terms with every museum director and chief curator in the entire world, or so it seemed. The last time I went to David Hockney's house, Cary Grant was coming to tea.

* * *

The journey. There were artists who were necessary to me when I was in my teens, twenties and thirties. They began to seem less necessary in my forties. Others became necessary, those I had not discovered earlier or who had perhaps become more important with the passage of time. Kossoff would nag away at me, as a constant dilemma, coming in and out of focus from my teen years until today. In other cases there was a chain reaction. As Hoffman became less essential to me, this in turn made Hoyland less relevant. As I delved more deeply into Picasso and Matisse, so Hockney would become less significant.

In my forties, as I made the pilgrimage increasingly to the Tate for orientation and enlightenment, it was getting harder to find directions, and slowly I came to realise that they might be found elsewhere, in the less cool but more shadowy, more unpredictable haunts of the National Gallery and the British Museum – and in my old home away from home, the Courtauld. In the transitional years from thrills to

wisdom, the new art generally dimmed and receded. I realised I was becoming exiled from my happy land, and found myself in a deeper valley, a colder territory without glitter but which hid and held other and greater revelations.

* * *

Saying that William Tillyer is quite possibly Britain's greatest painter since John Constable leaves me exposed as either a harmless eccentric or a snake oil vendor. Fifty or so years ago the art world consensus would have named Graham Sutherland. Many now would give the accolade to Francis Bacon. Bacon in turn considered Matthew Smith a great painter. Howard Hodgkin would say Howard Hodgkin, Sean Scully would say Sean Scully. As recently as thirty years ago you might have said Malcolm Morley, just as today many people would say David Hockney. I suppose a certain camp of art lovers would say Ben Nicholson. And many would certainly would say Lucian Freud. Once upon a time John Ruskin would have said Rossetti. Right now you might credibly name Leon Kossoff, or possibly Euan Uglow. I have no problem with people saying David Bomberg. There are a number of candidates, but I stick to William Tillyer.

* * *

The idea that there has been no major art movement since the sixties, no advance, is intolerable. Not to be forced to undergo a sea change in your beliefs is a kind of defeat.

It is not as if the artists are talentless or lazy, or at least not to start off with. They start with the ambition to make something new, something that needs making, and if they are fortunate or unfortunate enough to discover this something quickly enough, the money turns up. At which point they are condemned to their success. Tillyer, like Picasso and Matisse, affronts this model, by not offering up a finely tuned signature style, nor even a message of easy comfort. He requires his viewers to follow him on his journey, and they have to work quite as hard as he does. The spiritual and intellectual rewards are there, if you are prepared to travel.

Success means losing the desire to go behind enemy lines, so that eventually they are no longer the enemy but friends. It is not that Tillyer prefers to be different. But he is differently constituted. It is an awkward and uncomfortable position from which to function. Or rather it is two distinct places. On the other hand there is

what feels like the correct place to stand, a place of no confusion or distractions, along a path of steep hills, fallen branches, wild animals. But the path itself is clear and well-lit. On the other hand it is also a dimly lit place of rejection. Tillyer's path is both of these roads, which are in fact the same road. Along which he appears to walk alone, but actually has company, from Piero through Poussin, from Cézanne through Picasso and Matisse.

* * *

Since the arrival of homo sapiens, around 270,000 years ago, we have had art in one form or other. William Tillyer often talks about painting being as primitive and as sophisticated as making marks in the sand. Which means using whatever is to hand, old and new. Tillyer digital, in both senses of the word.

There seems to be a large and ever growing public for art ancient and pre-modern, up to and including the French Impressionists. The numbers fall away considerably after these artists, with exceptions made for Picasso and Matisse. After which the experts move in, the academics, critics, museum directors and curators. They tell us what is what, some vociferously, others intelligently. But the art produced in the past half century is no more a subject of agreement between experts than whether it will rain or not tomorrow.

When Harold Rosenberg, a great art critic, penned his by now infamous five word essay titled, *The Herd of Independent Minds*, he was in fact referring to the world of politics, not the world of art. Or rather, his object was the trivialising of authentic personal experience involved in the manipulation of mass culture by elites, and equally the superficial commitment of the arts to politics, also supported by elites. None of which, for Rosenberg, addressed or reflected the strange and complex business of human needs. But those five words of his title are poetry to me, equal in insight to any words uttered by the poets Keats or Wordsworth or Frost. They also ring as true and as substantial as anything by Camus or Sartre. I believe they carry at least as much meaning today as half a century ago. The general public may not know too much about modern or contemporary art, and would not profess to know, but the 'Herd of Independent Minds' knows it all on their behalf. Just as long as they have each other to prop themselves up, or they will surely fall over, and burst into tears of frustration and vertigo and blindness. If this book of mine convinces enough people that William Tillyer is worth taking a hard look at, how frightening to think that the Herd might go on the rampage and start pawing at my gallery door. What on earth would I say?

The dilemma which Tillyer presents, for Independent Minds, and even for his advocates, is that he does not remain entirely loyal to his last act. He has already moved to the next place. He refuses, or rather he finds it impossible, to sit on his laurels, even when – as has happened many times of the past half century – one of his many series, whether in paint or watercolour or print, touches an immediate nerve with the viewing public. That is not his concern. His plan is always to keep moving, to keep searching, towards a place where neither he nor anyone else has been before. 'I am going out and may be some time.' A kind of aesthetic Scott of the Antarctic or Walter Raleigh, or like his sometime Whitby neighbour Captain Cook. But in reality it is a more like a humble journey, not a well-funded and patriotic expedition. More akin to Paul Cézanne in Aix en Provence, traipsing daily towards Mont St. Victoire in the last years of the nineteenth century and first few years of the twentieth.

* * *

The short cut to success for an artist. Find a new twist to what has recently been done. Make sure the idea is simple and easy to comprehend. Make it as sensational as possible, for example by flirting with pornography. Use neon, use livid colours. If thick paint is in vogue, use thick paint. If transparent or thin washes are the flavour of the year, use your paint sparingly. Attend as many openings and previews as you can, however small the gallery or museum. Befriend famous artists and try to trade a work with them, perhaps your painting in exchange for their small etching or even a poster. Visit every biennale, however far flung. Most importantly, try to get close to a billionaire collector, and have yourself adopted. Remember, it only needs one rich and famous collector to make an artist. Pretend you have read James Joyce's *Ulysses* and make sure you have a nodding acquaintance with it. Don't say you have read *Finnegan's Wake*, because your interlocutor will know you are lying. Say you have been to Wagner's *Ring* at Bayreuth. Don't hang around losers, failures or has-beens. They are easy to recognise.

Whatever you do, don't say you know William Tillyer.

A Yorkshire Fantasia

> Slow down you move too fast
> You got to make the morning last
> –Paul Simon

The glorious Roseberry Topping dominates the Moors skyline and has all the majesty for Tillyer that Mont St. Victoire had for Cézanne. Its gentle jutting of the landscape has always been a great inspiration to this artist. He and I stare up at it to enjoy its grandeur, a sight you can see for miles away, not just from Roseberry Common or even Newton Moor, but as far away as Hutton Village, or even Guisborough. Perhaps while young William was running down the cone of the hill, on his way home to his parents in nearby Glaisdale, so perhaps young James Cook would be running up the hill, from his parents' home in nearby Aireyholme Farm, the two keen explorers from Middlesbrough, one to discover unknown territories of the earth's sea and land, the other its land and skies. To both discover becks that babble and brooks that beckon, those murmuring mountain streams, so clean and clear, good enough to drink and quench your thirst and cool off your feet from the exhausting challenge of Roseberry Topping.

When you are at Ingleby Greehow you are close to the mines of Greenhow. Willi and I have walked around here so many times over the years. It is quite a trek up Greenhow Hill to the village. But when you get up there, four hundred metres above sea level, you really get to see the lay of the land. They talk about the place going back as far as the Bronze Age, and the Romans were the first known miners of Greenhow and ingots of lead, from the first century AD, are still discovered once in a while. The mining of lead progressed and eventually the monasteries would govern much of the land around, and lead mining, which became so important for roofing the cathedrals and castles. Fountains Abbey became rich from selling rights to this precious commodity. As significant as this memory of a bygone age was to Henry Moore, on the other side of Yorkshire, you can tell how much it means to Willi on his side of the county.

We would be at Rievaulx Abbey. Such a pretty part of the world. Willi and I can stop nearby for a cup of tea, as we have done on many occasions. It is such a wonderful feeling, walking and talking, with this magnificent Cistercian monastery by us, the haunted ruins, the abbey sitting in this wooded dale of the River Rye, sheltered by the hills around. The monks were a canny lot, even redirecting the

Rye on two different occasions in the twelfth century to give the building enough flat land to build on and later to govern, even making great wealth from mining lead and iron, not to mention more wealth too by rearing sheep and selling wool to all over Europe. I will never, ever tire of walking around this part of England with Willi, the Abbey by us. Established in the early twelfth century, disestablished in the early sixteenth century by Henry the Eighth, here it still stands, thankfully with so much of the building still intact from a thousand years ago. Willi is a great admirer of John Sell Cotman, who painted it in 1803 and also of Ben Nicholson, who drew it in 1957 while staying with his friend, the poet, anarchist, and great writer on art, Herbert Read. It was also an inspiration for Turner for making watercolours. If you cannot see Rievaulx Abbey in any works by William Tillyer, that is your fault, not his. All of Yorkshire is in his work, as are the skies above. You just have to look. We are not in the twelfth century now. Not even the nineteenth or twentieth century. We are in the twenty-first century. As Richard Mabey wrote, so succinctly and so full of insight for a non-art world writer, but a writer on nature 'But if Lanyon observed the world from up high, in a glider, Tillyer's acrylics have the eerie feeling of being landscapes painted from *beneath* the ground.' But that was long ago. Tillyer has embraced the landscape, its wealth, its pulses, its heaving alive forces, although, unlike Peter Lanyon, who he admires so much, an artist who would love to glide over the landscape to paint its abstract qualities, William Tillyer is neither above the landscape nor even beneath the landscape. He is in the universe, although he is just another citizen of the world, of Yorkshire, as he strolls down Stokesley's High Street to stop off at the corner shop to buy a loaf of bread or a pint of milk.

Strolling down to Helmsley, the afternoon's late autumn heat still surprisingly powerful, this medieval town I have come to know so well now, over the years, with its Norman castle, and that old bridge I feel I have walked over a million times, that magical feeling returns to me as Willi and I take to the Cleveland Way, our undulating path, or you can take a stone track, those wonderful tall trees, the path bordered by hedgerows, the castle ruins can be seen on your left, with its large walled garden beside it. And that delightful little tea room. Can you see Willi and I there, sipping tea again with our scones and jam with thick cream? The walk is arduous but just magical. And that bridge. For a crazy moment I feel like I know it better than Willi, who has perhaps walked across it a million times. His earlier studio was close by. The place of hundreds of watercolours and paintings. His space for ruminations and productions. A silence just a tiny walk away from the bustle of the town, just a short distance away from all the people, in that seclusion

where he could make magic happen, over and over again. We will always have Helmsley, even better than Paris.

* * *

Willi and I are stretching our legs on a bench in the deepest spot on the North York Moors. The sun is pouring down on this hot but pleasant early September's day. The town clock over in Helmsely strikes twelve times, and you can only hear it dimly from here, several miles away.

12.01 and a large hawk passes by, skimming the warm air.

12.02 tiny birds playing in the heather.

12.03 a lovely cloud travels over a Tillyer sky.

12.04 'You know, The Golden Striker is a great painting and probably your best. But it is only thirty feet long. I wish you could make a painting one hundred feet or a mile long.'

12.05 The skies are so massive here, the heather so still, all is so still, a silence so strong it can scare you. The world has stood still.

12.15 'I dream of those paintings actually,' says Willi.

12.16 Tranquillity beyond your wildest dreams.

12.30 'Come on, let's keep walking. There is so much day ahead of us,' I say, so Willi and I move along. It seems clear to me now that seeing that Robyn Denny painting, by chance, in the early sixties had significant impact on me, it probably opened up a door to what I would eventually fall in love with, the new art being made by British artists, a world entirely new to me and also everyone else for that matter. It was a visual world for sure, but also a world with strong social meanings too, the post war years, full of hope and light, full of energy and youth. It forged a new visual world for me, one so completely different to that world I discovered at the Courtauld gallery – but that was painting for a different time and this was now. In fact it wasn't so much an art and a world of today but rather for tomorrow, and I was one of the chosen few who could see tomorrow, today. Half a century on from that time, I cannot be honest to myself and say that this new art, of the sixties, is as good as my first love, that art from the final years of the nineteenth century. It certainly was different though, filled with new vitality and promise, vibrant colours and pop images. That gang of artists saw their careers and world blossom and explode in the following decades, but all, without one single exception, could not live up to the promise. For me it took an outsider, one who didn't figure in their lives or minds at all in the sixties, seventies, eighties and barely even in the nineties, to learn and take what he wanted and needed, to go ahead of them all,

one by one. Truly a Gustave Courbet of our times. The sixties explosion meant so much back then, although it means so little now and holds a miniscule place in the world's art story, from let's say two to three hundred years ago. They were a brave and brilliant set, although, however good their paintings and sculptures were, these works are practically sealed off in an aesthetic bubble, one that reads The Sixties.

I didn't express any of this to Willi. It could perhaps be too painful to be reminded how he had been excluded from the party, although I sense he wanted it that way, anyway. So we continued across the moors, and headed to Robin Hood's Bay.

* * *

By the time Willi and I got to Whitby, James Cook was already out, although we did go to Grape Lane and did go to the old building where James did his apprenticeship with the shipbuilder John Walker. Then we went down to the harbour at the mouth of the River Esk. It would have been so helpful if William Tillyer and I could have had a chat with James, obviously away at sea. To know a truly great man. Like William Tillyer, a man of few words and they lived virtually down the road from each other. What a damned shame he wasn't in. Two true explorers, two great explorers, one by the sea, one in his studio. Both with a fearless interest in the world, one who discovered hundreds of miles of uncharted waters and the other who was a child of the space age, which obsessed him quite as much as James's obsession with the sea and undiscovered lands.

The sailor in the village of Marton, the artist over in Glaisdale. The barque would set off with James as captain and discover that Tahiti was just a speck on that vast ocean in the South Pacific while Willi who knew more than James, realised that the Moon was just a speck in the vast universe. But the Endeavor only cost £3,000 to build and the Apollo cost billions. And of course, William Tillyer could paint Tahiti and also the universe. It really was such a disappointment James was away, as he and the artist would have had so much to discuss.

* * *

And so eventually Willi and I would walk into Middlesbrough. The Vikings were here but are now long gone, not before they left their names behind, Orm leaving Ormesby, Malti leaving Maltby and Toll leaving Tollesby. Even the early Anglo

Saxons were here in Mydlisburgh, sorry, I mean Middlesbrough, which we later named it. But that seems a very long time ago, compared to this moment, when the twenty-first century artist and his art dealer take to the sad high street, shoppers seeking the best possible price for a pair of shoes or a hamburger or a kettle. You can feel the money in the shoppers' pockets and handbags is difficult to get and hard to earn. You feel, wandering down this main street that art, any kind of art, is no more essential than a Rolls Royce or a yacht. The town has seen both great success and great hardship over the years, and Willi walks quietly along, filled with a sense of perspective of the situation and respect for its people. In 1800, Middlesbrough was a farm with a population of just 25 people. It would soon, in a generation or two, become a dynamic, powerful and rich beneficiary of the Industrial Revolution, the extension of the pioneering Stockton and Darlington Railway, transporting millions of tons of coal and eventually steel and iron, drove its expansion. Steam, power, deadly fumes, riches, the arrival of the local dignitaries, the puffed-up mayors and industrialists. Wealth filled the air. Yellow dust from the ICI factory would fill the air. And for many years the mighty Teesside set the world price for iron and steel and many shipyards would line up its River Tees. Fortunes were made, lives were lost through greed and carelessness and brass became the central driving force, not brass the metal but copper and bronze coins, and Yorkshire would, in Willi's century, create the expression, 'Where there's muck there's brass' and the word can today still be heard in the streets, shops, factories, football pitches. Brass, slang for money. There was great need for tough labour, in steel works and the blast furnaces and the powerfully resilient poor Irishmen poured into the area, to become ten percent of its population, the second highest Irish workforce after Liverpool. The Scots and the Welsh would also arrive, even workers from further afield. Money, power, a kind of progress, and worse and worse air to breath. The population was bulging. Then it would decline around 1980. Willi had seen the final years of its boom and saw its sadness in its decaying streets and its post war years. But by this time he was an outsider, a visitor from his home in Glaisdale in the fifties or from London in the sixties onwards, with fond and sad memories of earlier times. The yellow air has gone now, but so has the power and the wealth.

Willi and I kept on with our magisterial walk, out of this town of his childhood and youth and studies, and back into the landscape.

We traipsed over to Broxa Forest, because I had not visited it for too long. If it was a hundred years since I was last here, it may well be another hundred years to see it again. That is much too long to wait. Willi complied. We lost the path, the ferns with their feathery fronds, spiky tall gorse and the haphazard heather had, over time, so overgrown now to become just about hidden in the landscape. Scudding skies above us. Silent valleys, so tranquil that you want to fall asleep inside them, there and then. You reach Whisper Dales. We are in the middle of nowhere. 'Are we in Heaven, Willi?' 'No, this is Broxa Forest,' he replies. A lonely cone from the conifer tree beside us has plopped into a beck right where we are sitting, it stirs us a little and takes me out of my daydream. 'Shall we move along?' I suggest. Willi, who is probably designing a new painting in his mind, gets up, brushes himself free of the forest's vegetation, and so we do move along.

* * *

Here, in the heather, autumn's sun warming our faces, the world complete, nothing can touch us, nothing can bother us, the very thought that life is so good, the purple as far as the eye can see and above it the pale blue of kindness and love and many more pictures to paint, many more days on the moors, the heather springy beneath your feet, the silliness of the avaricious art market a million miles away, every day a blessing, every hour a blessing, every minute a blessing, to hold feelings close to you, to never let them go, we two together, over hills and dips in the landscape, when the price of a picture, any picture, isn't worth the price of a good meal, to begin to feel just a little of what it must be like to be as my walking companion, understanding some things are not worth a penny and yet other things are quite priceless, the warm air makes you dizzy from happiness, and then we heard some shy bleating somewhere over the distance. We followed the sound and nearly tripped over a lamb. The bleating made me sick to my stomach and I wanted the pained noise to stop. There was a lot of blood on and around the poor animal and I felt nauseous and scared and upset. I so wanted the pleading sounds to stop. The sheep had somehow got itself stuck in the wild landscape, probably a trip or a fall. Willi found a large stone and with mercy stopped the agonising sound. I was a city boy, and a frightened one at that. Willi was a man of the landscape, and did what was needed to be done. And the screaming had now stopped. The stone was covered in blood and Willi threw it as far away as he could and it fell into the deep heather, making practically no sound.

* * *

Willi is right next to me as we walk along the lane. Willi. William Tillyer, the painter of miraculous paintings, the artist at one with his feelings, and his intellect. And I so disagree with him. We stroll, as friends in silence, as colleagues, as artist and his dealer. The absence of sound, other than the birds singing to each other is quite wonderful, and it produces a magic all of its own. I don't want to break this enchanted moment, although I so want to quarrel with my walking partner. But that would break the spell! I want to open up what would become an awkward conversation, on Wassily Kandinsky. As we venture further and further down this lane, I decide to see the Russian artist, his pictures and his writings through Willi's eyes. What a meaningless and horrible argument to have, with an artist who has spent so much of his adult life with the Russian as one of the major bricks in his own edifice. And through Willi's eyes the pictures and thoughts do indeed become better than I thought. I must have more faith! And so we simply amble on. Eston Nab isn't that far away, and nor are Runswick Bay or Kettleness for that matter. We really should not argue over Kandinsky, especially as there is so much natural beauty in every direction your eye glances. A curlew calls out loud.

At the delightful village of Thornton-le-Dale, Willi and I stopped for a short while, to put our feet up and rest, a cold beer in each of our hands. We sat back on this park bench and enjoyed the view. There was another bench there and two old codgers were seated on it. It was Mr. Koodav and Mr. Schoodav, leaning on their walking sticks. They were mumbling away, complaining about the success of that minor art world talent, William Tillyer and both separately agreed that Tillyer had stolen all his ideas from them. I went up to them. 'Excuse me, gentlemen, but I am William Tillyer', I lied. Willi looked up into the sky. 'I just want you to know that I stole what I saw and wanted – but there really wasn't much to steal. Anyway, that was an exhibition at the Institute of Contemporary Art, over forty years ago. What happened to you since?' I enquired, and walked briskly off. They threw their walking sticks at us, but being old and decrepit and filled with too much ale, they missed us.

The Romantic Bernard and the Stoic William, sitting beneath an oak tree which is sheltering them from the afternoon's heat. The taciturn Willi, one who holds back from spelling things out too much, explaining away his ideas, his methods, his aesthetic history, his ambitions. Whether it is that time of the day or that time in his life, he opens up and decides to explicate.

'I suppose there is the move from a North Yorkshire landscape to an analytical, modernist, minimalist, conceptual approach of the sixties and the early seventies. It is basically a honing of ideas – about Landscape, Life, Painting, Art.'

'A constant re-appraising of thought and forces. I recall, while teaching at Corsham, around 1967 and 1968, that I was in danger of making a painting close to the nihilistic Malevich – his Black Square, of 1915. I felt I was entering a cul-de-sac. So I turned around and headed toward an image that was essentially figurative. That's how those images you know and published come about – *The Large Birdhouse, Mrs Lumsden's, The Style, The Furnished Landscape* and those works I made around that time. So definitely figurative, although in a minimalist format, that is using the grid and the lattice.'

After all these many years, Willi had never opened up and explained his inner thoughts like this, so succinct and yet so simple to understand, so uncomplicated and straightforward. There was a little respite from the artist and I gave myself time to let my thoughts drift back, to going shopping for groceries with my closest and dearest friend. It was different, although I had the same sensation. Karel Reisz would never, ever talk about his childhood years to me. There was a barrel of authentic pickled gherkins in the shop. Karel said to me that he was reminded of going shopping with his father. He was very quiet, and there were tears in his eyes. In his teenage years he had been put on a train by his beloved parents, from Czechoslovakia to eventually London in the late thirties. He would receive a brilliant education at Cambridge and would become one of the greatest figures in the British cinema and direct several of our greatest films. His parents waived him goodbye and he was never to see them again. They both died in a concentration camp. Although Willi's story was not a tragic one, he did confide in me in a similar way.

'The essence I suppose has always been to find a way of making a painting which still adhered to the traditional idea of a support, that is a panel or canvas yet endeavoured to move them on into the space and reality of the gallery and home. I did write a considerable amount about this in that catalogue which appeared with the *Encounter Series*. You made an exhibition of that group of paintings in 2000.

'I was also searching for a way that reflected the modernist approach to mark making and structure. For example a position between drawing – design, and architecture. If anyone looks carefully at my early prints, or the watercolours I made of Fallingwater for instance, I think it becomes clear.'

Willi, after all these years, why did you not explain all this so simply? Now, I feel, we are really getting somewhere………..

'I think we were all privileged and lucky to do that basic design course at Middlesbrough College of Art! That course came directly out of Bauhaus thinking. My four years at Middlesbrough lead to my analytical attitude toward landscape. I did my thesis on Constable.'

My goodness! Everything is falling into place. Everything is becoming crystal clear to me. It was like finding those essential pieces you need, doing a giant jigsaw puzzle. No wonder his fellow students would say to me that they were virtually messing about, while Tillyer knew exactly where he was going and what he needed to do.

'About that time I made the *Vortex* prints, also the paintings with a double horizon. Also the grid of field patterns.

'Compartmentalising as well as an embracing view. All this way of thinking, and working, lead to the way of thinking when I was at the Slade. I was sorting out my thoughts on attitudes to life. Heaven and Hell, with life in between. At this point my ambitions came together. What I had wrestled with earlier suddenly came clearer – the desire to be a monk, to discover who, what and where are we. The painter, meaning an artist as philosopher, and farmer, working with and understanding the land and also landscape, and to understand space.

'You know I was rejected in getting my painting diploma in 1960 from the Slade. I had to take one more year to receive it. There was the Bomberg approach, which at that time wasn't for me. I rejected the use of muddy earth colour and heavy paint. That was taken up by artists such as Auerbach and Kossoff but that was not where I wanted to head. There was also the Coldstream stance, which I found too pedantic and with it was the measured attitude to construction of the life figure. Euan Uglow took that path. Over at the Royal College of Art a new position was being promoted, probably leaning heavily on what was coming out of America, like Pop Art for instance.

'Actually, that left me in No Man's land. Although American Abstract Expressionism at first passed me by, I later became aware it was the only way to deal with an all embracing approach to content and mark making proffered by Cubism.'

He repositioned himself, to get more comfortable.

174

'That's when I headed for Paris, on a French Government scholarship.
'On reflection, something I didn't think, or perhaps I had entirely forgotten about, around the age of seven or eight I became very keen on fretwork. I also liked embroidery and tapestry. I suppose, like a lot of young kids actually, I loved Meccano. Now I think about it, this all seemed to be a propensity towards unitary thinking. I became very fascinated by the unit, the modular, which seems to have a duel manifestation. That was the forties, those years immediately after the war had ended.'

This was a side of the personality of Willi that I had seen very little of, a letting down of his guard, and I lay back in the clear Yorkshire air, and wallowed in it. I felt it was perhaps something I may not experience again, so cherished the moment.

'The mark, the painting, graphics,' and, as if a sort of mantra, he repeated again and again, 'Who we are? What are we doing here? How can we best express our stance?' So, melding the two elements, the mark – that is painting and making graphics, and also the philosophical – who and what are we, and why?

He continued, as if actually talking to himself, Tillyer moved on persistently, wanting to find a new and better and a more direct way of communicating. 'The big question for everyone was duplicated for me. How can you make a canvas or panel painting for today? Now I think about it, a real first attempt after the *Vortex* prints and paintings, which tried to deal with an all embracing, over-arching attitude to landscape, very much coming out of my thesis on Constable and regularly looking at Pasmore's images, was the piece I made at the Slade, which lost me my diploma for that year. That was *Falling Pinnacle*. It attempted to use a traditional format, the triptych, so looking backwards to go forward. On top of that, there were the ideas on landscape – cloud, tree, heaven and hell. The formalism of that triptych produced others, how we read or react to space and environment. This brought me to forms – such as architectural mouldings.'

'You remember that work I entitled *Meander*. That was a very important piece for me. It was my first use where the supporting wall become a part of the image – a breaking of the picture plane. So at last the painting now incorporated the wall, being REAL as well as – well, those works you know, drawer and door handles. Rocks. Clouds. Hinges. Hardware. All these being real as opposed to artifice.'
He wasn't rambling. He was explaining deep things to me, and I think in the process, to himself also. I felt completely in awe and privileged, and transported to a far, far deeper place.

And then he seemed to lighten up. He smiled and added, 'Over years my work has sought to explain those two opposing polarities. You know, there are some forty or more series of paintings which I have given you over the years, expanding on this explanation.'

As he stood and stretched his body, from our long sojourn under our larch tree, I felt small and humbled, and realised I had a great amount more to learn and understand.

We wandered onwards, in utter silence.

* * *

We returned home very late, dusty, exhausted and delighted, seeing the curvature of space, while staring intently at the horizon, and time and space became poetry, the melody to be easily discovered in the watercolours of Tillyer and more complicatedly in the paintings. The soporific sounds that wash kindly and gently over you as you listen to Tillyer's neighbour, from Bradford, Frederick Delius, with his Aquarelles, like *Summer Night on the River*. Time and space are momentarily lost in those rich harmonies and swirls of colours, and then regained. Time is something to stretch and perhaps also to contract. Time gives us new meanings and new discoveries. The journey visually spelt out and explained, that gives us William Tillyer caressing Constable, Delius caressing Bach, Einstein caressing Isaac Newton, taking magical discoveries and making new discoveries for tomorrow's artists and scientists, in a time of a year or two, or perhaps only a century.

If all things run true, until forced to curve, as in time and space, so do they in music and painting, and we should not fear that new giants, and even newer giants would in time supersede these giants after them.

Because these mere mortals are only block builders, and sometimes the blocks needed are missing or hidden, or misunderstood. Writers and composers and artists are all scientists in their way and not entertainers. It really is complex and confused. As light does not travel in a straight line, so too is art made in a curved line, with its setbacks and moments of great discovery. To get from Bach to Delius, you probably go via Beethoven, a composer who Delius disliked, for all his greatness. So yes, it is indeed a tough path, the road not taken. And the path

from Constable to Tillyer, you probably need to go via Lanyon and Nicholson, two artists he would eventually supersede, and he actually is a huge admirer of both of them. Complex. As complex as to understand to go from Newton to Einstein, you will probably need to go via Michael Faraday, yet another great Englishman. But if you want the excitement not entertainment, you have to be very patient and humble.

Only fools are sure, the greats consider, and are full of hesitation and doubt. The quantum leaps in modern art may well have come from Cézanne and Monet, soon after by Matisse and Braque and Picasso, but the relatively unknown William Tillyer has managed to produce a mere hop, perhaps more than any other artist in current times has managed to do. A hare, hiding in the shell of a tortoise. And there is still more valuable time ahead for him, to make even further advances and discoveries.

Tillyer has evolved from traditional landscape painting to virtually painting the cosmos. So far it has taken him sixty-five years. He has moved stealthily along a slow and arduous path, one he had no idea he would take when he was a young man in Middlesbrough, although, if you read his catalogue introduction for 1958, it seems quite clear that he did know the project ahead. What he achieved in his paintings in his twenties and thirties was, to be kind, a tentative effort, a sign of an artist worth keeping an eye on his progress, compared to the big names of the famous artists of the sixties, but what he was able to achieve slowly and steadily over the next decades up until today is a great body of work, becoming greater and greater, surpassing every one of his contemporaries. Their early success weighed them down. His slow development kept him humble and light on his feet.
'Why can't we walk over to High Force? It would be wonderful to see that waterfall. You made such a great screenprint of that nearly half a century ago.'
'That was a very long time ago and anyway, it's an extremely long walk.'
'Come on, Willi, we have all the time in the world.'

May his watercolours continue to give pleasure for generations to come and may his paintings become a source for learning and inspiration forever and ever.

As Willi and I walk through hundreds of miles of moors and dales, village upon village, filled with its human warmth, tea rooms and pubs with delightful food and drink, I do begin to think some strange thoughts.

These people, happy and content, strangers who would give you so much more time of day, cocooned in their fairytale land of a world, centuries old, centuries of local wisdom, this is a land that has not been touched by Henry Moore, like Willi a fellow Yorkshire man who went off to London to find himself and the world. But if Britain's greatest sculptor, Henry Moore, has had no impact on these people on a landscape covering several hundreds of miles, how on earth can William Tillyer? Henry Moore moved himself and his family to Hoglands in Perry Green, fairly close to London. Tillyer remained in his native Yorkshire, always retaining a humble address in London. While David Hockney made his home in California, Willi held on to his roots, tightly. His work has become more and more linked to man in the cosmos, but the man himself has stayed in Yorkshire for his strength. Hundreds of miles covered. A pleasant loitering journey, remembering the sweet promise of the past.

We now needed to rest our feet.

As he and I travel from village to village, discover marvellous and magical places to eat and drink the local beer and rest our bodies, we eventually find the most splendid place of all, a gorgeous public house with an enticing menu on a board outside it.

There is room for us and we are fortunate to be seated in a quiet spot in the restaurant, with a great view of the moors. A kind of perfection. The sky is clear, save for a few tiny clouds passing slowly by. The evening is arriving and the day's light is no longer at its brightest and a mellow tone fills the early evening air. The only light you can see is a narrow streak of sunset flickering just below the hem of the clouds. You could think of a Tillyer sunset, with that narrow streak, and you could easily think of Tillyer's ancestors, John Linnell or John Constable, Samuel Palmer or John Varley or William Turner himself, or with a bit of your imagination, Richard Wilson or Thomas Gainsborough. The fragile hem of the clouds, and think of George Morland's early summer evening with a yellow orangeness just like this.

The warmth in the late summer air has encouraged the landlord to throw the pub's windows wide open and the strong perfume of the moors drifts pleasantly in. Autumn in season, autumn in our years. He and I have never been quite so relaxed together, as one. It has been a lifetime, just about, and he and I have absolutely no regrets about that. The conversation flows so easily, like his River Esk, such a short distance away from where we are eating quails and new potatoes, next to a giant dish of mixed vegetables from the generous Yorkshire land.

'Sorry to interrupt,' said a gentleman at the next table with a rather strong Italian accent, 'You know I am sorry if I seem rude, but I really loved much of what you were talking about. Mr Tillyer, that is your name I understand. I don't know your name and I do not know your art. But I would love to see it.'
He too had completed his main course and was deciding on what desert to follow it up with.

'Would you like to join us so we can eat these delicious deserts together? Is that all right Willi?'

'Of course', he replied.

We got a third chair and he sat with us. 'I am not actually from England, although when I do come I always make a point of coming up here to Yorkshire. I don't really know why but it has become like a magnet to me. I find a peace here, which I do not find anywhere else on the planet. By the way, may I introduce myself? I am Carlo Rovelli, from Verona.'

The evening was closing in on us. The balmy air remained, but the sky was getting darker. I had never seen Willi cry before but now there seemed to be tears in his eyes. We all ordered the same dessert, large helping of apple crumble, with custard.

The evening remained mellow, even with our stranger, in fact it became even more so. We didn't talk too much, just about the need for art in the twenty-first century and Carlo's ideas of the cosmos in the twenty-first century, small thoughts to some, big thoughts to us.

It was now practically dark. After a cognac or two and a plate full of cheese and biscuits, it was decided that Willi and Carlo would meet up next morning, so that Willi could take me to the station for my train home. Please, please keep in touch, Carlo. I know you and Willi will, the artist and the philosopher, the painter and the physicist. Me merely a go-between, Bernard Jacobson the interloper.

* * *

So, William Tillyer began the long journey, way back in the fiftiess. He followed the ever expanding road in the sixties with his decade of high experimentation of pure ideas, the decade of his conceptual art. This followed on to the seventies, when he returned to the old – fashioned picture format but significantly and importantly to embrace the two earlier decades. This would lead to the eighties, when he would put himself into the picture, or rather man, not visible but present. In the nineties he had discovered that he could integrate the force of nature's energy and that the power of time and space in our landscape could be recorded in a melding of science and poetry, to put it in basic terms, and this would be followed in the twenty-first century by visually expressing the very vibrations and pulsing of nature's forces at work, the actual excitations, the earth's and the infinite universe's forces in perpetual motion.

He has done it slowly but surely, covering his tracks as best he can, to a huge pathway, compared to that one he travelled down over a half century ago.

Here to me is why he has moved, in the goodness of time, from Constable's giant ambitions, through Cézanne's even greater visual discoveries, to a new visual world, a new visual experience, one that cannot possibly be fully understood by his viewers. With all the scholarship now available at our fingertips, it should not take an enormous amount of time to catch up with him and marvel at his discoveries, which I feel may compete in greatness to Constable and Cézanne. But there again, as you may catch up with him, by the time you have achieved that goal, he will have already moved on, deeper into man and the cosmos – a far advancement of the original step of man in the landscape.

Out into the unknown. And where else should an artist wish to go?

The Journey Home

The train sets off from Northallerton to York's majestic station, then on its way, via Peterborough to King's Cross. The late afternoon train to London is already crowded. Schoolchildren, businessmen, mothers with their small children, long-haired travellers with open faces. The carriage is full but I am on my own, by the window, and I hear nothing but the rhythm of train's motion and the general murmur.

The train is fast and smooth and on its way. I have just seen a thirty foot painting by William Tillyer that has filled me with joy and wonder, filled me with contentedness and deep inner happiness, filled me with a huge feeling of awe.

The sky is clear blue in the late afternoon's Yorkshire skies, with the occasional billowing cloud. The sunlit fields with their margins of trees and occasional cows and horses and sheep, these fields go away so fast.

Sixty years of looking at art. Fifty years of selling art. Sixty wonderful years of loving Gauguin and Cézanne and Van Gogh and Lautrec and Renoir and Seurat and Monet and Degas and Manet and even Picasso and Matisse and Chagall and Modigliani and Soutine and Braque. Fifty years of love affairs with Hockney and Denny and Smith and Blake and Kossoff and Hodgkin and Uglow and Caulfield and Auerbach and Hoyland and Vaux. I've looked, I've learned, I've loved, I've become disappointed. Never an artist to inspire me through one decade until the next and manage to not to let me down, manage to not to let themselves down. Hockney's first fifteen years a kind of miracle. The wonderful times we had together, although, I was not to know it at the time, in my tender and impressionable years, the great years were would eventually be behind him. The elegant and courageous Robyn Denny, with his magical close-toned paintings from the early to mid-sixties. He always showed great dignity and strength and I would always feel, much later in the day, the nineties onwards, that he was too intelligent and sensitive to make great work anymore, so lived in a mysterious zone of rare or no exhibitions, of works that didn't live up to the first years.

How well I remember those healthy lunches at his Flood Street studio, where we would talk for hours and hours on end, and me in my twenties and thirties, greedily learning about art, love, life. And then there was his great friend Richard Smith, with a more glamorous career and more fame on both sides of the

Atlantic, a hugely talented artist whose natural flair perhaps got in the way of him digging deeper into his own art making and how he slipped more and more into decoration and effects, while Robyn, who always was seeking depth itself. That marvellous time in Italy when Dick represented Britain at the Venice Biennale – and how at the dinner so many Americans, I remember they all seemed to be from Texas, although that was not the case, all those Americans wanting a Richard Smith painting but also wanting a bit of Richard Smith too. Loads of good times and loads and loads of sales. Frank Stella would ask, how is Dick? Jim Rosenquist would ask, how is Dick? Larry Poons would ask, how is Dick? Peter Blake was a great friend of both Dick and Robyn. When I was his exclusive world dealer in the late sixties and early seventies, we would go to Rock concerts and Jazz concerts and fun fairs and circuses. Peter would take forever and ever to complete a painting and never really wanted to let it go, preferring to keep it for himself. The best years were already behind him, those when he was represented by the great Robert Fraser. If you hung out there in his Duke Street gallery you would easily bump into John or Ringo or Paul or George, or the Rolling Stones. Peter loved all that. To me it always seemed that Peter needed Robert, just like David needed Kasmin. When I first got my high-powered highly sexy Ford Mustang convertible, Peter was one of my first passengers. I was so embarrassed when it seemed that I had run out of petrol at the traffic lights in Mayfair. Peter, who would always act innocent about so many things, explained to me I was in park, and so I put it in drive and we shot off. Peter had a nice dry sense of humour. When your mind is charging ahead at 100 miles an hour, like this train, it is disorientating stopping off at York station for a couple of minutes, but soon we are on our way again. Oh yes, Leon. I first met Leon Kossoff in 1960, when I interviewed him for the Willesden Chronicle. It was my first job and I was a cub reporter. A truly delightful and good man. His Jewish Russian roots are never far away. He was the son of the owner of Kossoff's the bakers but he chose lots of paint as opposed to dough. He is such a warm and honest man and would ask, how is Karin? How are the boys? He waited for the answer too. I think his fifties and sixties paintings and drawings were wonderful. I think he is a truly rare artist, in that his later work, even to this day, may well be even better. He never bought into fame and fortune. As honest and good as I found Leon, I would consider Howard Hodgkin the complete opposite. I considered him dishonest and completely duplicitous. I always put this down to him being so neglected while all his friends, like Dick and Robyn for instance, were becoming so successful and famous and exhibiting everywhere. When he finally got around to painting the 'Hodgkin' we know, I feel he was eaten up with anger and jealousy. Once he struck that recognisable image, he would

go on to make hundreds of them and they are so attractive at their best. When he did the double portrait of Karin and me, and I am not too sure which is Karin and which is me, he sneakily did a second version. When he took me to Little Italy in downtown New York, he explained to me that he was now gay. I didn't know what to say in response. I well remember the red and white tablecloth, the Chianti bottles lining the walls, the busy Italian waiters, a perfect subject for a Hodgkin painting perhaps. Oh, and the time I was off to Charles Saatchi to give him a copy of the Oxford Dictionary of Art for his birthday. Howard insisted I tell him what book I had in the bag I was holding. I told him and he went to his desk where his colours were carefully laid out. It was actually quite a moving experience. He measured the book and proceeded to paint a wrap-around cover for the book as his gift too. Here, he said, here is your William Tillyer. It was a sad moment for me because I realized he was deeply jealous of Tillyer. He didn't need to be, not with his new fame and fortune. But it obviously bothered him. Perhaps he understood the depth in Willi's work, which he himself could not reach. If there was one artist that Howard thought was underrated it was Patrick Caulfield. He would on so many occasions say that Patrick's career was wilting at Waddington gallery and that I should take over the career. However many naughty things Leslie did to me, I have never poached an artist away from another dealer. I did love Patrick's work though. He lived around the corner from me in Fitzroy Road in Primrose Hill, when I was bachelor. John Hoyland lived there too. We would see a lot of each other in the sixties, and then on for a long time too. I published prints with him, I owned paintings by him, sold paintings by him. He had a phoney posh accent and eventually it was the only way he spoke, so we accepted it. Again, I must say that the Robert Fraser years, the early years, produced the best work, although his later paintings always had a lot of style and humour and touch all of its own. As I sit here and contemplate, the landscape moving just as fast but the light fading in the early evening sunset, I consider Patrick one of very few artists I would say can compete against Willi, although his work lacks the breadth and depth for me. Another artist I rate extremely highly, and managed to sustain the intensity and quality until his last breath, was that bohemian Euan Uglow. I only got to know him a lot later on, in the eighties, and when he first invited me over to his studio he caustically exclaimed, 'Welcome to my La Boheme.' All his close friends nagged me to represent him and his work but once again, and I hated doing it because I felt strongly about it, said I would not steal him from my friend, William Darby. I owned a great many of his paintings and got Charles Saatchi and David Bowie and others to grab as many as possible. In my opinion, he was the continuation of his and my hero, Paul Cézanne, with the most wry sense of humour and the

most intense painting skills imaginable. I felt he had far surpassed his mentor, William Coldstream. However much I wanted to represent him, however much David Sylvester and perhaps his closest friend Rudie Nassau insisted, I saw it as theft and dishonourable. It did hurt though, and actually that still does to this day. Like Leon, his good friend Frank Auerbach was also a student of David Bomberg and utterly under his spell, as a painter and also as a teacher. I find the very early paintings, the works from the fifties extremely good. Like a fellow student at the Royal College of Art, David Hockney, he would capture an innocence and a truthfulness in the sixties. Both seem to lose that quality for me. Perhaps Frank goes too close to the same picture for fifty years now, while David perhaps goes too wide and far away from the great roots he laid down in the homosexual paintings of the first fifteen years of his long and adventurous career. While I tried to get David to revisit the magic of pen and pencil on paper, from his early years, he would reply in his adorable and contagious Yorkshire accent, 'I've doon enough of them, luv.' Frank, on the other hand, would get completely confused if you suggested he move on with his art, as he acts as if he is on a mission from God virtually. Of course, Frank did nearly become an actor, before turning to art.

We are now way beyond Sheffield, where John Hoyland was originally from. He too was a Yorkshireman, like Willi. In the mid-sixties I was a regular buyer of the work of John Walker. In fact I even bought him his first roll of canvas on the understanding I would receive one painting from that roll. I even got him into his first London gallery, the Axiom, by introducing him to the owner, James Crabtree. Anyway, John one day very generously said he wanted to introduce me to real painter, as he put it. So John Walker would introduce me to John Hoyland, who, by the way, in time would introduce me to Mark Rothko and also Barnett Newman. Like Leon, although in a completely different way, John was a true painter and you feel that both of them were born to paint. Sadly, once again, and I do feel too mean or perhaps too critical, John was a marvel in the sixties and even in the early seventies, but the work petered out for me. I even took him to Los Angeles in the late seventies, to get away from the huge funk I felt he was in. He did some stunning work there and I thought the LA lifestyle and environs was great for him. But I just could not feel that former magic, where he could paint one great picture after another. One day he asked me to go over to his studio in Charterhouse Square by the Barbican. He said I would be 'turned on' by the new paintings. I thought the visit was an embarrassment and I was not turned on. But I did like John Hoyland! He was terrific and we would often have great fun together. Probably John and John were too heavily influenced by the Americans and simply

did not have the originality to climb above them and so probably only managed to remain in the shadows of those great mid-twentieth century giants.

I'm on this beautiful and fast moving train today and I am aware that I am now in my mid-seventies and when I first fell in love with the work of all these talented artists, I was so hugely impressionable and in my twenties and thirties and at that stage I was filled with innocence of my subject, art of our own time, and also in awe of artists. I, in my forties, fifties and sixties, with all the good will in the world, would become more critical, more wary and more demanding on the artist and on myself.

There was just one artist over this extremely long period that would not let me down with his work, or should I say, did not let himself down. He is William Tillyer.

Several artists would come agonizingly close to this high bar he had set himself. As I said to you, I feel Uglow and Caulfield and Kossoff are of equal ambitions with themselves and the canvas, of course there are several others.

While we are travelling along, some children and babies are getting extremely restless and noisy and my concentration is dipping a bit by these distractions. But I want to stay focused to rave about one painter who didn't get the sufficient attention he deserved. Marc Vaux is now in his late eighties and like Leon and Euan, he seems to have simply got better with time, not coasting and sitting on his laurels and not slipping into mediocrity and staleness. His whole life, and I have known him nearly sixty years, has quietly and thoroughly and passionately dealt with light and colour. It is a happy obsession that has produced a truly wonderful body of works, hundreds of paintings and coloured drawings and, without any self-promotion like his friends and colleagues have left us with a staggering array of colour, light and hope for a joyous future.

And as the train speeds along towards King's Cross, I feel you and I have reached some kind of immaculate timing. Can I put together my thoughts on this quiet man who up until now has received a miniscule thank you and reward from the art establishment.

* * *

Obviously I have looked in the mirror many times over the years, although I have never seen myself like this, as I look into the mirror, made by the twilight on the window of the train, and I see myself as if for the first time. I have seen many trees bordering fields in the landscape but I have never seen those trees or that stretch of verdant green in the darkness quite like that before, and it was if the volume had been turned up to a pleasing but loud pitch, where I understood so much more, about everything. I feel content. I am more complete.

* * *

You see, I am on my journey too. The speed of this train is a complete fit to the speed of my mind and of my heart. On my journey so few of those artists are any use to me, to help me understand who and why I am and where I am going. I always feel in comfort with Gauguin. I always feel in comfort with William Tillyer. They enable my journey to be soulful, joyful, happy and full. Willi is my servant and I am in turn his servant. As the billowing clouds fill with a warm and glorious pink, as the soulful and joyful and happy and full, as......... Only yesterday Willi and I walked the beach at Whitby and watched the sands appear and disappear as the waves came in and went out. I believe in his journey and his journey nourishes my lonely journey and makes it become not just bearable but wonderful too. As the waves go back into themselves and leave the shore, Willi and I observe how new patterns appear in the sand and I remember, as he has said many times before, art will never die. It is as natural and as basic as making marks in the sand with a stick. And over in Whitby the receding waves make fascinating patterns in the sand, so God, or Nature, is an artist.

* * *

It is a bit like playing with fire, seeing a kid with a live box of matches. It is only conjecture. But it seems to me that truly great art crosses the invisible boundary, from art world art into the superlative territory of world art. And it seems the further it travels into the wonderful position of world art, the more it is frowned upon and even detested by the cognoscenti who rule the domain of art world art, to hate it so just because the people beyond the art world adore it. That is why the art world snobs sneer at Chagall and Renoir and even our own Constable, because the child has left the fold and ventured into the grown-up world. It seems highly unlikely that art world heroes will progress beyond the art world as there is nothing there for the general public, artists such as Brice Marden or Robert Ryman or

Agnes Martin. But William Tillyer can be scorned upon because real people love it. It is like a kid playing with matches, if you hold on too long, you will burn your fingers. Because if you try too hard and if you are too self-conscious about it you will fail in both camps because the art world will have turned its back on you and the people, through plain intuition will not find a love for you and so the walking of the tightrope becomes treacherous, when for instance Hockney attempts to woo people with his woodland scenes, which don't quite transcend the fashionable glare as it falls short of high art on the one hand and giving off a true feeling of a genuine love of nature and the landscape on the other, Tillyer, in his quiet and lonely space can succeed.

* * *

I try to stop myself from nodding off to sleep with the soothing rocking of the train. I take a short break from looking out of the window. I recently picked up a little book entitled *Inspirations*. Seemed like a neat idea for a pocket-sized publication, so I flicked through it. And so I read:

It's amazing that you can win the Turner Prize with an E in A Level Art, a twisted imagination and a chainsaw. Hirst
No Damien, it is not amazing at all.

The moment you cheat for the sake of beauty, you know you are an artist. Hockney
How intelligent of William Tillyer to just make art and not talk. Best to remain the quiet man of the North. David, say less and you may learn more.

Art is a line around your thoughts. Klimt
I'll let you have that one, because you are such a good artist, Gustav. But it's a bit silly actually, isn't it?

I rarely draw what I see. I draw what I feel in my body. Hepworth
Good artist. Stupid comment.

The artist that paints every tiny detail is an artist with nothing better to do. Adoquei
Vermeer might disagree with that, Sam.

Every man is an artist. Beuys
That's plain stupid, Joseph.

What I try to give form to is the subjective experiences of living behind our faces. Gorky
This doesn't make sense and gives you away, Arshile.

The artist's job is to be a witness of his time in history. Rauschenberg
This is nearly interesting, Bob.

An artist should never be a prisoner of himself, prisoner of style, prisoner of reputation, prisoner of success. Matisse
Now you are talking, Henri.

I paint flowers so they don't die. Kahlo
Now listen, Frida, that is just soppy.

Art is anything you can get away with. McLuhan
You always were a visionary, Marshall.

One must not be afraid of making mistakes now and then. Van Gogh
What a sad and great and wonderful man Vincent was.

The Louvre is the great book in which we learn to read. Cézanne
So humble, so great, Paul – if I may call you that.

An artist's early work is inevitably made up of a mixture of tendencies and interests. Riley
The less said the better, Bridget.

Every artist should be ahead of his time and behind in his rent. Friedman
This is brilliant, Kinky.

Art is much less important than life, but what a poor life without it. Motherwell
Bravo, Bob.

And so this beautiful train travels on.

William Tillyer has always made an art that goes beyond the art world, while remaining completely faithful to it. He has integrated all the art world discoveries, ancient and modern, to distil a picture that initially seems to fail the viewer looking for simple and attractive painting and also the artworld's police force and in their huge numbers, roaming an international art terrain, repressing that art which breaks taut boundaries. In the fullness of time, perhaps very soon, say the next decade or two, these pictures will coalesce into the great mid-twentyfirst century art. To produce an art that makes the tiniest step to the next place in art history is indeed useful and well-intentioned and good. To make the gigantic leap is wonderful, and that is just what William Tillyer is attempting.

The image of the bustle of hundreds of people milling around at Kings Cross, going home, going off for the weekend, going about their business.

- The Real world!